HICKMANS

P9-DNB-330

WITHDRAWN
Brunswick County Library
109 W. Moore Street
Southport NC 28461

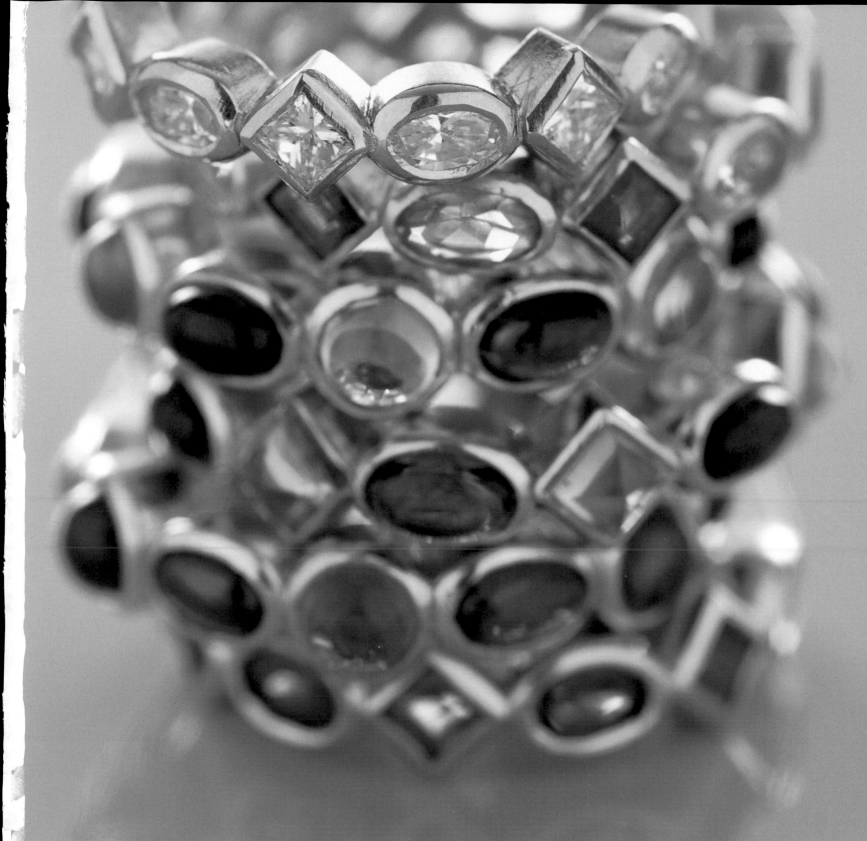

ALCHEMY

ALCHEMY

A PASSION FOR JEWELS

TEMPLE ST. CLAIR

COLLINS|DESIGN

An Imprint of HarperCollinsPublishers

FOR

MAY YOUR LIVES

ALEXANDER

BE FULL OF LOVE

AND

AND ADVENTURE.

ARCHER

CONTENTS

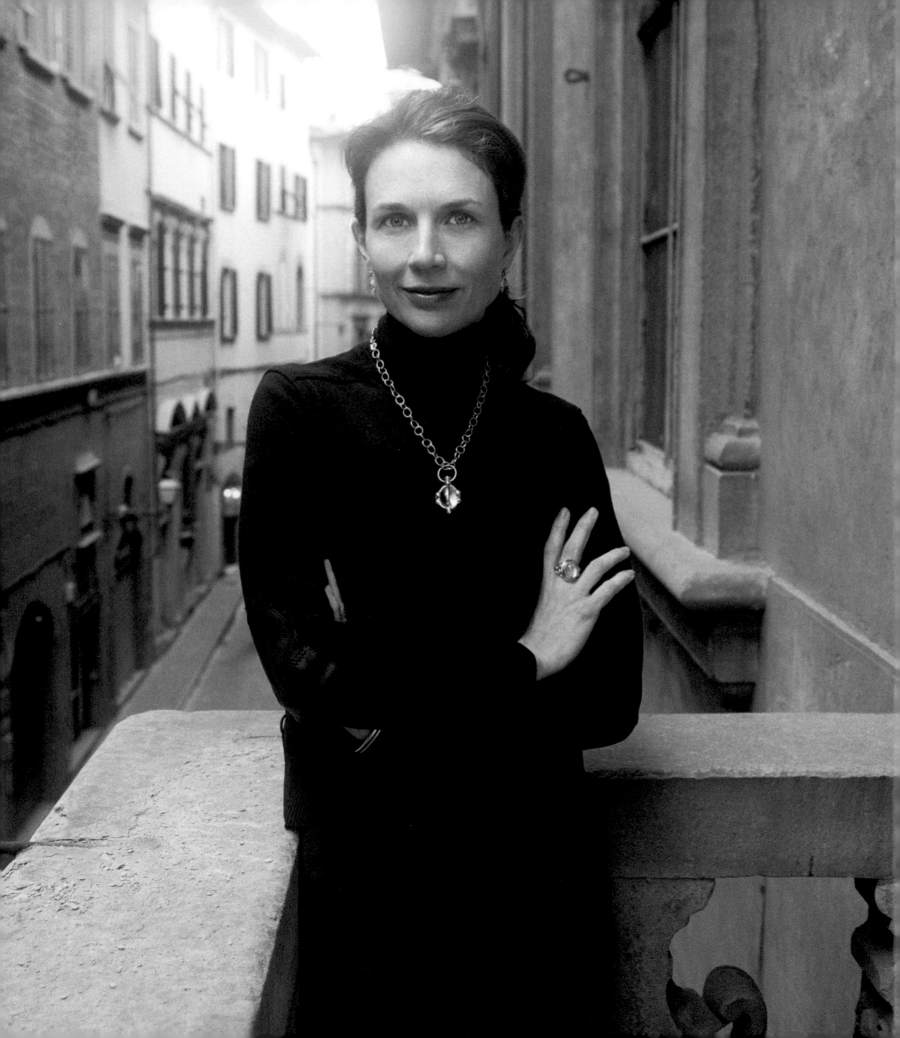

I HAVE BEEN DESIGNING JEWELRY for over twenty years, and collectors and students often ask me how I came to be a designer, and why jewelry. I think for many in the creative fields, these are common questions, and short answers do not come easily.

I love what I do and have come to it in a very organic way. I could certainly have "become" something or someone else but, in my case, there were many factors that coincided to bring my interests and passions together in a career of jewelry.

To some, the so-called creative process is a mystery, yet I imagine every creative person believes his or her method to be entirely logical. For anyone who might be interested in how one creator in the jewelry world works, and for anyone who has the desire to live and sustain themselves through their own creativity, I hope that this book may demonstrate how the art can be the life.

In this book, I have included images of my own work along with images and references to historical and contemporary works, people, and places that have been influential and inspirational to me as a designer and a human being.

What I most want to share and communicate is an appreciation of the richness available to us in the world through the timeless pleasures of enjoying art, nature, and literature. As we add technology and live our everyday lives faster and faster, we lose the ability to observe, contemplate, and communicate with care. It is important to take time to dream, conceive, and create. After all, it is art and culture that truly connect us as human beings.

Temple St. Clair Carr
New York City • March 2008

TITLE PAGE: 18K Colombina rings. CONTENTS PAGES: Caravanserai necklace in royal blue moonstone. LEFT: On the balcony of the Palazzo Corsini in Via del Parione, Florence. FOLLOWING PAGES (LEFT TO RIGHT): Drawing for Fiori bracelet; Fiori bracelet in royal blue moonstone.

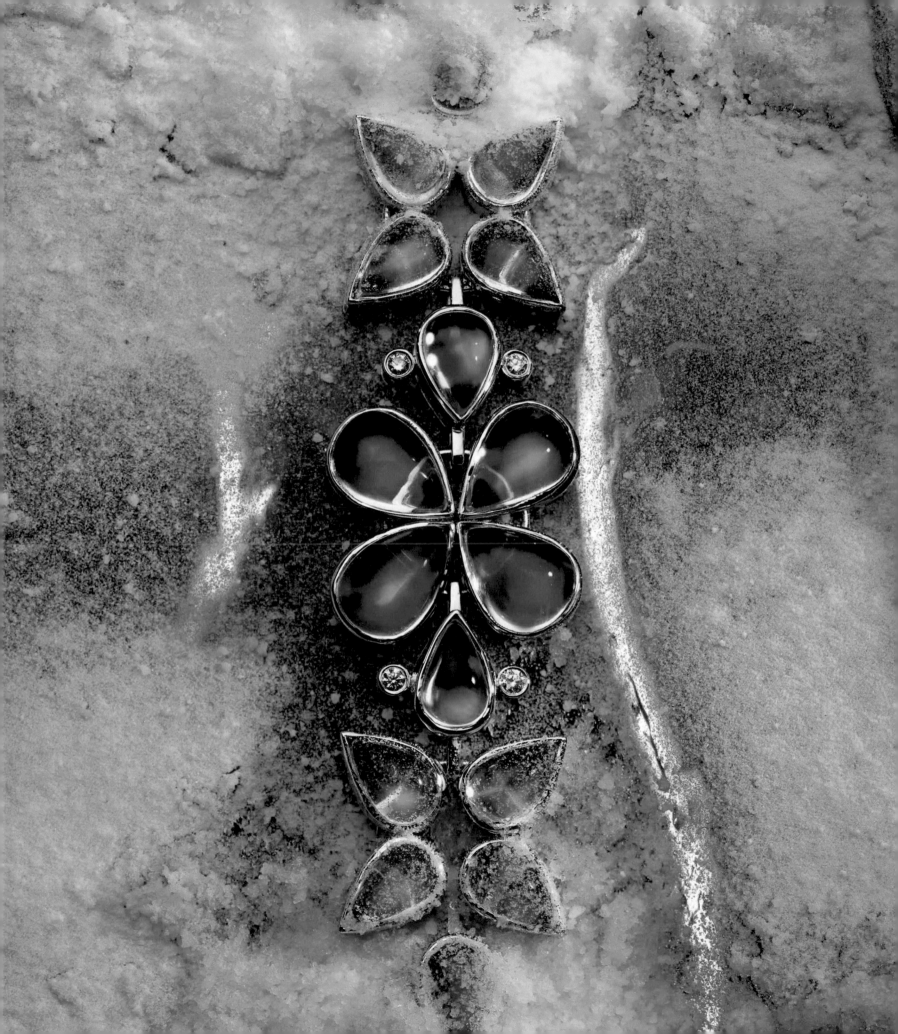

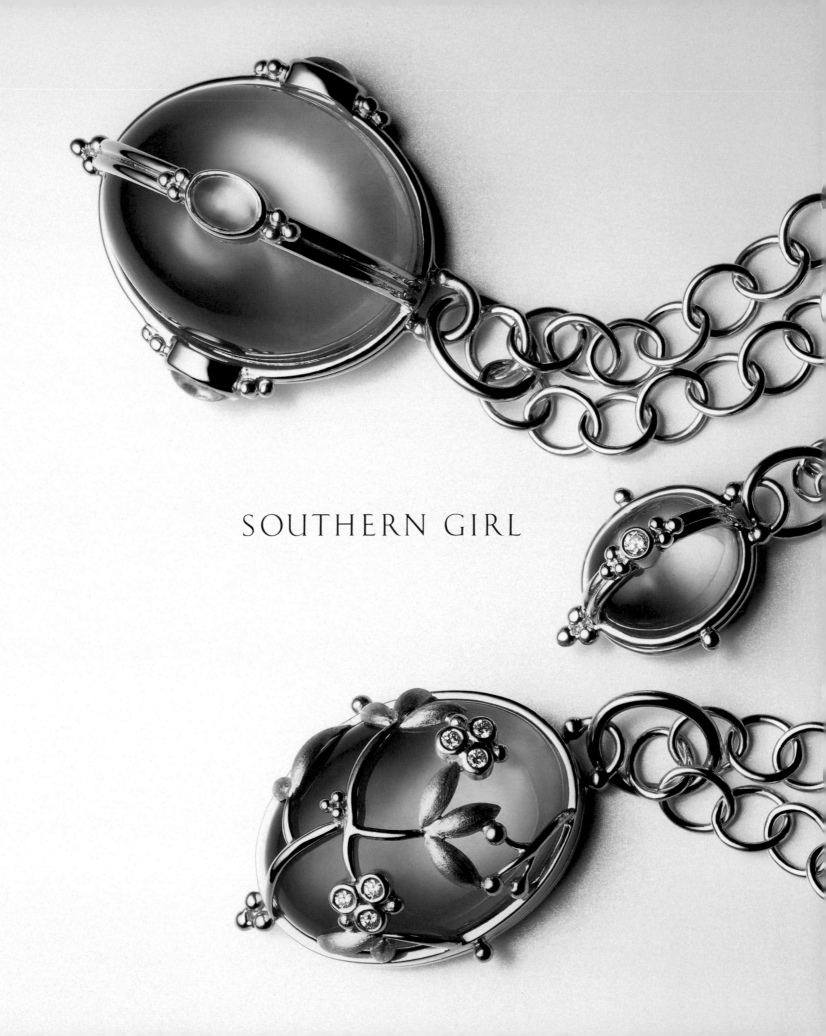

SOUTHERN GIRL

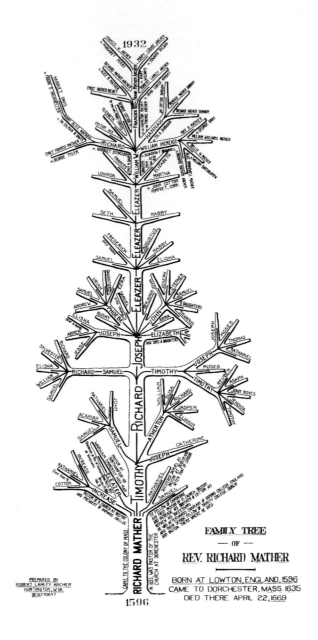

The family tree illustration shows the "FAMILY TREE OF REV. RICHARD MATHER, BORN AT LOWTON, ENGLAND, 1596, CAME TO DORCHESTER, MASS. 1635, DIED THERE APRIL 22, 1669." The tree spans from 1596 at the base to 1932 at the top, with "PREPARED BY ROBERT LAMLEY ARCHER, HUNTINGTON, W.VA., DESCENDANT."

SOUTHERNERS TEND TO BE LOYAL to their heritage. No matter how many decades I have been away from the South, I always think of myself as a Southern Girl. In fact, Southern women persistently refer to themselves and their "girlfriends" as girls, however old they get! As a fellow transplant affectionately refers to our roots, no matter where we end up, we are always part of the "Magnolia Mafia."

I have not lived in the South for a long time, but love to frequent family homes in Virginia, the Carolinas, and Georgia. I visit and revisit my favorite Southern architectural treasures, such as Drayton Hall on the Ashley River outside of Charleston, secret gardens in downtown Savannah, and Thomas Jefferson's various creations in the countryside of Virginia. Strangely enough, my Southern accent seems to be

OVERLEAF PAGES: 18K Vine and Classic lockets in mango green and royal blue moonstone. TOP: The Mather-Archer family tree. OPPOSITE (CLOCKWISE FROM TOP): Drayton Hall, Charleston, South Carolina; three generations: Granny, Mary Archer; my mother, Temple St. Clair; and me at about age two; my grandparents' home, White Hall, Gloucester, Virginia.

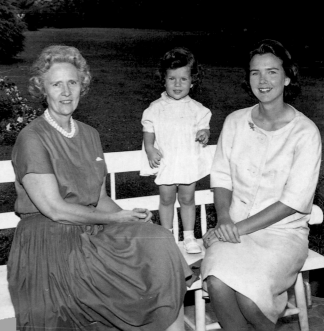

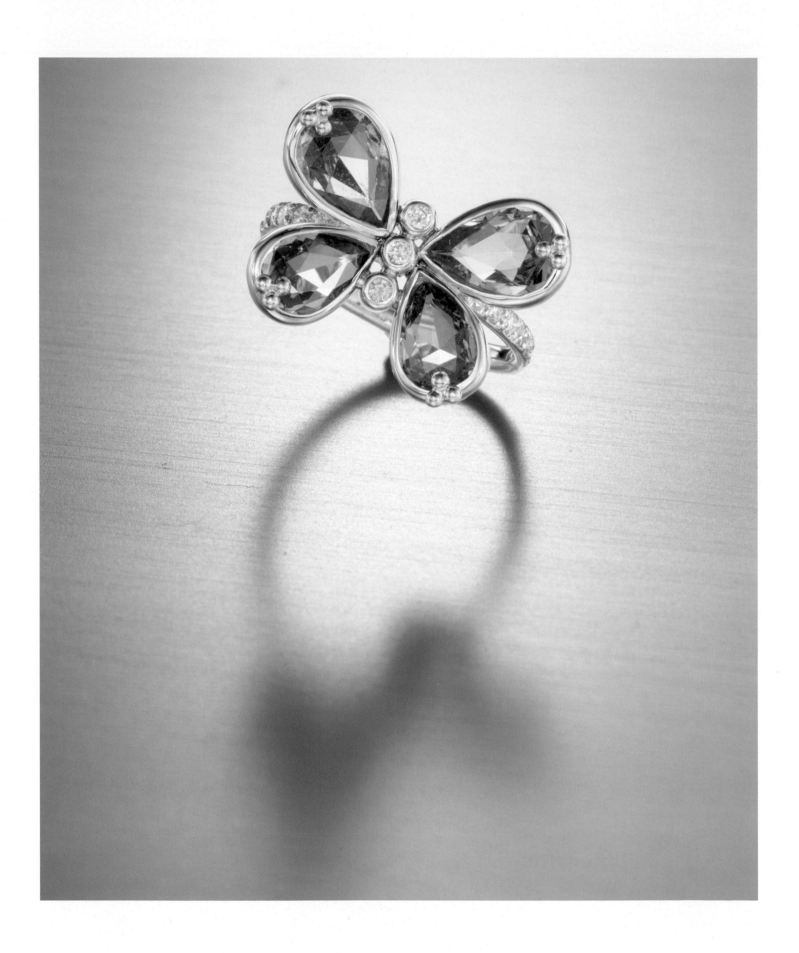

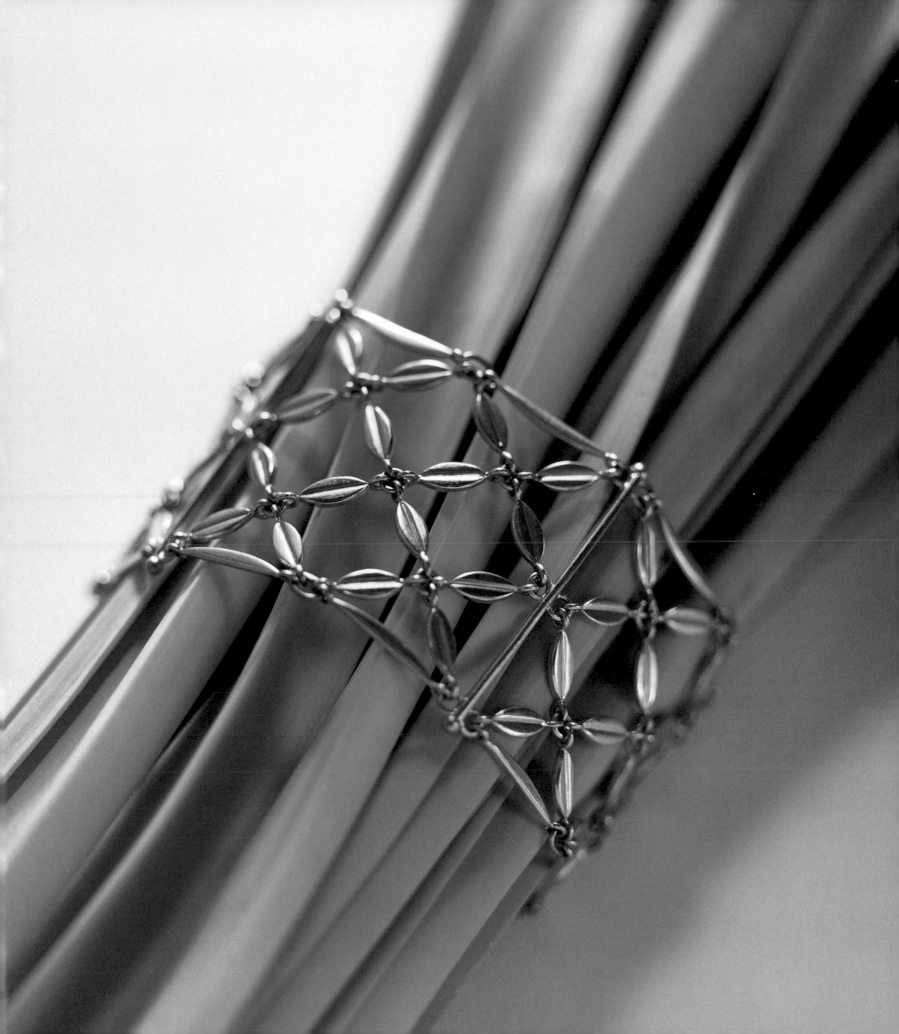

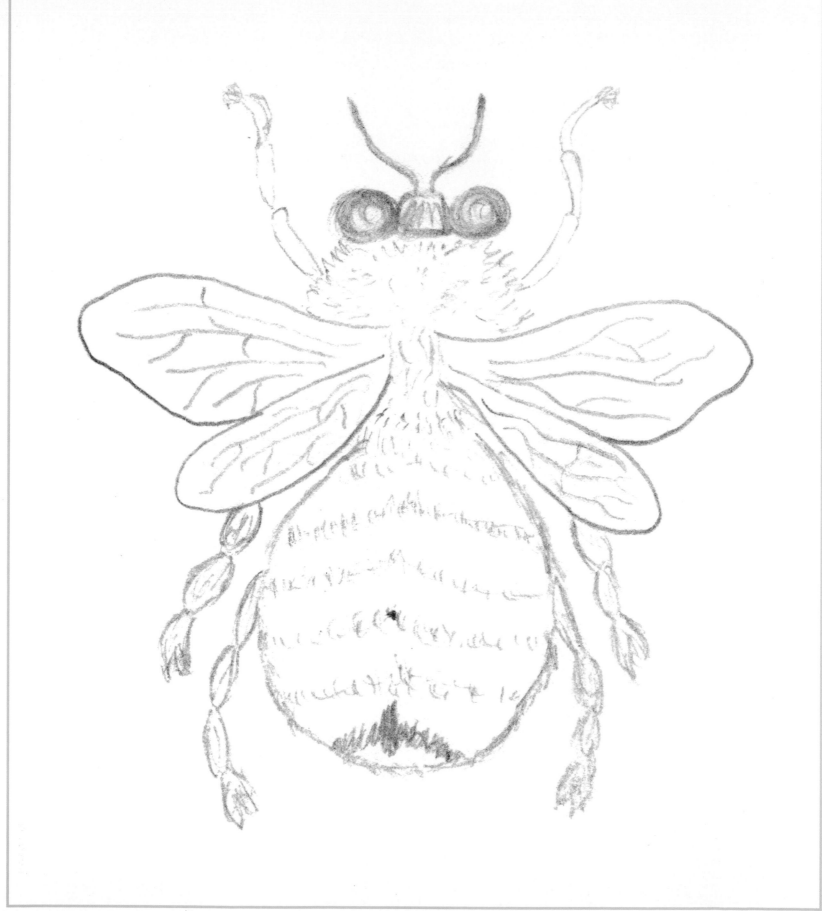

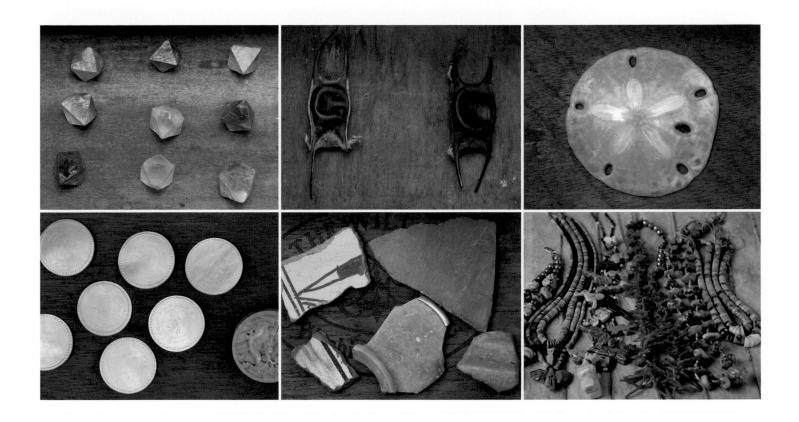

ripening with age, despite my permanence in New York City and frequent escapes to Europe and beyond.

I consider myself a thoroughly contemporary woman, but my "Southern Girl" heritage leaves me with a love of history, tradition, and ritual. I vehemently hold on to a sense of legacy and manners. In the midst of the big city, I try to raise my children in a Southern way, paying attention to manners and simple pleasures. We enjoy all the city has to offer, but we try to keep life a bit old-fashioned with sit-down family dinners, an emphasis on books, drawing, and classic old movies for entertainment.

Southerners often dwell on stories of the past and their ancestry, and as with most families, there seems to be a strong pull between the soulful and seductive skeletons of the past and life in the present. My mother's American family history originated in New England and later moved south. While in the North, our ancestor Cotton Mather's witch-hunting activities in seventeenth-century Massachusetts overshadow any positive contributions he may have made. Having such an infamous forefather is, of course, of great interest to my young sons, just as it has always been perplexing and horrifying to me. No doubt, Cotton would have raised an eyebrow or two at me and at many of my outspoken and independent Southern Girl relatives who have held forth over recent generations.

Not only do Southern families preserve tradition, but they love to preserve names. When male heirs don't come

OVERLEAF PAGES (LEFT TO RIGHT): 18K Butterfly ring in rose-cut sapphire and diamond; 18K Foglia bracelet. LEFT: My early sketch of a bumblebee. TOP: Personal treasures: from potsherds to fossilized sand dollars to skate eggs (also called mermaids' purses) to Native American necklaces.

along to carry the family names, the Southern Girls get them as first names. Now Temple, Archer, Ryland, Mather, and Carr are popping up in the latest family additions.

I am one of the few members of my family who settled north of the Mason-Dixon Line. My parents probably never imagined that I would not return south, but they themselves altered my Southern destiny. They animated my childhood with travel and the message that anything was possible. They instilled in me a strong spirit for adventure and fun, and encouraged me to explore my interests in depth.

As a young girl in Virginia, most of my time was spent making up games and playing outside, climbing trees accompanied by a good book or sketchbook. Inside, my room was a mix between a petting zoo and my own personally assembled "museum." I had dogs and cats, brood after brood of gerbils, tropical fish, a bevy of quail, and a jeweled beetle that I brought back from Mexico long before they were outlawed. I curated my own collections of beads, shells, potsherds, Native American arrowheads, and old American coins, and would string things together to make primitive necklaces and bracelets to sell to my friends at school.

A passion for travel and collecting was a gift from my family and upbringing. Our connection to other countries and cultures was always important, and the movements of both sides

TOP: Granny at age sixteen. RIGHT: My maternal great-grandparents: Mamie (Maybird Williams) and Big Daddy (Francis Mather Archer).

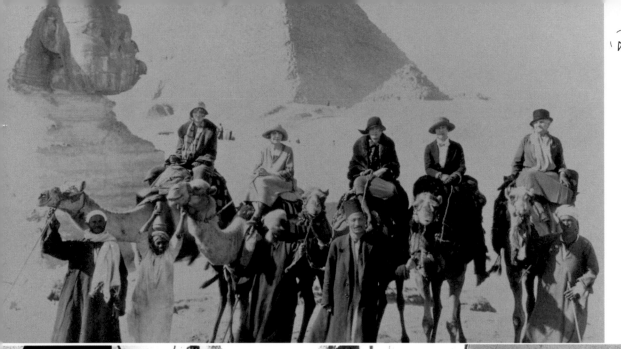

For Mary Lou Prosser
Memories of the
Conte Biancamano
& of Virginia Beach
from her admirer
F. Scott Fitzgerald

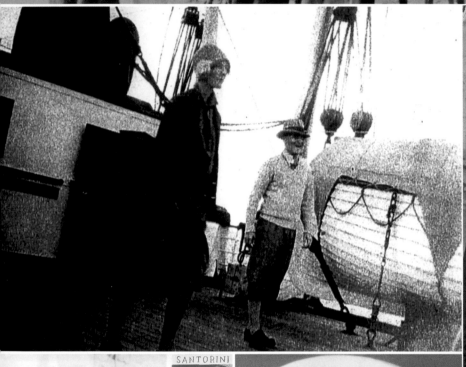

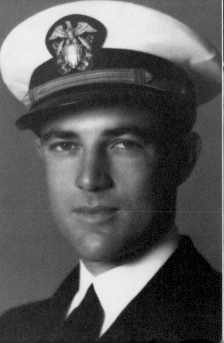

of my family have long been documented and romantically recounted. Now in his midnineties, my father has long been a history buff and an authority on his own family history and on the twentieth century, for that matter. His ancestors crossed from France into England with William the Conqueror during the Norman Conquest in 1066. His family made its way to America just before the Civil War. To this day, my father is arranging his next trip following his ever-vital interest to explore the world and his desire to revisit his favorite places such as Rome and St. Petersburg.

My maternal grandmother (the notorious "Granny") captured our attention with tales of our heritage, her parents, Big Daddy and Mamie, and her travels. She studied in Versailles as a young girl and remembered galloping on horseback through the palace gardens. She regaled us with her accounts of being one of the first to enter King Tut's tomb in Egypt while all the gold and treasures were still in place and there was a threatening curse over the door. She showed off her letters and frustrated us all with her wistful yet unspecific accounts of her flirtation with "Scottie" Fitzgerald, whom she met on one of her transatlantic crossings.

It is largely thanks to my mother's enthusiasm for visiting new places and my father's love of history that the urge to explore settled deep into my bones at an early age. Both have always loved to travel and took me along on many voyages in the Americas and abroad from the time I could walk.

Each summer, after school, we would take a monthlong meandering trip in Ireland and Scotland, or to Bavaria, the Loire Valley, Egypt, Morocco, or the Yucatán. On all these trips, I was encouraged to keep a journal and various mementos to compile a scrapbook upon my return. We never traveled like complete tourists. We did visit the important churches, castles, and monuments, but we also shopped in the local markets and made picnics out of the local breads, cheeses, and wine. There was always an immediacy to how my parents traveled. They taught me to take the time to get to know a foreign

OVERLEAF PAGES: Early 22K rings. OPPOSITE PAGE (CLOCKWISE FROM TOP LEFT): Granny in front of the pyramids on a World Tour in the 1930s; note to Granny from her admirer, F. Scott Fitzgerald; my great-grandfather with his dog; my father, James Edward Carr, in his navy uniform during World War II; my father, touring in the Greek islands; Granny playing shuffleboard with F. Scott Fitzgerald while on a transatlantic crossing. TOP: 18K Vine ring.

place more intimately by studying its language, history, and literature before departing.

By the time I was in elementary school, I was duly prepped for more adventure; my Southern borders were feeling like a constraint. My mother came up with the idea of my studying abroad, and since I had been studying French from an early age, focused on France and Switzerland. We settled on a Swiss school in Lausanne: Château Brillantmont. The school was housed in four villas way up on a hill in a residential area of the city. One villa was a finishing school, and another was for girls pursuing academic diplomas, which is the program I was enrolled in. My room looked across Lake Geneva to the French Alps and the village of Evian. Although some classes were conducted in English, many were in French, and we were meant to speak French at all times outside of class. We could also take great advantage of our location; my class would go to Paris for a weekend or to Greece for spring break and, of course, skiing in the Alps.

Many of the girls at the school came from extremely strict families. With their newly perceived sense of freedom at boarding school, they were always contriving ways to sneak out and go into town, practically tying sheets together and climbing off the balconies. I arrived a fresh-faced, preppy Southern Girl who was there to get the language down. The first two friends I made were from Saudi Arabia and Iran; Randa Malki was a beautiful blue-eyed girl from Riyadh, and Souhair Sindi, her giggly roommate from Tehran. When I first saw Randa, she was carrying a Christian Dior bag and was dressed in very chic designer clothes that seemed like they might have been borrowed from her mother or an older

TOP: One of my childhood travel journals, circa 1970. OPPOSITE PAGE (TOP): My favorite armband, which I refused to take off for years; Bavaria, near Neuschwanstein Castle; (CENTER): Anne Hathaway's Cottage, Stratford-upon-Avon; Stonehenge; departing with my parents in the days when you dressed up to travel; (BOTTOM): hot chocolate with my father in Bavaria; exploring Uxmal in the Yucatán.

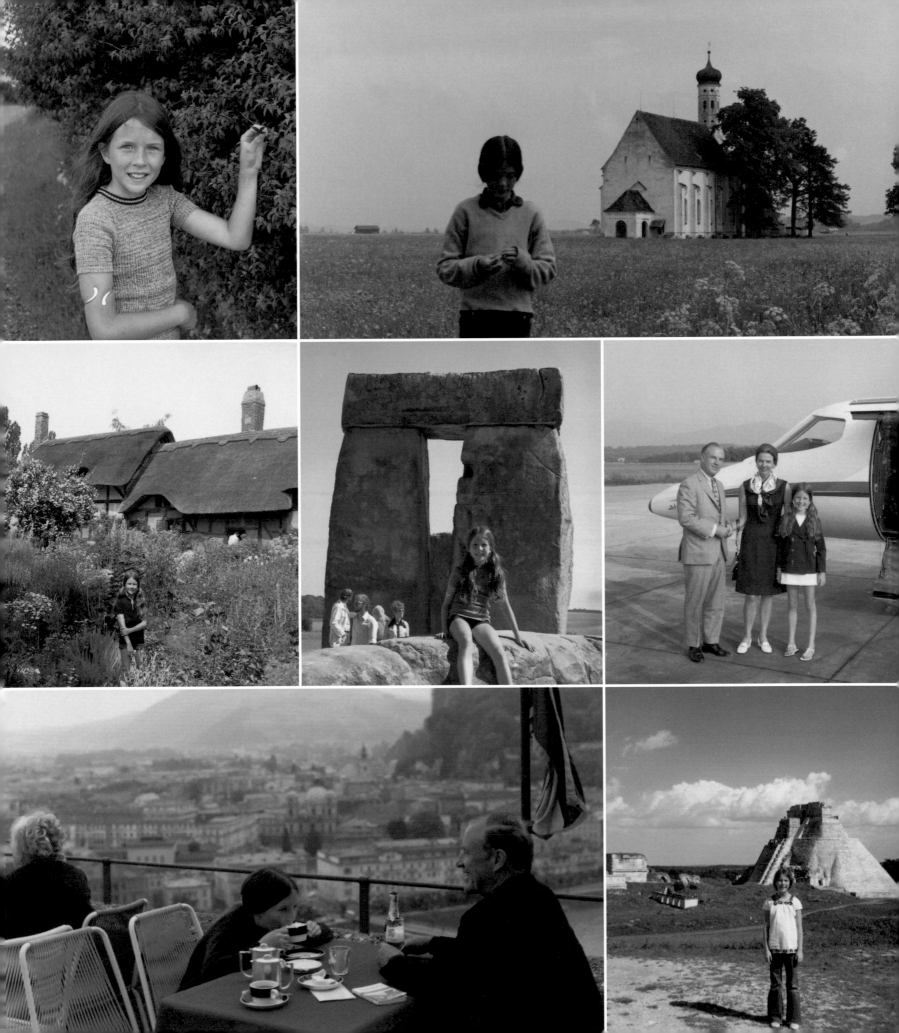

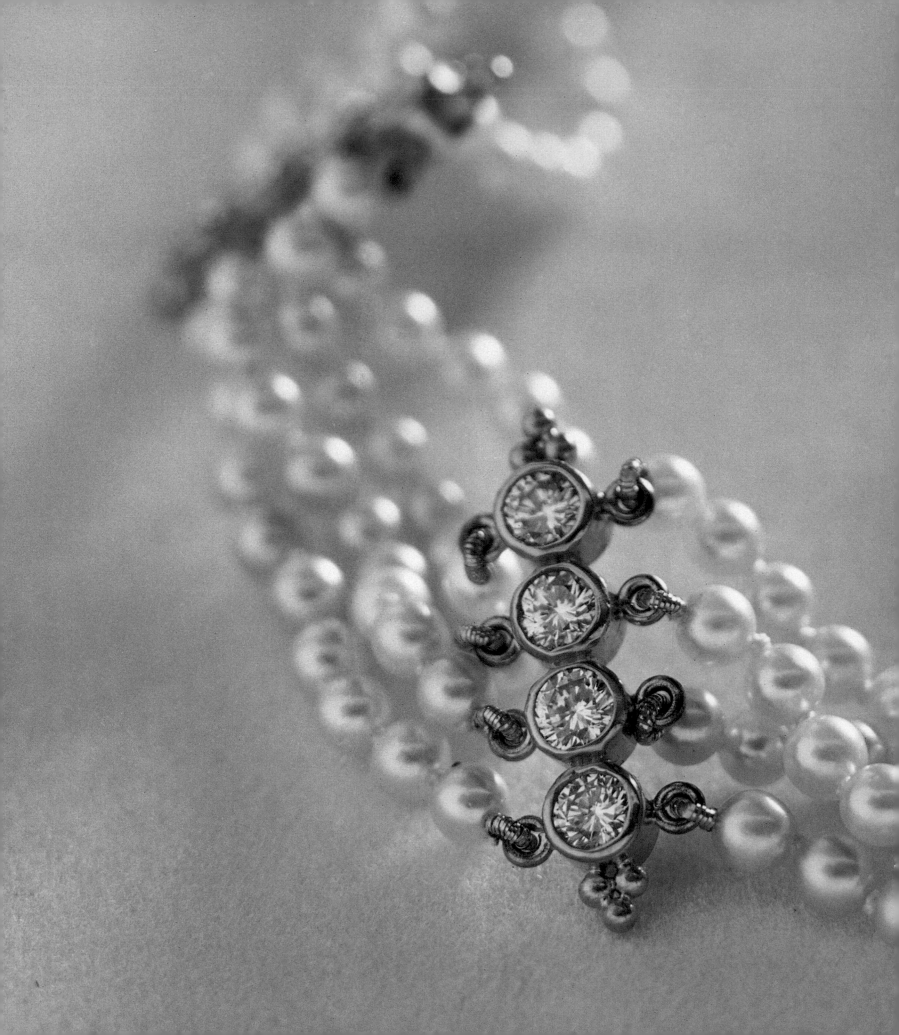

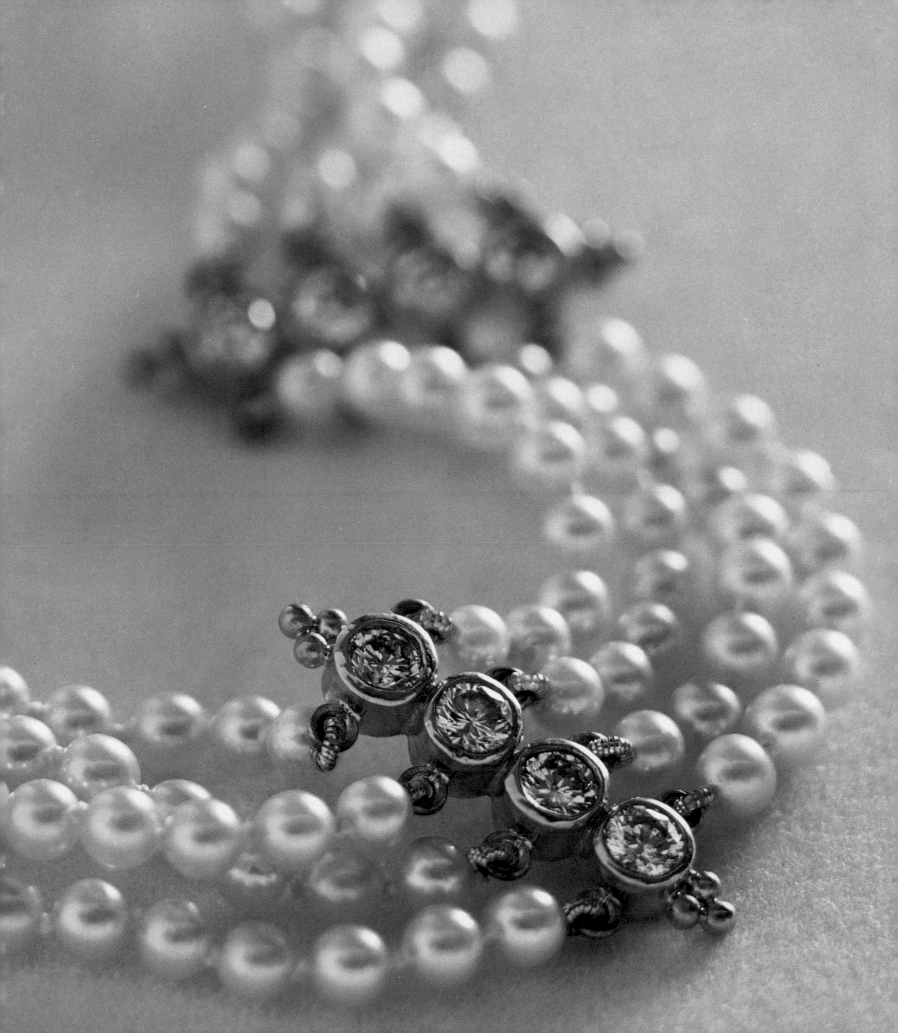

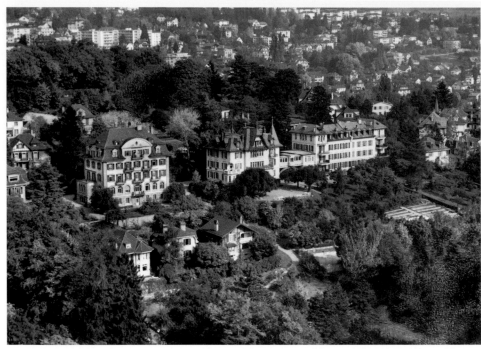

sister. She appeared intimidatingly sophisticated. But by the next day, we all were in jeans and looked like the teenage students we were.

That first year, my roommates were from Brazil and Australia. Ariane de Cavalho was adorable and desperately homesick for her boyfriend in Rio de Janeiro. Candy Nyhuis, from Melbourne, was a wild child. At one point we had another roommate, a Swiss American girl from the Nestlé family. Every weekend she would visit her grandmother and come back loaded with chocolate, which she refused to share and would promptly lock in her armoire. (Candy ultimately broke in and indulged in the wealth of sweets, which, given her name, seemed only appropriate.) The rest of the floor in our villa was sprinkled with girls from England, Germany, Mexico, Italy, Finland, India, and Japan.

Being at an international boarding school in Europe changed my life. My family had given me a basis for exploring the world; studying in another country only further expanded my horizons. There was no turning back. Upon my high school graduation in Switzerland, I came back stateside to Smith College, where I centered my studies in the French and Italian departments—and worked at a way to get back to Europe. I asked both departments if I could study abroad for a year each in Italy and France. The French department was uppity and did not comply, but the Italians were happy to figure out a way to make it work. I ended up dropping my French studies and dedicating myself to the more fun-loving Italians.

I spent my junior year abroad in Florence, where I was placed with Clara Benelli, an older signora who had housed Smith girls for decades. She was very nineteenth century.

OVERLEAF PAGES: 18K Classic pearl choker. TOP LEFT AND RIGHT: Château Brillantmont; my school in Lausanne. RIGHT: Giuseppe Zocchi, *Vedute di Firenze e. della Toscana*, eighteenth-century engravings of my home in Settignano.

Veduta di Campagna vicino a Gamberaia.

Veduta dell'ingresso alla Villa di Gamberaia del S. *Marchese Capponi.*

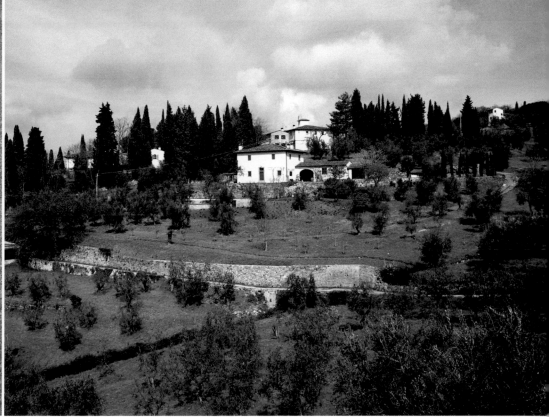

Although Clara did not have a lot of money, she knew how to live well—all her shoes had been custom-made decades before, and her clothes, which she kept in perfect condition, were from a clothing atelier she had owned in the 1940s. She was a Red Cross volunteer, a great cook, and she went to mass every single day.

Clara had a household helper, Anna, a wizened old woman about four feet tall, who always wore her white hair in a tight little bun. Slight but with a strong grip, she would take me by the hand and recount stories of Clara and her true love who had died in the "Great War." The two of them would reminisce about "the old days, when Mussolini was in charge and all the trains ran on time!"

Clara was tough; she had her rules, regulations, and standards, and it was often difficult to comply, but she had great hopes for me—mostly that I frequent the company of the "right kind of people," or at least the Florentine aristocracy. I learned a great deal from her about the quality of life that can be found in treasures such as a friend's fresh-pressed olive oil or just the right aged parmigiano. She taught me some of the basic tricks of Italian cooking and introduced me to the world of the artisan, which still exists in Florence.

I became completely enamored with life in Italy, which isn't difficult. After graduating from Smith, I was determined to return to Italy, so I entered a masters program with Middlebury College that allowed me to resume my life there. I found a mansard apartment in Via della Vigna Vecchia, a medieval street in the center of Florence. At the University of Florence, I took fourteenth- and fifteenth-century literature courses. In between readings of Dante and Boccaccio, I brushed up on my colloquial Italian with Florentine boyfriends; you don't marry them, but they are useful for perfecting your Italian!

After finishing my studies, I continued to contrive reasons to stay. I settled into a cottage in the hills above Florence near the village of Settignano, not far from Bernard Berenson's Villa I Tatti. I traveled throughout Italy taking in the art, the history, and the Mediterranean way of life, embracing the simple pleasures that are so pervasive in Italy: delicious peasant dishes, a great glass of red wine, a landscape of olive groves, vineyards, and cypresses. Florence became my home base. From there, I traveled farther and farther afield to Greece, Turkey, North Africa, India, China, and Japan. I made a life of collecting simple but meaningful treasures through reading, traveling, and exploring.

Designing jewelry was never my plan. I wasn't looking for a career in the traditional sense; I wanted a lifestyle that would allow me to continue to travel, look at art and architecture, read, and explore. Somehow all of these interests culminated for me in jewelry.

OVERLEAF PAGES (LEFT TO RIGHT): Collection of antique keys: the top one was my Settignano key; Settignano. RIGHT: 18K Natura rings.

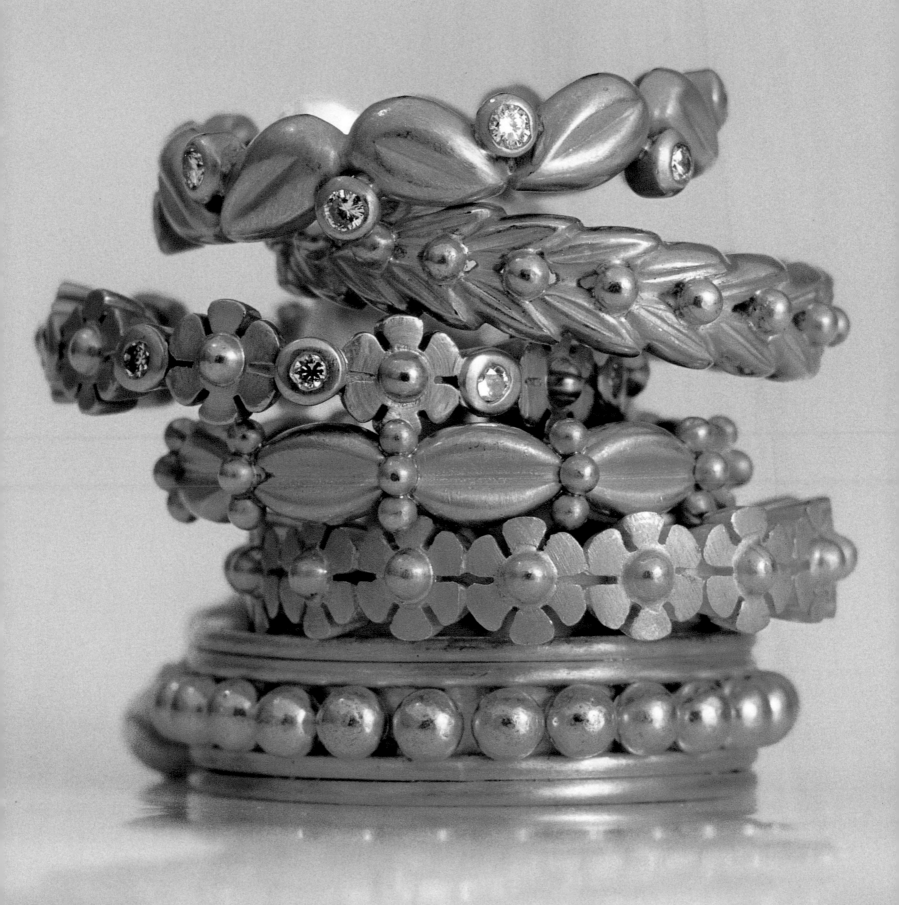

ALCHEMY

Alchemy—any mysterious change of substance or nature

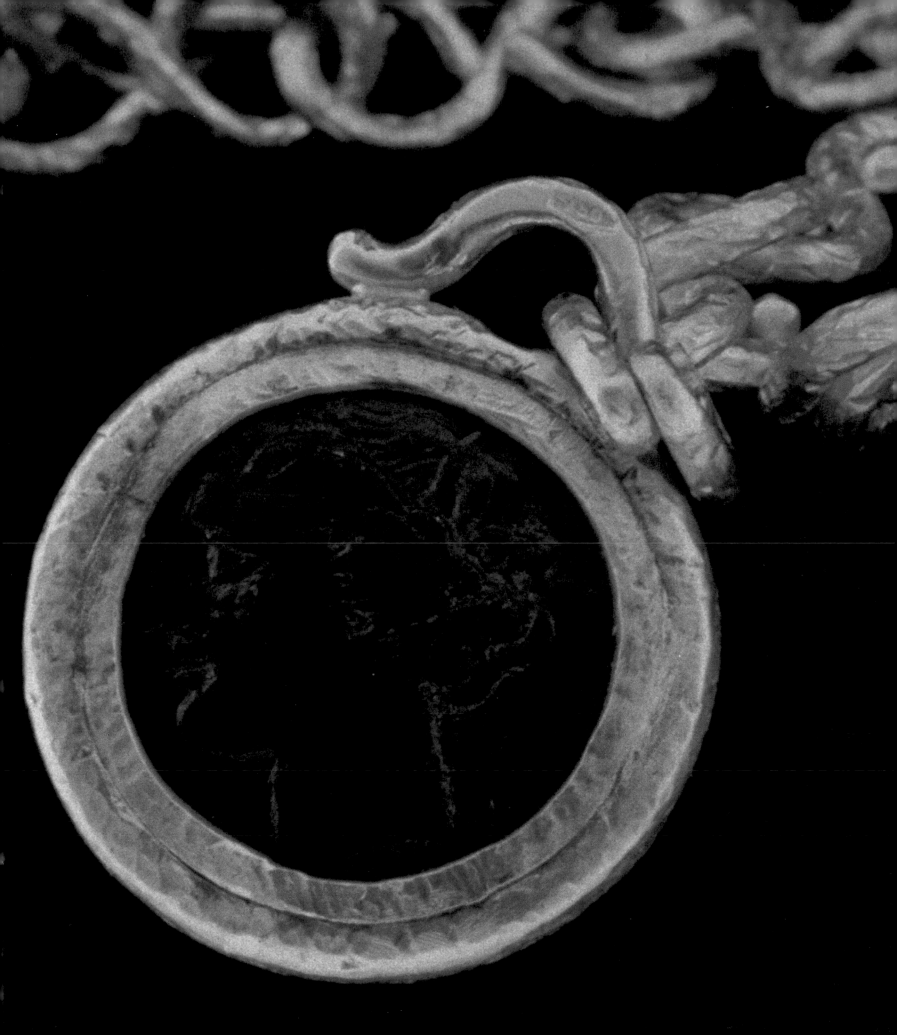

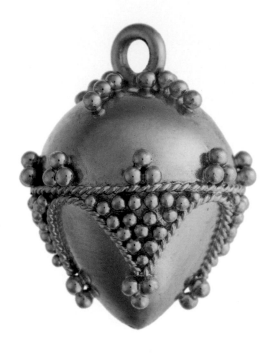

TRAVEL AND LIVING abroad certainly brought out my adventurous nature. A direction was set that would lead me to jewelry and design, a path that I have been on for more than two decades. It has been an exploration and an adventure, a course with all the twists and turns that keep life amusing.

Living and studying in Florence in my twenties was a transformative period. After I finished my masters in Italian Literature, my mother came to visit me in Italy, and at the time, was intent on finding an ancient coin to have made into a necklace. We found an antiquarian in the center of Florence who dealt primarily in ancient Greek and Roman coins. My mother chose a fourth century BC coin from Carthage. This beautiful piece had a horse and palm tree on one side and a profile of Tanit, the Carthaginian goddess, on the other. Tanit particularly captured our interest when we learned she was the only female deity in the classical world who was head of her pantheon. Carthage was a matriarchal society and she was its figurehead, an unusual contrast to the male-dominated Greek and Roman worlds. Being independent Southern Girls, my mother and I liked her image. Thus

OVERLEAF PAGES: Early 22K necklace with fourth-century Carthaginian coin showing profile of the goddess Tanit, circa 1986. TOP: 18K Chinese bead pendant, circa 1986. RIGHT: Bardini Gardens, Florence.

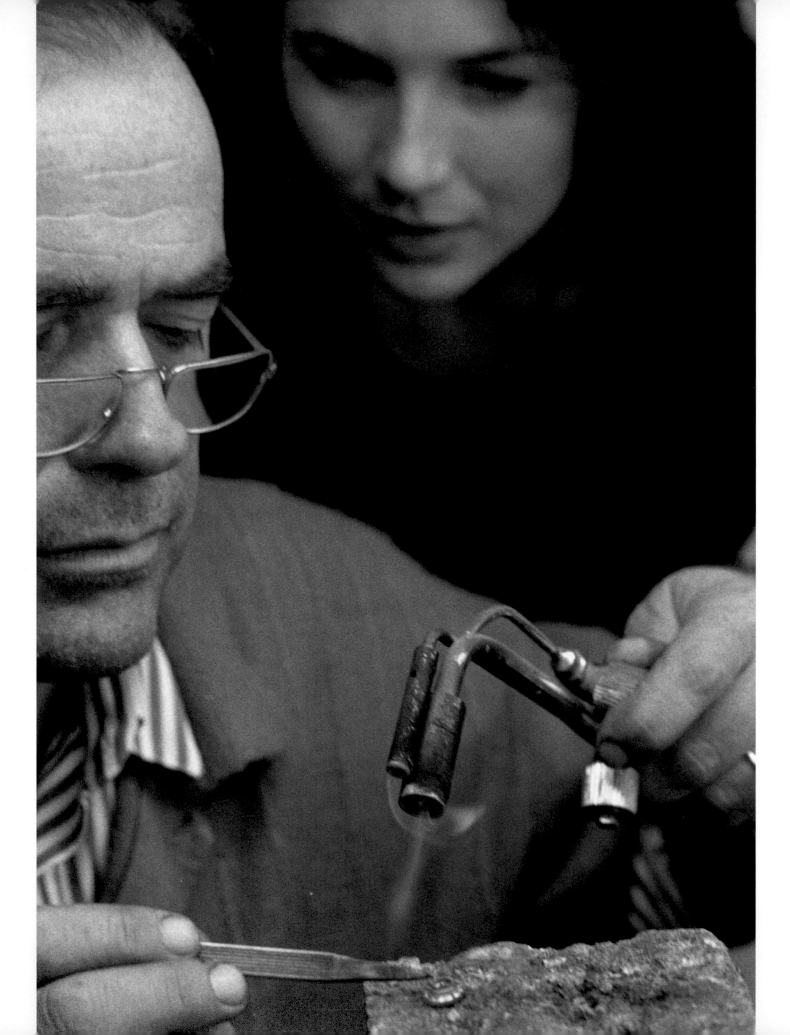

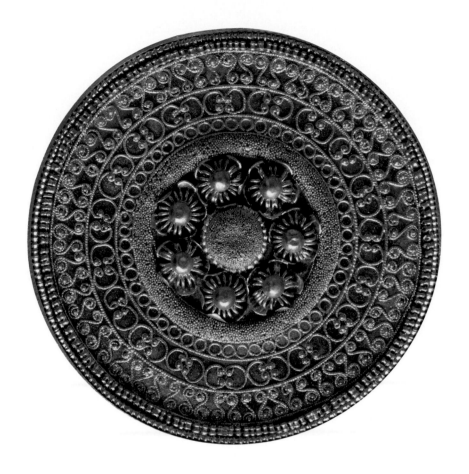

satisfied with our find, she returned home to South Carolina and left me the task of having a necklace made for her. Little did I know that this would be the catalyst for a life's work.

On the recommendation of a Florentine friend, I took the coin, along with a sketch, to a local goldsmith. The goldsmith was located in a medieval palazzo tucked in a back alley near the Ponte Vecchio. There was a labyrinth of workshops: centuries-old, small, cramped studios housing from one to ten or more artisans. Italian goldsmiths have been working in various palazzi in and around the center of Florence for generations, and this particular building was a beehive of activity. Because of its medieval layout, I took a wrong turn and ended up not with the recommended goldsmith but with another. It was a fateful turn; I found a goldsmith who was initially suspicious, yet subsequently intrigued by my foreignness and my growing desire to explore goldwork and jewelry. The goldsmith guild in Florence has been and largely remains a man's world, so it was quite something for them to be approached by a woman, particularly a foreign one speaking their language.

When I entered the Palazzo dell Orafo (The Goldsmiths' Palazzo), I entered another world, a world relatively unchanged

LEFT: Working with a goldsmith in Florence, circa 1987. TOP: Disc earring, Magna Graecia, sixth century BC.

since the Middle Ages. I continued to buy ancient coins from the antiquarian that my mother and I had found, and my first goldsmith would create settings following my sketches.

A world opened for me. It brought together my years of study and my love for the Mediterranean culture with its timeless and classic aesthetic. All my rich curiosity for this other era began to transform and inform what would become a life of creativity. I had spent years walking to school through medieval alleyways past the Bargello, past Dante's house, and through the neighborhood where, as a young boy, Dante first saw his beloved Beatrice. Having daydreamed of medieval and Renaissance life for a long time, I was finally

crossing a line. I had become an active participant in the world I had strived to be closer to and yearned to experience more deeply.

Partnering with the old guild of Florentine goldsmiths, I worked with them in the same way that one would have in the fourteenth or fifteenth century. The Florentine goldsmiths are in an odd way practically archaic themselves. They do not work in the same way as their modern-day counterparts might work in the more commercially sophisticated gold centers such as Valenza or Vicenza in Italy, or in New York. Even the way gold is purchased is different and more romantic. In Florence, the pure 24-karat gold is purchased in sheets.

TOP: 18K swivel ring with ancient Greek coin portraying Hercules and the Nemean lion, circa 1986. RIGHT: My collection of ancient Roman, Greek, and Byzantine coins.

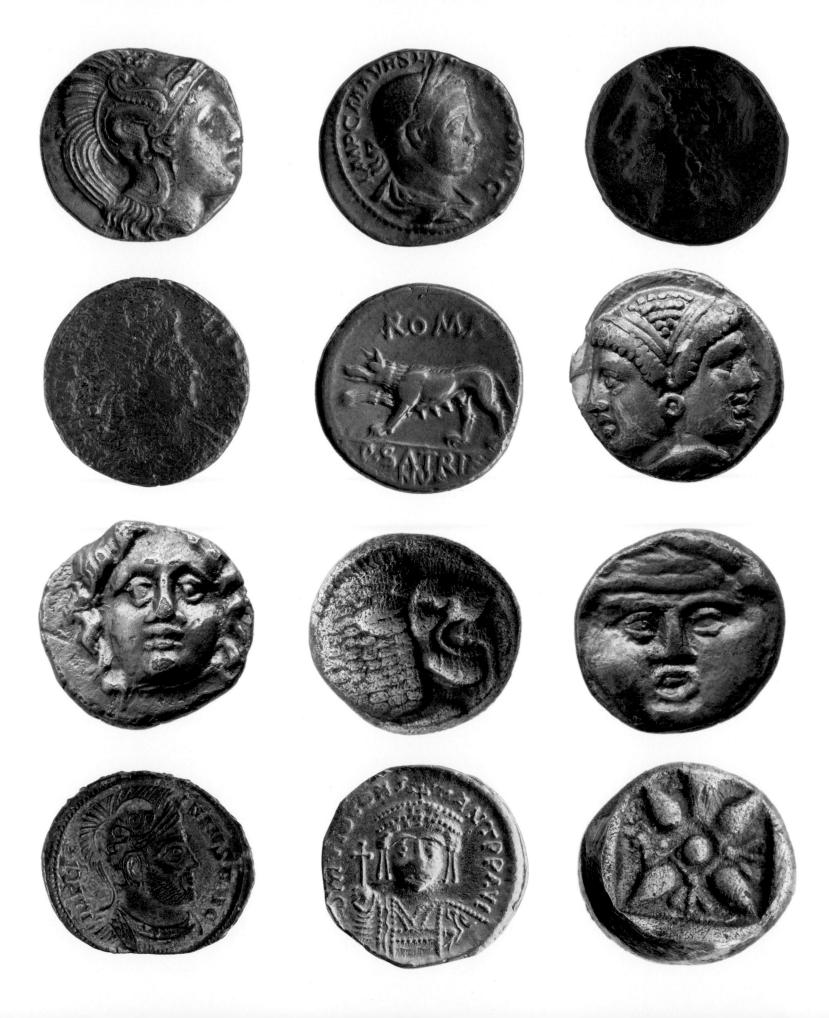

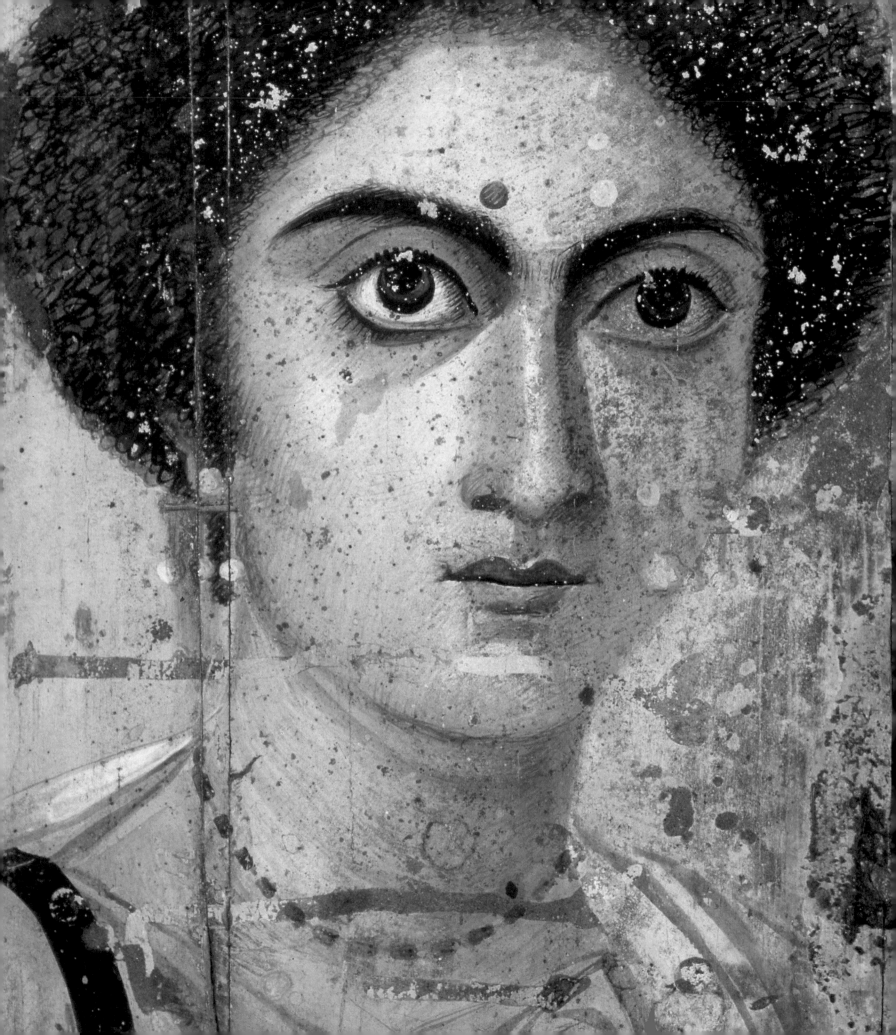

It is a beautiful, pliable, yet weighty substance with the rich color that you see in museum collections of early Greek gold. Handling it, you can understand why it has enticed humankind for centuries. A sheet of gold is practically a jewel on its own. I like to wrap a piece around my arm and contemplate wearing it in its pure state.

With my early ventures into gold, I continued to work with coins. I was fascinated by the myth and symbolism attached to these objects. I romanticized the past, imagining a time of life when classical mythology governed daily thought and behavior. The artistry of coinage reached great heights in Magna Graecia and particularly in Sicily. The coins from this period have intricate detail in bas-relief illustrating popular deities and heroes of the classical world such as Athena, often pictured with an elaborately crested helmet and her symbol, the wise owl, or Hercules combating the Nemean lion. One of my favorites is a Greek coin (actually from southern Italy) that shows a boy riding a dolphin. It illustrates the story of the boy, Taros, who, while lost at sea, was saved and taken to shore by a dolphin. The safe landing of the boy commemorates the founding of the classical town of Tarentum, modern-day Taranto.

As I traveled to numismatic shows in Italy and sought out more coins, I soon realized that the special ones were

LEFT: Fayum mummy portrait, tempera on wood, Egypt, second century AD.
RIGHT: Etruscan pin from tomb of Littore di Vetulonia, 630 BC.

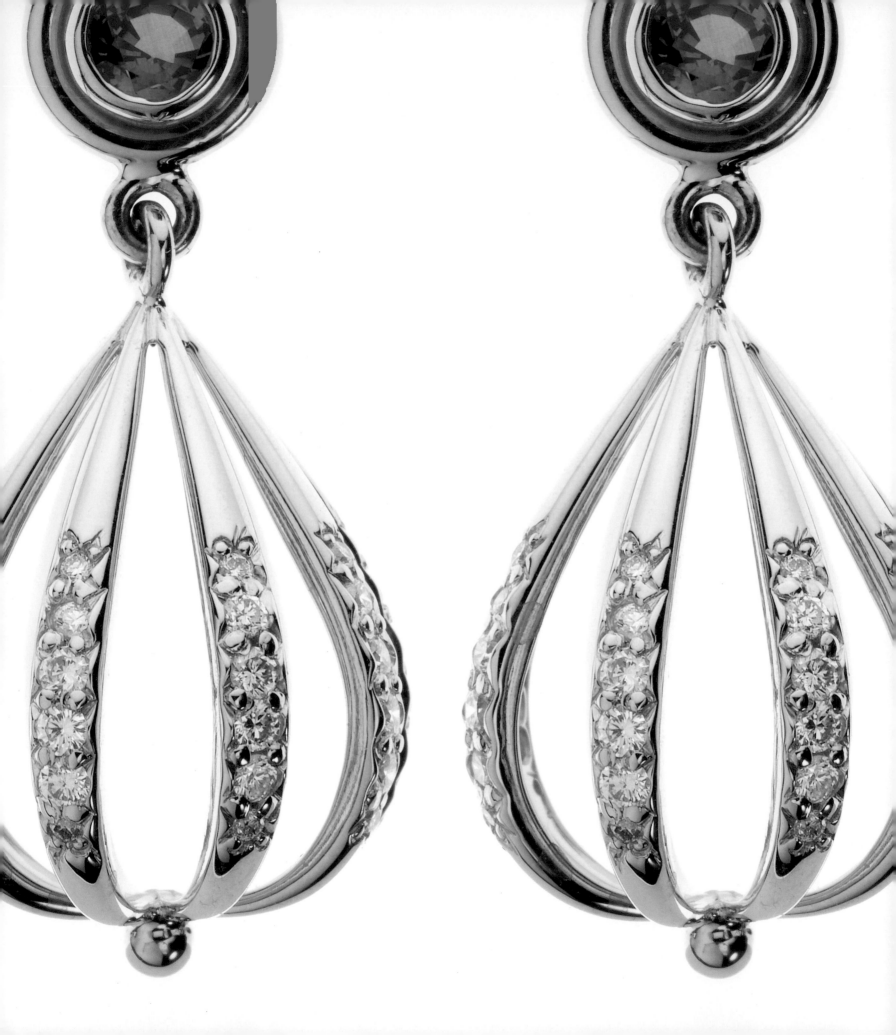

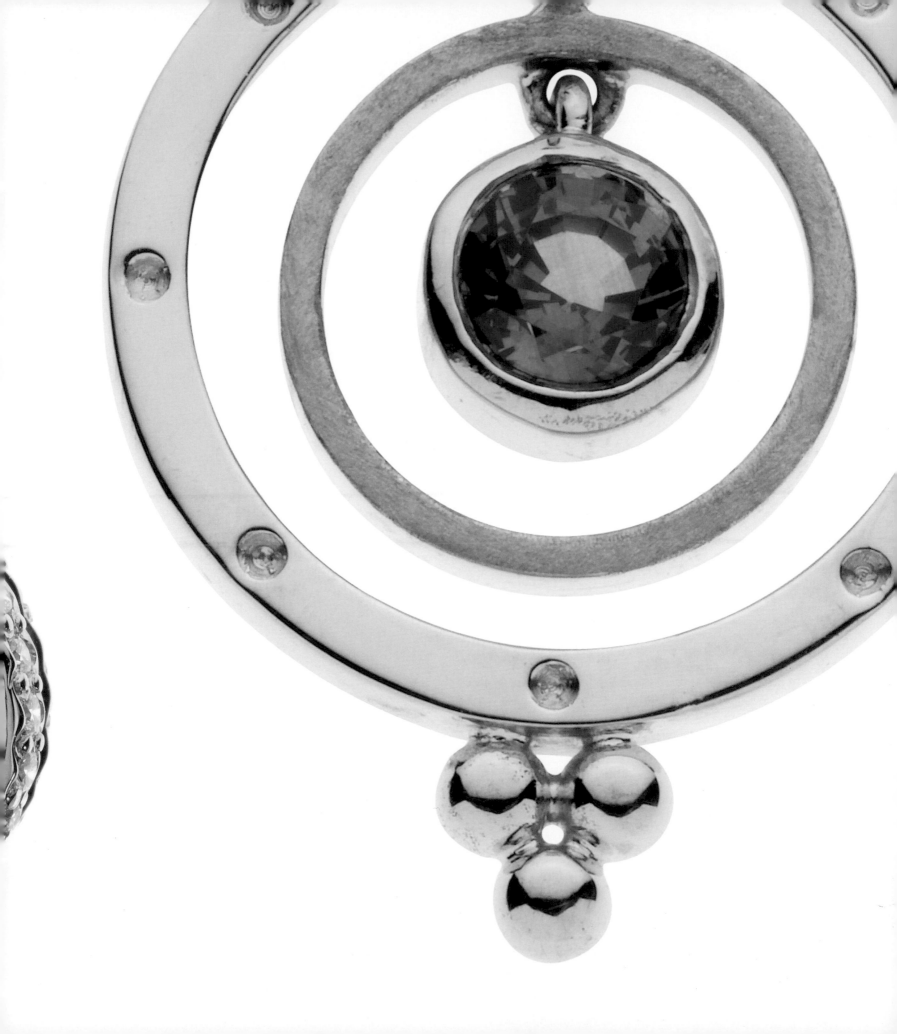

more and more difficult to find or were becoming prohibitively expensive. I still have a collection of ancient coins that I have never parted with. Occasionally I will give up one to set in one of my swivel rings for a collector or a dear friend. Some of the coins that I have are "oboli" and "di-oboli." An obolus is an early Greek silver coin that measured a sixth of a drachma; a di-obolus measured a third of a drachma. In ancient Greece, an obolus was placed in the mouth of the dead so that the soul would have the means to pay the mythological ferryman, Charon, to row across the River Styx into the Underworld.

The coins never lose their interest. My mother and other of my collectors from years ago still treasure their coin pieces.

As I studied the origins of the coins and mused about whose hands they had passed through, I began looking more closely and reading more about the goldwork of ancient civilizations. I then incorporated into my sketches details, such as granulation and filigree, that I was learning about from Etruscan and early Greek gold.

The Etruscans inhabited Italy from around the ninth century BC until the beginning of the fourth century BC,

OVERLEAF PAGES (LEFT TO RIGHT): 18K Cosmic earrings in blue sapphire and diamond; 18K Orbit earring in blue sapphire. TOP: Etruscan "grape" earring from San Paolo, fourth century BC. RIGHT: 18K "Etruscan" Shield necklace, bracelet, and earrings, circa 1989.

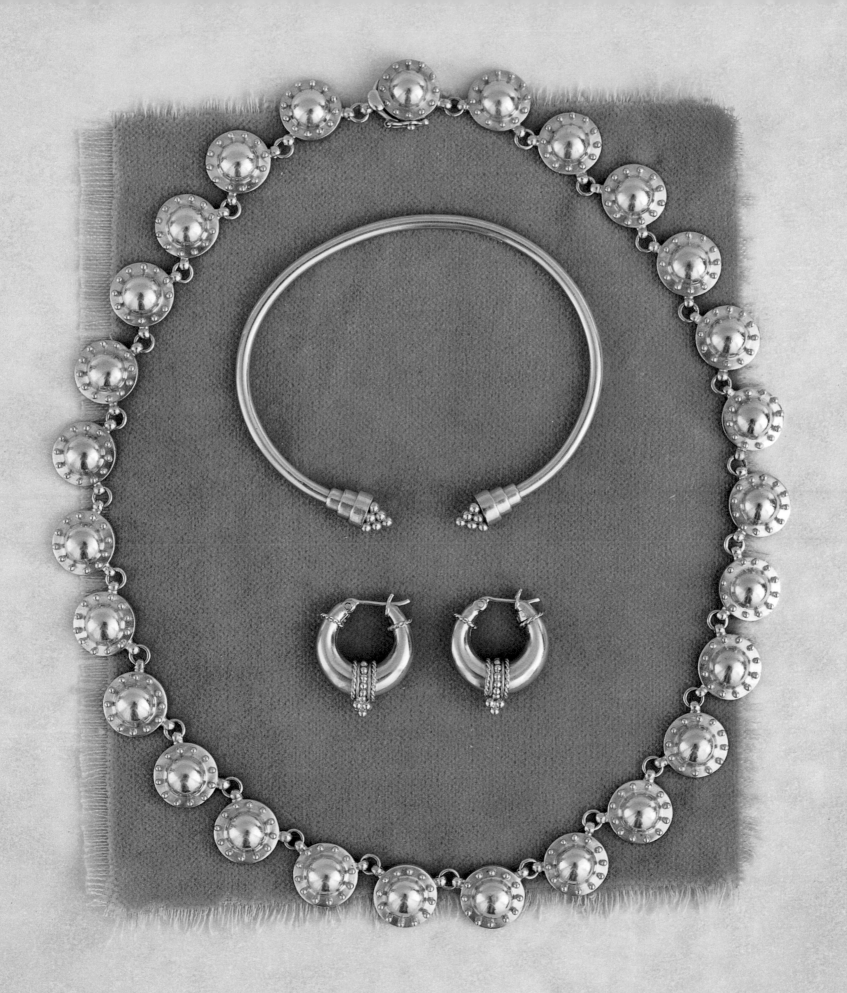

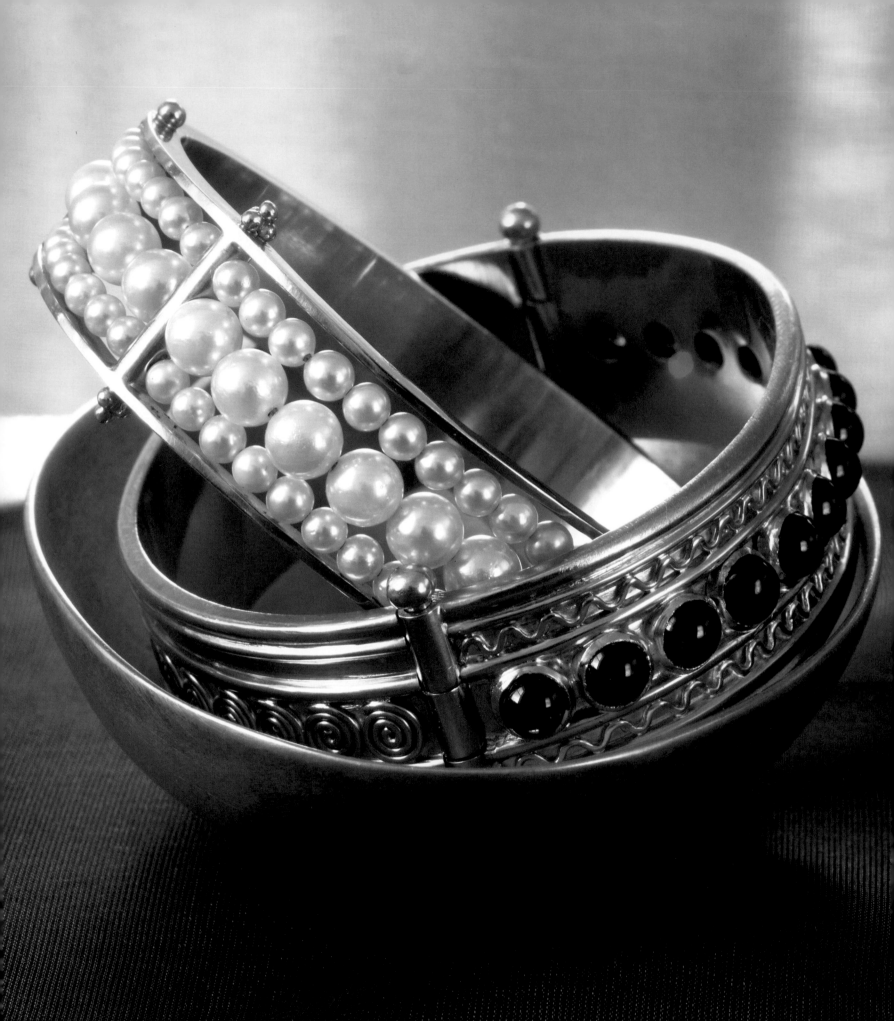

8x10 smeraldo ∘ 10x12

Rosi

Aliani

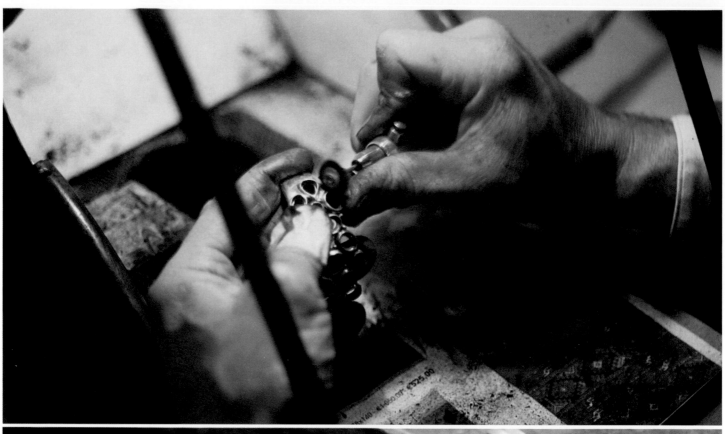
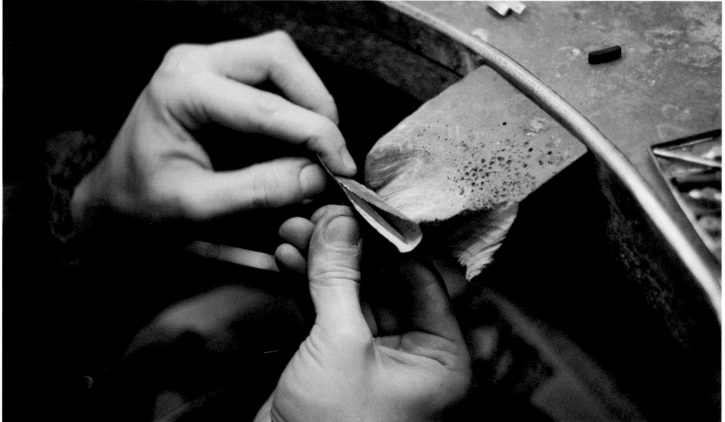

when they were dominated and assimilated by the Romans. They created some of the finest goldwork known to man. The secret of their granulation work continues to baffle scientists. Granulation consists of tiny gold beading applied to a smooth surface to create decorative motifs. The Etruscans used this method extensively in their jewelry. They created everything from elaborate hunting scenes on golden belts to abstract floral and aquatic patterns on diadems done entirely in tiny granules. Experts are still unable to ascertain exactly how the Etruscans did this work. There is no sign of solder on existing pieces. The mystery surrounding this artistic achievement gives a mere glimpse into the scientific and technological advancement of these sophisticated people. The Etruscans were a migratory people, possibly of Greek origin, from the region of ancient Lydia, which lies on the west coast of modern-day Turkey. Granulation shows up in the goldwork

of other ancient civilizations, both in China and the Indian subcontinent, but it reached its pinnacle with the Etruscans.

As I watched the goldsmiths manipulate gold, I became fascinated with the substance and wanted to bring back some of the details of goldwork that were referenced in books and paintings and archaeological pieces. I wanted to take the goldsmiths back to the old ways of working the metal. In keeping with my love of primitive and tribal jewelry, I wanted to make pieces that I referred to as "archaeological," like treasures that might have been unearthed, having been buried in a box or in some other protective vessel. I was taken with gold to such a degree that I asked if I could learn to work at the bench, but I soon realized that I would never catch up with these seasoned artisans who had been refining their art since early apprenticeships in their teens. Fortunately, my years of studying the Florentine language and culture

OVERLEAF PAGES (LEFT TO RIGHT): 18K "Abacus" and "Marea" bracelets in pearl and rhodolite; granulation doodles from my sketchbook. OPPOSITE AND TOP: A Florentine goldsmith's studio.

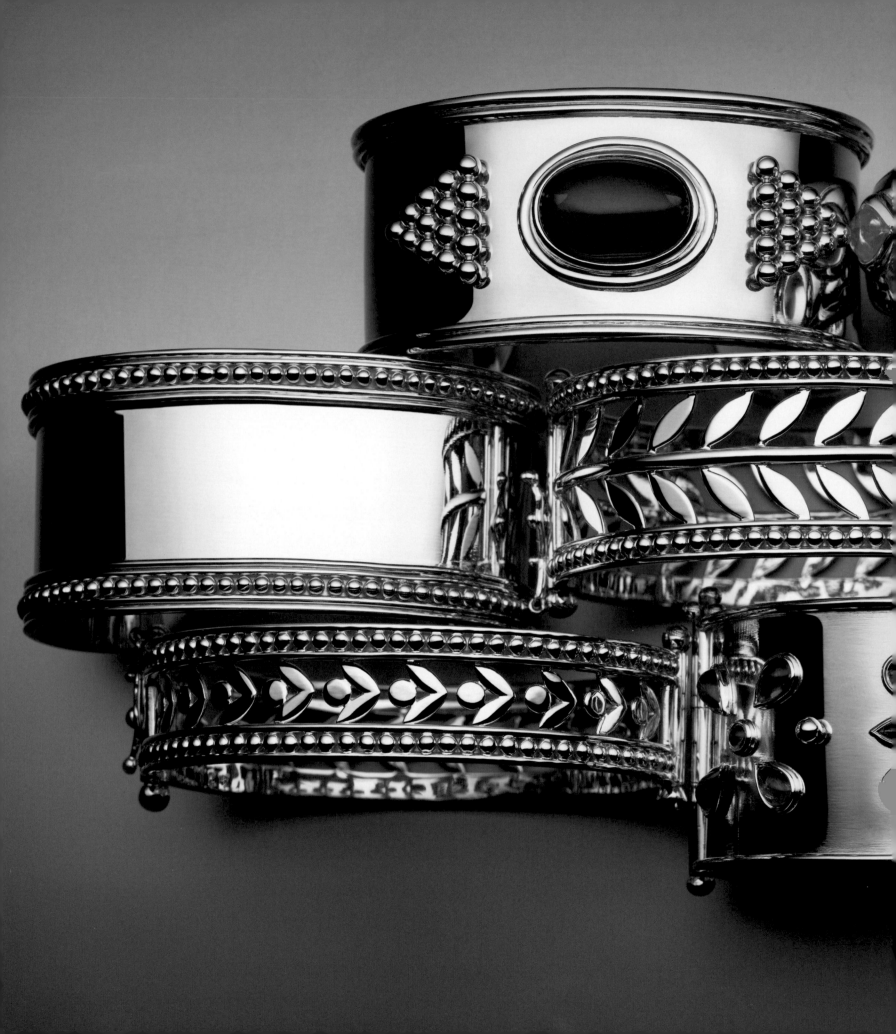

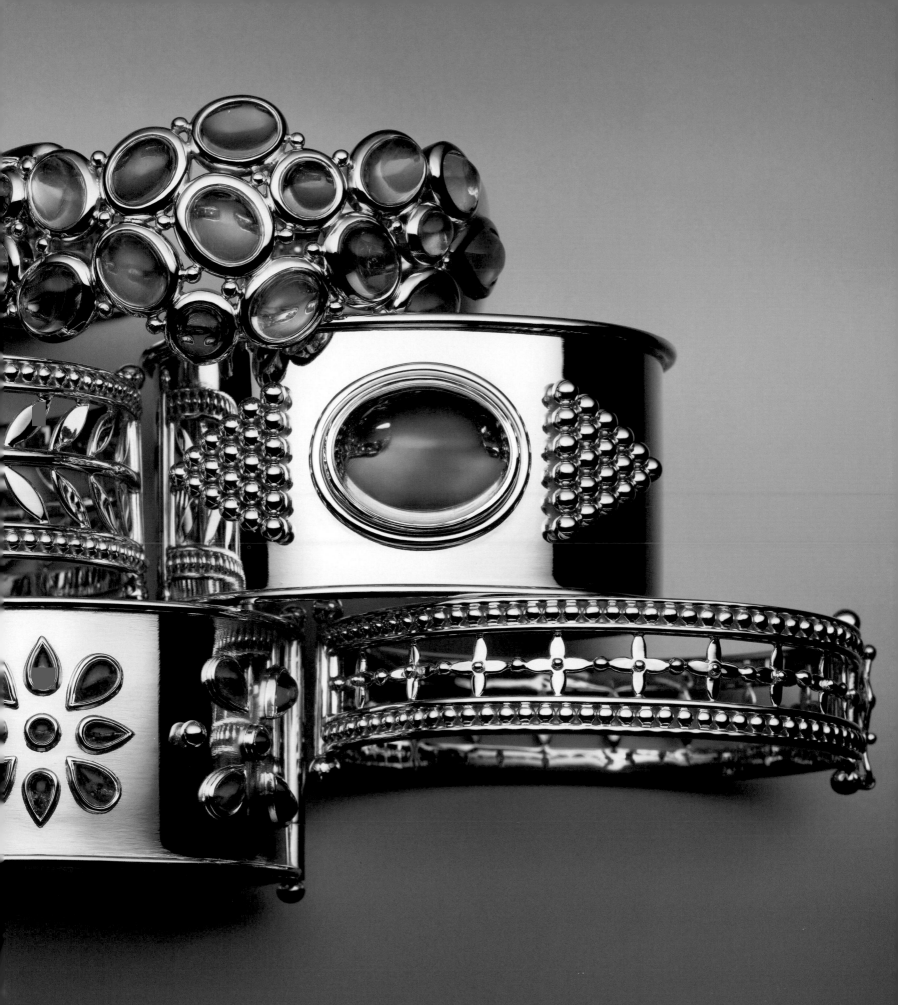

provided all I needed to enter their world. I had on my side the ability and desire to translate my ideas to the goldsmiths in a way that they would understand. It did not take me long to realize that my strength was in bringing ideas and designs to the master makers instead of trying to do it myself. The Florentine goldsmiths are great partners to me. They have such a depth of skill and an innate understanding of beauty, and, so important, they still have a passion for gold and their trade in a way that is lost in the big commercial world. There are pockets of great craftspeople in the United States, but the tradition is not as deeply a part of the culture as it is in a country such as Italy.

Gold is the oldest precious metal known to man. Its molecular structure is very dense, which makes it malleable and wonderful to work with. One kilo of gold can be made into a one-kilometer-long wire, and it won't break. When I first started, I wanted to use a high karat, rich yellow gold similar to what the ancients used, so I chose 22-karat gold: 24-karat is 100 percent pure gold: 22-karat is approximately 91.6 percent pure. For a number of years now, I have chosen to work in 18-karat gold, which is 75 percent pure. The 18-karat gold has a more contemporary feel, which is in

OVERLEAF PAGES: 18K bracelets. TOP LEFT: Studies from my sketchbook.
RIGHT: Sketchbook cover.

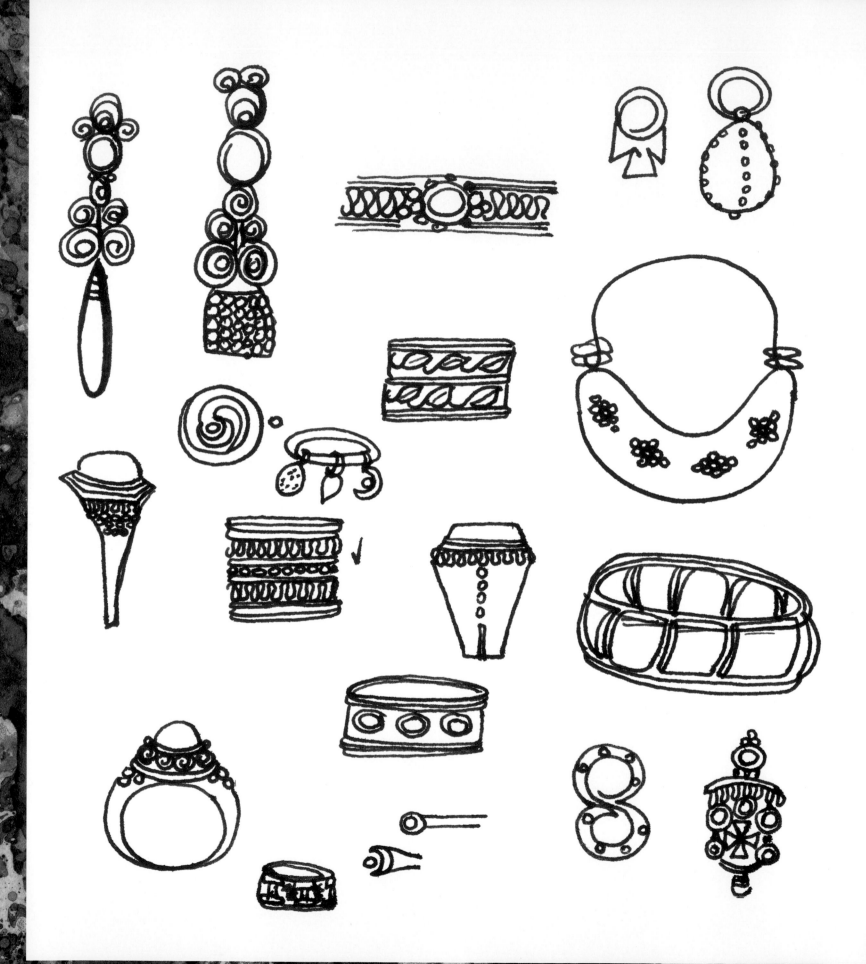

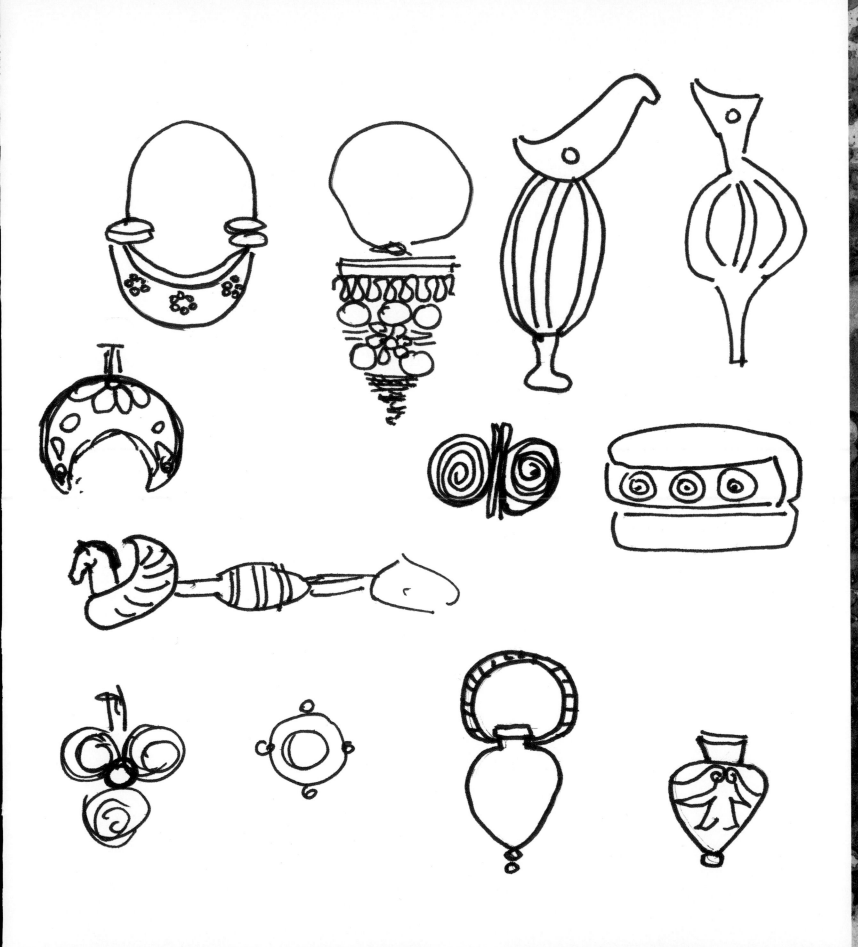

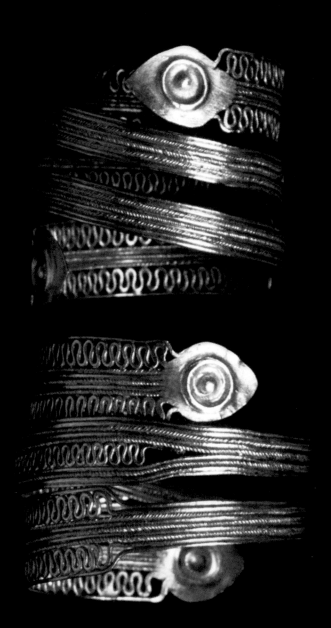

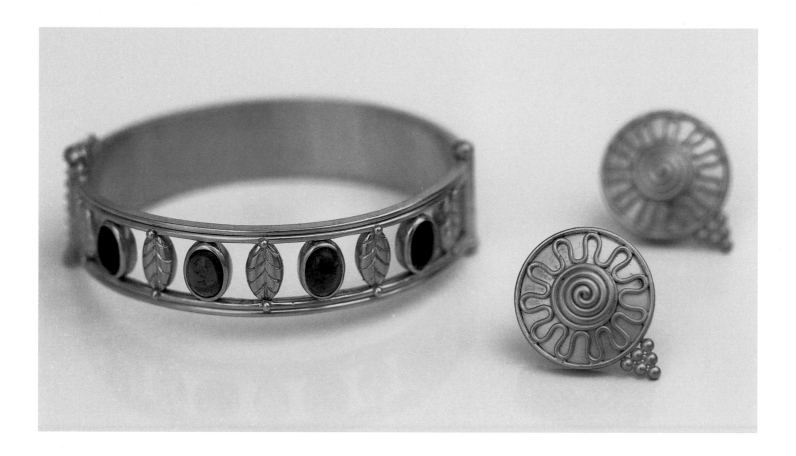

keeping with the evolution of my own aesthetic. To arrive at the different karats of gold, one adds alloys such as silver and copper to the pure gold. For instance, my 18-karat gold is 75 percent pure gold plus 25 percent of a special mix of copper and silver. With my recipe I seek to achieve a classical yellow tone that is flattering to the wearer and serves as a perfect frame for colored gemstones.

A pyramidal configuration of three granules has become part of my signature trademark. My use of granulation hearkens to my beginnings in jewelry and my love for antiquities, history, and myth. Over the years, my goldsmiths have worked out our own techniques of granulation. The 18-karat gold is alloyed and then drawn through a simple machine that creates wire.

The gold wire is then cut into tiny pieces, which are heated. The heated pieces pop into spherical granules. Each granule is then held gently with a tiny chip of solder against the surface where it will become part of a pattern. Just the right amount of heat is applied so that the solder softens and holds the granule on the surface. It is a tedious process because each granule must be individually applied. If the heat is not controlled perfectly, the granule will merely melt and the process will have to recommence. The end result is a triumph of patience and nerves.

Working with the goldsmiths is not just about business. It is about a collaborative relationship with artisans who have an ancestral lineage within their art. When I visit a goldsmith,

OVERLEAF PAGES: Florentine sketchbook. LEFT: Etruscan braid ties from Cerveteri, seventh century BC. TOP: 18K "Arcadia" bracelet and earrings in green tourmaline.

61

it's not merely to drop off a design or pick up a finished piece and settle a bill. It is about an ongoing tradition based on mutual admiration and respect. We exchange stories and the most recent family photos. They offer me apricots and figs from their gardens, and always a bottle of olive oil from the latest pressing. They are, at this point, my extended family. It is not merely about the work but about an all-encompassing lifestyle and appreciation for beauty and quality and a connection of past to present. All of this comes together to create pieces that are intrinsically soulful. Each one speaks

to the fine handwork, the attention to detail, and the collaboration that goes into its creation.

In Western culture, we are labeled or defined by what we "do," what our "work" is. My alchemy has led me to be labeled "jewelry designer." I suppose it is true insofar as I design and sell jewelry; I live and work in a world of designers known as the jewelry industry. But I find it hard to relate to myself in that way. I'm more of an amateur anthropologist, a hopeless hunter and gatherer, a bit of a wanderer, and a self-made jewelry historian who loves to dream and draw.

TOP: Ponte Vecchio, Florence. RIGHT: Bardini Gardens, Florence.

INSPIRATION

Inspire—from the Latin inspirare: *to breathe in*

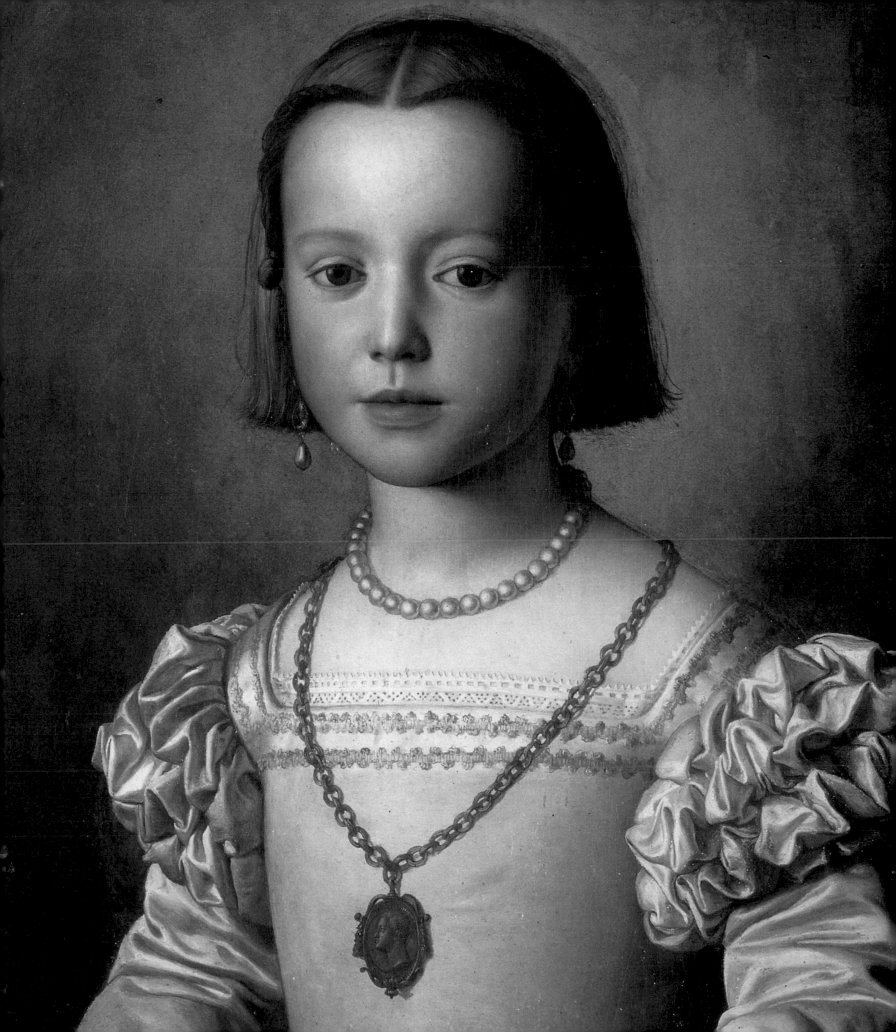

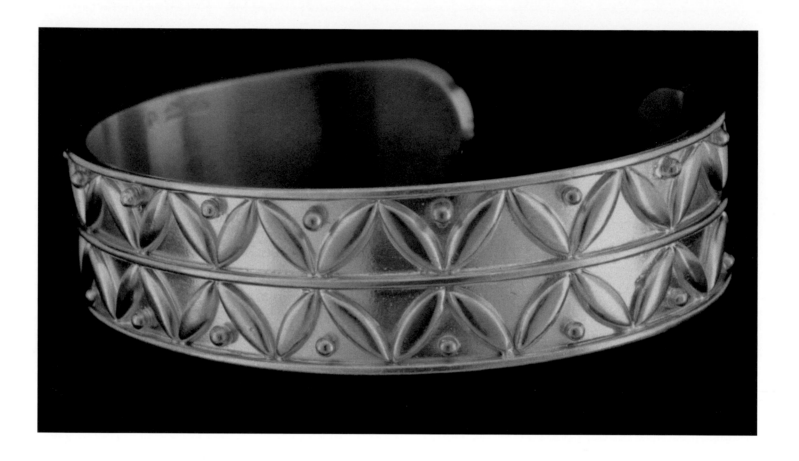

LIVING IN FLORENCE INSPIRED ME in the true sense of "inhaling" that which was around me. When I was back in Florence in the early 1980s, studying after college, I was so absorbed by the fourteenth century that I was even speaking the archaic Italian of Boccaccio and Dante with my fellow students. Instead of referring to girls with the modern Italian word, *ragazze*, we referred to each other as *damigelle*, the old Italian for damsels! I was studying the literature and the art of the place and living in the midst of it.

Without a conscious plan of becoming a jewelry designer, I followed my interest in the history of art, architecture, and literature and designed jewelry that fit different eras, myths, and influences of centuries past. Through the pieces that I made, I followed a loose history of jewelry according to my tastes and desires. In the beginning, after working with ancient coins, it was a natural path to then look to ancient jewelry. Romantic ideas of how jewelry was worn, and by whom it was worn, animated my imagination and influenced what I

OVERLEAF PAGES (LEFT TO RIGHT): Classic "Byzantine" pearl drop earrings; Agnolo Bronzino, *Portrait of Bia de' Medici*, 1541. TOP: Early 22K Olive Leaf cuff. RIGHT: Fayum mummy portrait of Eirene, tempera and gold leaf on wood, 100–120 AD.

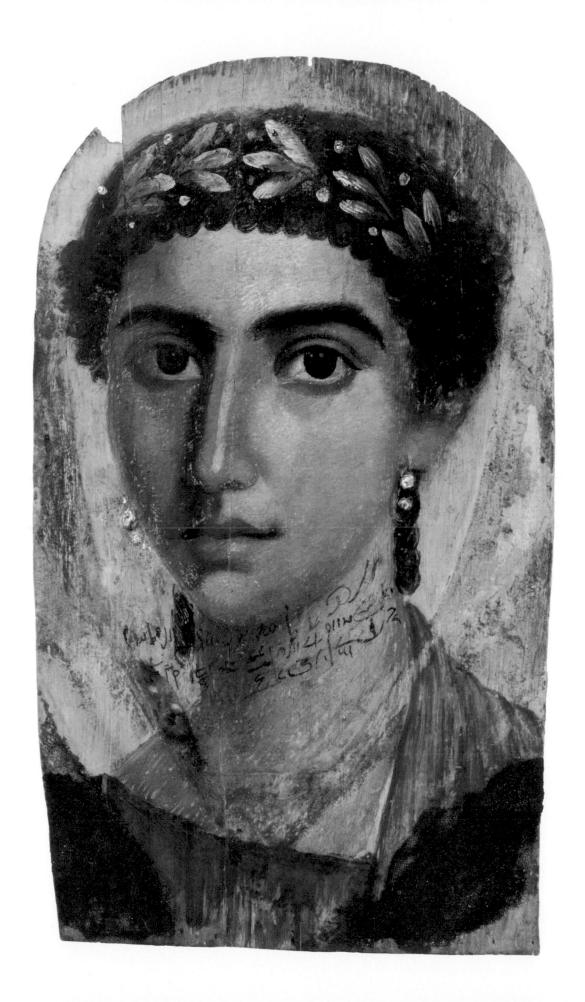

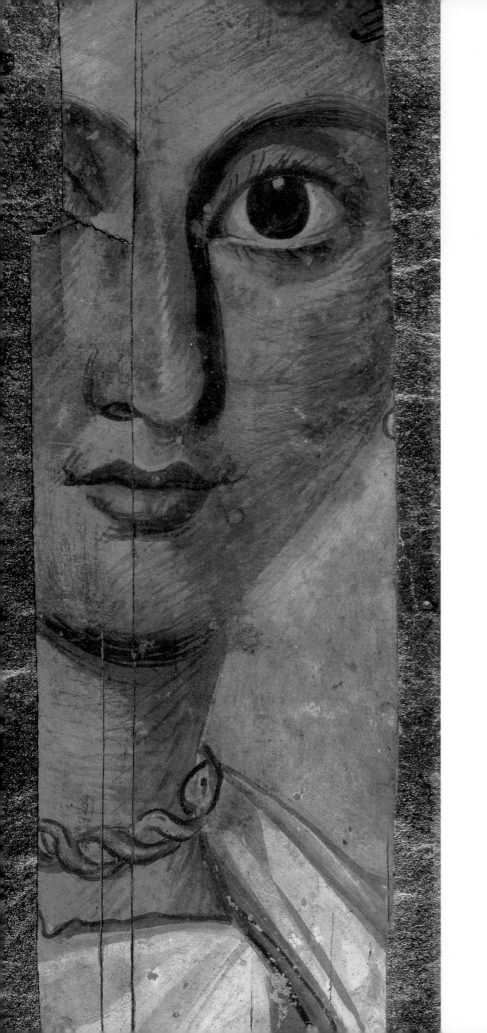

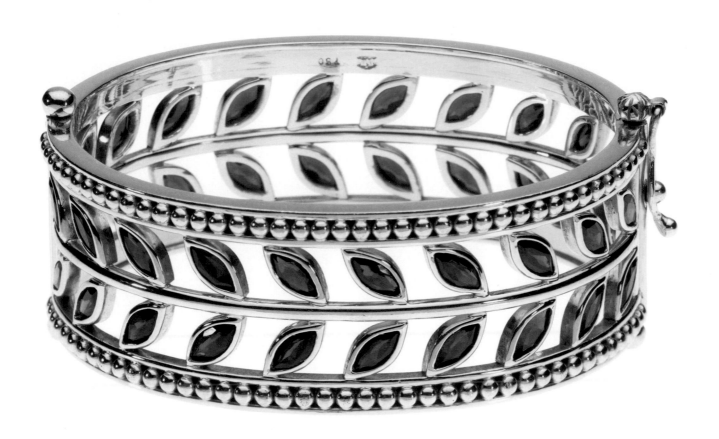

OPEN →

created. Just as the coins had a history and unique provenance, my pieces always had, and still do have, a story or theme behind them.

When I first started adding color and learning about gemstones, the variety of colors drew me back to the art of the Early Christian era and, in particular, to the influence of Byzantium. Some of my favorite studies in art history have been of the Byzantine mosaics in the churches in and around Ravenna such as San Vitale, Sant' Apollinare, and San Apollinare in Classe. I am always mesmerized by the compositions of these pictures created entirely out of brilliant-colored squares of mosaic. There is a naive quality

in the depiction of the figures, yet such a sophisticated and playful use of color. The tourmalines, peridots, aquamarines, emeralds, and sapphires that I was becoming familiar with were reminiscent of the precious colors in the Ravenna mosaics. I wanted to create jewelry around these colors and compositions of color, and I referred to my first gemstone pieces as "Byzantine."

Other early pieces I described as medieval or Renaissance. My descriptions always referred to the "feeling" of the piece. In my imagination, I like to transport myself to different historical periods to experience the lifestyle of the era in my mind. In contrast to the early expansive Hellenistic and

OVERLEAF PAGES (LEFT TO RIGHT): Fayum mummy portrait of a woman with gold hairpin, tempera on limewood,140–160 AD; study for Vine bracelet; 18K Vine bracelet in rhodolite; study for Vine bracelet. TOP: 18K Theodora earrings in aquamarine, seafoam green beryl, and diamond. RIGHT: Empress Theodora, mosaic detail from San Vitale, Ravenna, sixth century AD. FOLLOWING PAGES (LEFT TO RIGHT): A court lady, the so-called Antonina, mosaic detail from San Vitale, Ravenna, sixth century AD; 18K Ravenna rings.

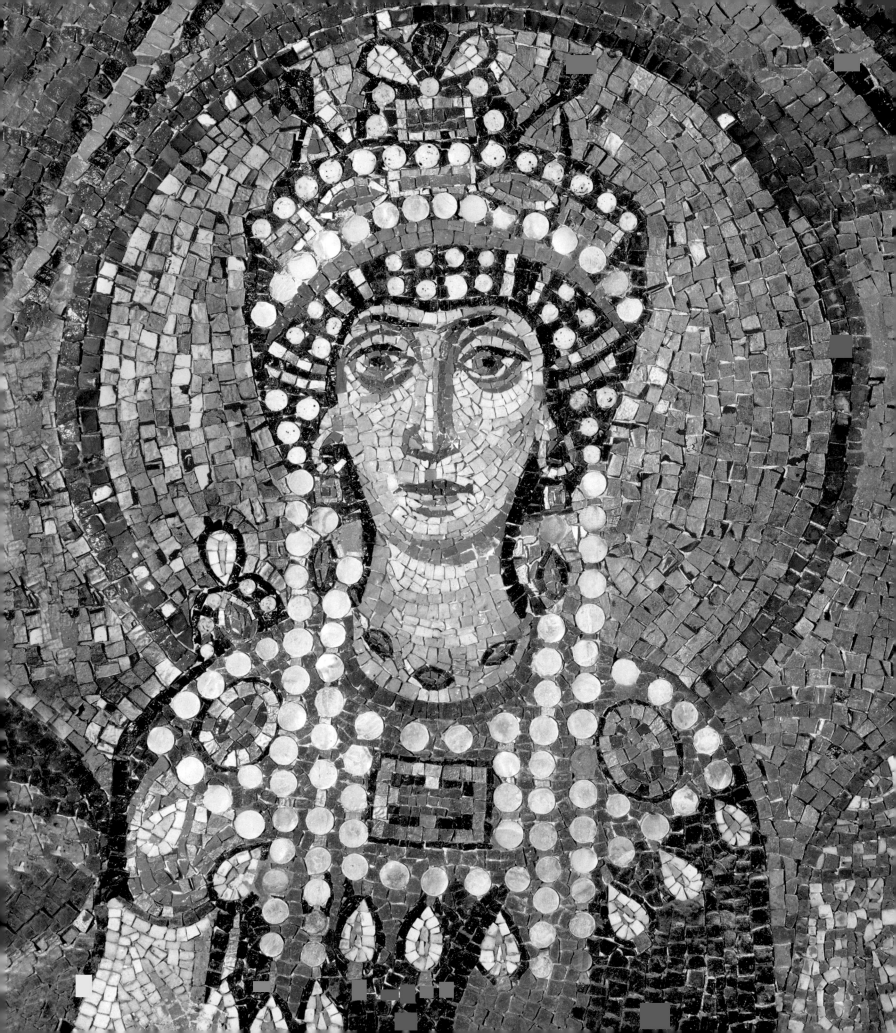

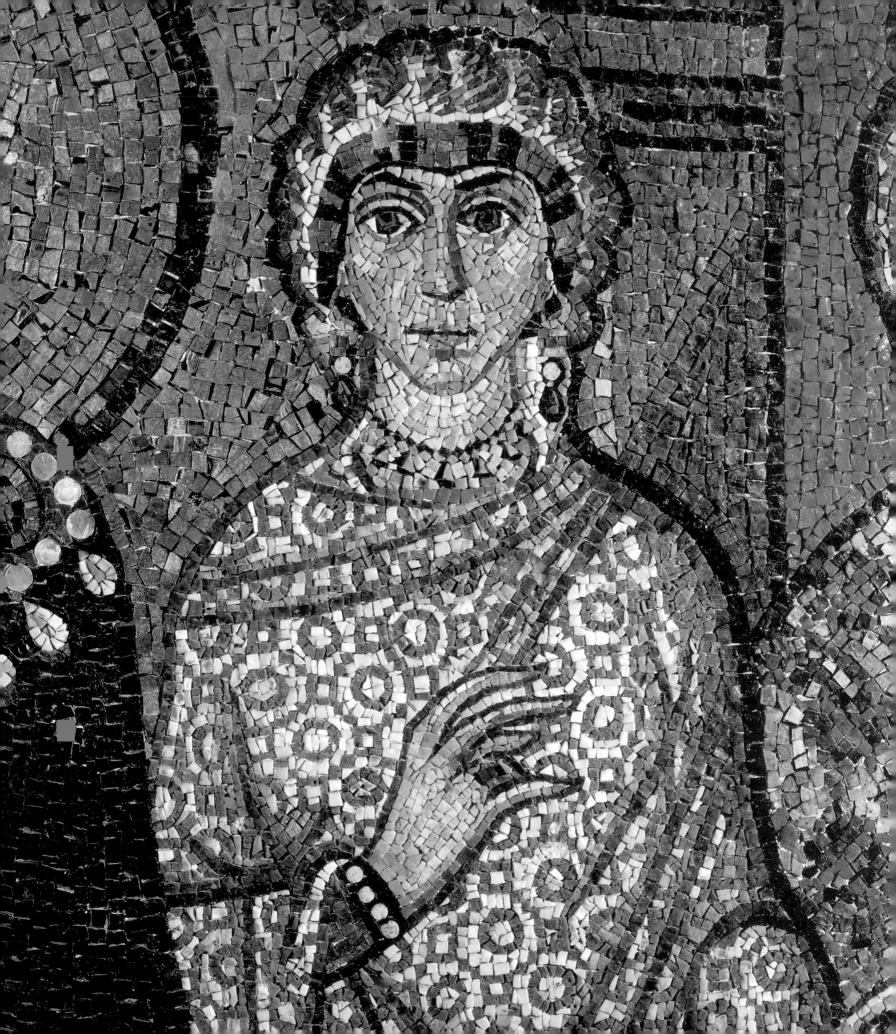

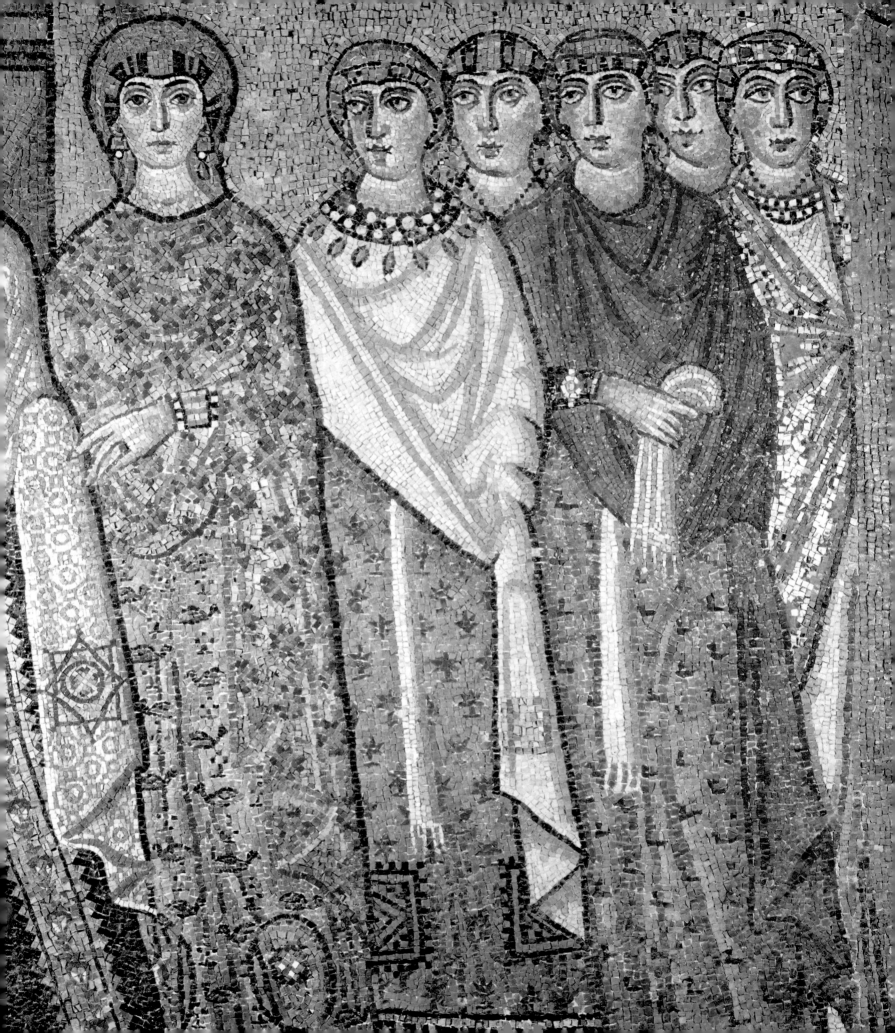

Roman times, historians describe the Middle Ages as a time of suspicion and superstition, a time of closed walls and secret gardens, a period of introspection. The vastness and open exchange of the Roman Empire had come to an end; walls were raised, and citizens retreated. My "medieval" designs reflect this time of austerity, and my love of amulets was born of this period. My crystal amulets are loosely based on medieval talismans that were worn and coveted for their protective powers. Stories of the Middle Ages are animated by secret meetings and exchanges of symbolic gifts. For me, jewelry inspired by this period should feature hidden details to be revealed and discovered only by its giver and wearer. Imagining

how people in other cultures and eras lived enriches both my life and my design work. Collectors from other times inspire me—indeed, I think of the artists, writers, and travelers of the past as kindred spirits; I carry on their tradition of exploration and reflection. I find it fascinating to study the inspiration and story behind various creators. It demystifies their work and tells of the personal passions behind it.

As the Middle Ages drew to a close, the Renaissance was again an age of expansion and international exchange. Lorenzo de' Medici, a great collector and patron of the arts, was attracted to a larger vision of the world. The heritage of ancient Greece and the new discoveries of the Orient were

OVERLEAF PAGES (LEFT TO RIGHT): Rendering for Apollinare necklace in royal blue moonstone; the ladies of Empress Theodora's court, mosaic detail from San Vitale, Ravenna, sixth century AD. TOP: 18K Vine bracelet with mint tourmaline and diamond. RIGHT: A page from my sketchbook.

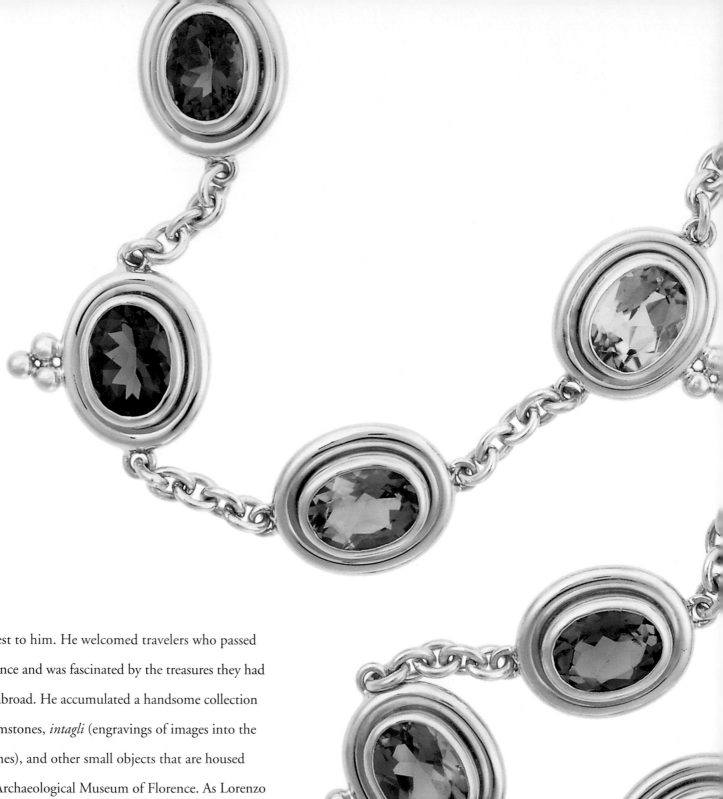

of great interest to him. He welcomed travelers who passed through Florence and was fascinated by the treasures they had traded while abroad. He accumulated a handsome collection of scarabs, gemstones, *intagli* (engravings of images into the surface of stones), and other small objects that are housed today in the Archaeological Museum of Florence. As Lorenzo was, I am starved for insights into the arts and workings of other cultures. I like to collect objects such as coins and archaeological findings that connect history and culture.

TOP AND RIGHT: 18K Classic Mosaic necklace. FOLLOWING PAGES (LEFT TO RIGHT): 18K "Byzantine" pearl bracelet and earrings; Agnolo Bronzino, *Portrait of Maria de' Medici*, 1530s.

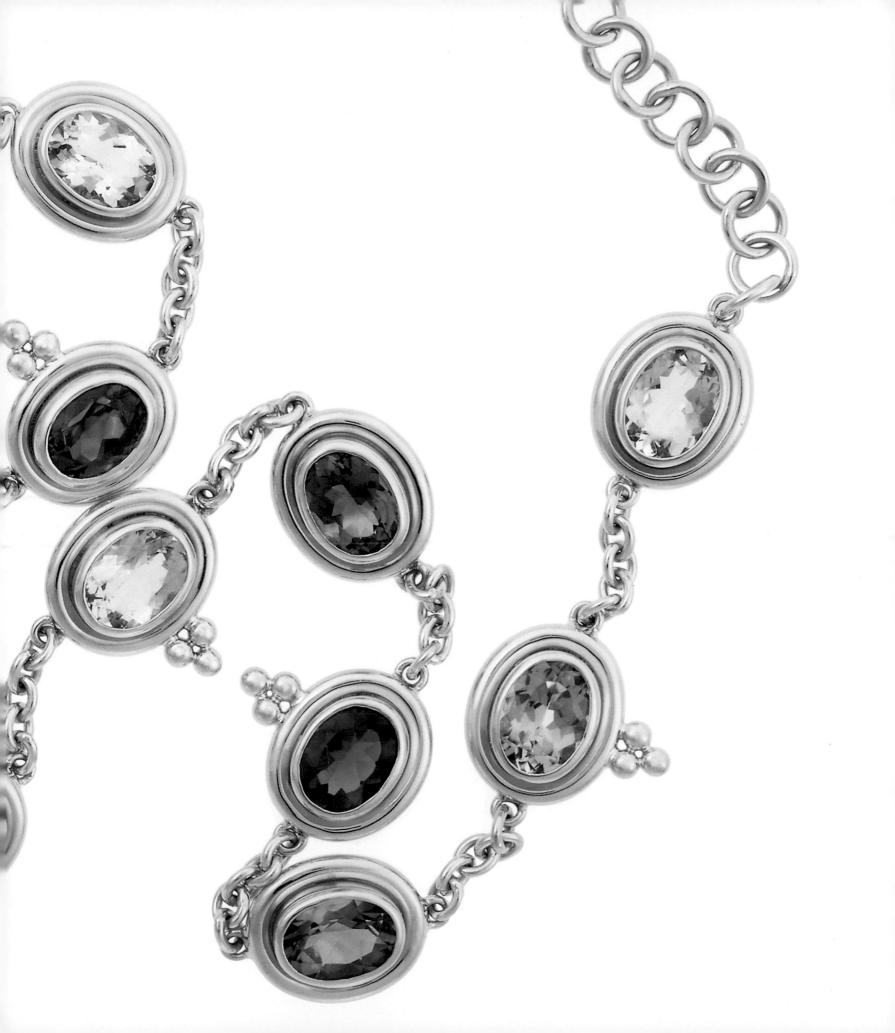

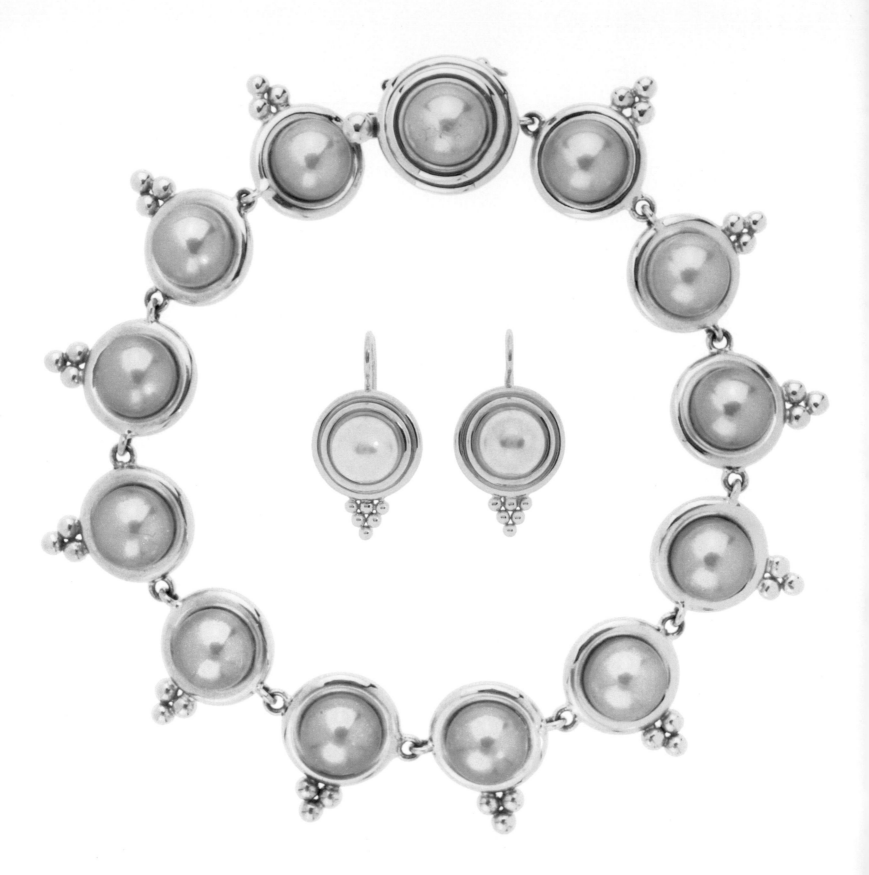

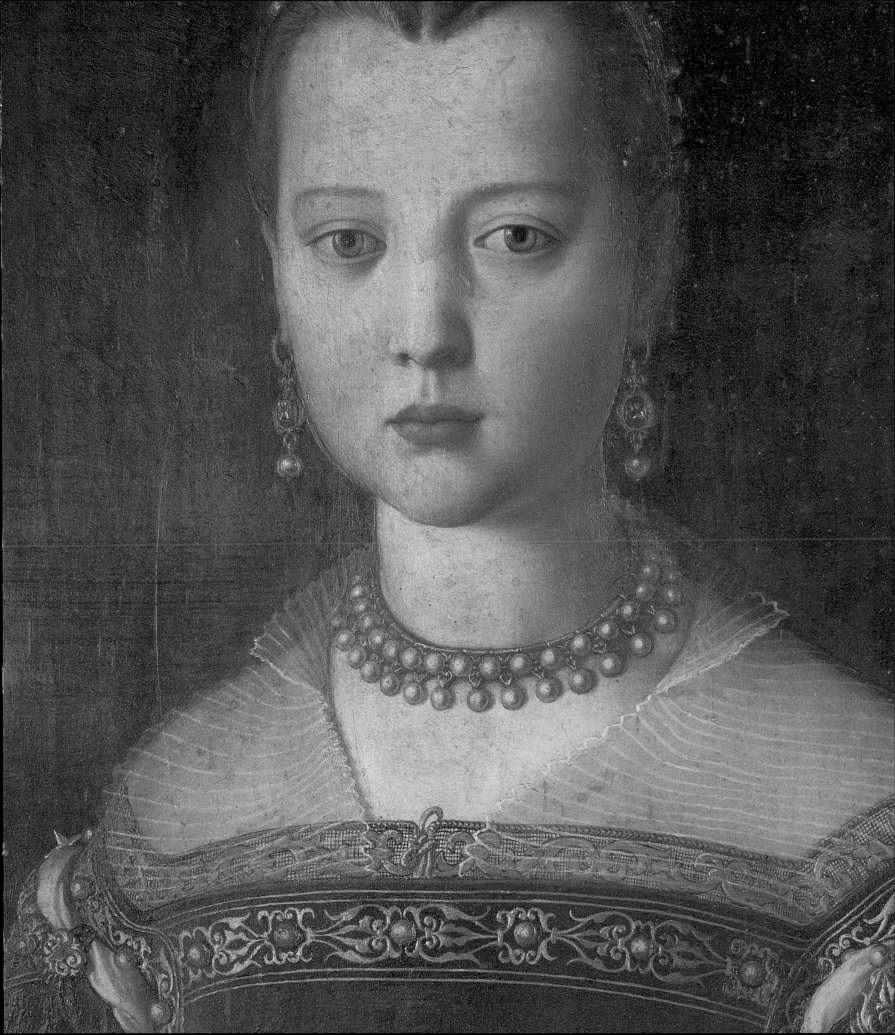

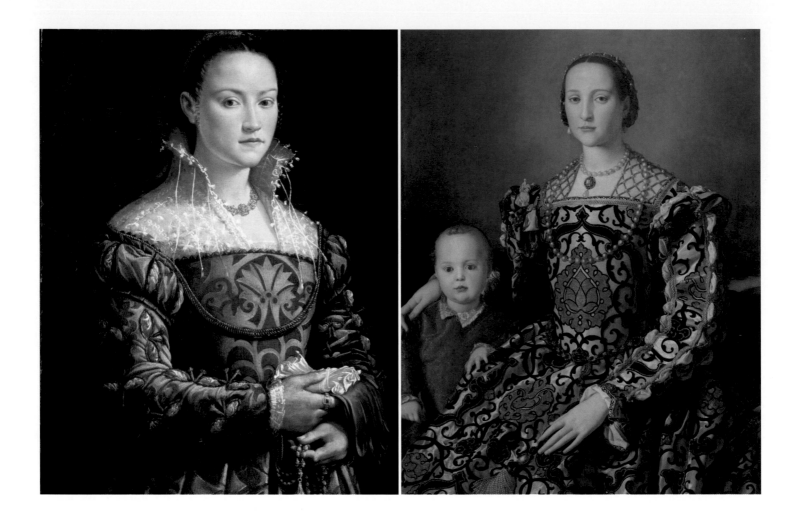

Among my favorite Renaissance images, many of which are housed in the Uffizi in Florence, are the portraits of various members of the Medici family by Agnolo Bronzino. These portraits are great documents of the style and times of the Florentine aristocracy. The artists of the day took great care in depicting the textile designs and colors, clothing, hairstyles, and jewelry that they wore.

My first pearl earrings were inspired by Bronzino's portrait of Bea de' Medici. At the time, I wanted a pair of pearl earrings but found pearls alone to be too plain. I wanted simplicity and elegance with just the right amount of detail. Something about the way Bea's earrings hung from her ear had a romantic and feminine feeling that I sought to emulate. I imagined that these might be Bea's first earrings, an heirloom gift from one of the older family members.

The sense that jewelry has an ongoing story is very important to me. Examining these portraits fills me with ideas, from the patterns in the textiles to the individuality of the wearer. It is not that I see a specific jewel that I want to re-create; it is rather the suggestion of the jewel and the attitude with

TOP LEFT: Agnolo Bronzino, *Portrait of Florentine Noblewoman*, 1540. TOP RIGHT: Agnolo Bronzino, *Portrait of Eleonora di Toledo with Her Son Giovanni*, 1544–1546. RIGHT: 18K Marina necklace in green tourmaline, royal blue moonstone, and diamond.

which it is worn. The Renaissance was a celebration of the individual, an important era in art history when realistic portraiture truly came into being. Personalities such as Eleonora di Toledo were highly influential at the time for their style and aesthetic point of view. They contributed to the fashion and art of the time. Bronzino's finely detailed portraits document their importance.

In the beginning of my work as a designer, I approached design in an academic way. Being familiar with the classics helped me to create my own language of design; it gave me a foundation. I have always been fascinated by how history repeats itself in a constant cycle of classical and nonclassical: how the rules and knowledge from the Renaissance were loosened and allowed for the experimentation that led into the Mannerist and Baroque periods. Constant actions and reactions lead to new movements in all of the arts. Nothing is absolutely new. Everything is connected in an ongoing flow of ideas and responses to the past and voices toward the future.

OVERLEAF PAGES: 18K Classic Color rings in green tourmaline, aquamarine, and pink tourmaline. TOP: Cypress hills of Tuscany. RIGHT: Cy Twombly, *Natural History Part II, Some Trees of Italy, Sheet 3*, 1976.

Inspiration always comes when I go back to what I love to do: acquire knowledge and feed the imagination. Looking to art, literature, dance, music, architecture, sculpture, garden design, and even the textiles of other places and distant cultures awakens the dreamer in me. A thirst for information is in my bones. As a child I would surreptitiously order series of books about animals, nature, and the sea. I would pore over encyclopedias, reading whatever attracted my attention, copying drawings and pictures. Today I always make sure I have a sketchbook in my bag so I can make note of any details or patterns, whether natural or man-made, that catch my attention. I like to re-create elements in my designs such as vine motifs or medallion shapes from the loggia of a palace, or from the bolts of a door, or from a Rajasthani textile.

My curiosity and imagination may be childlike, but I try to maintain them and encourage and preserve these qualities in my own children. It's important not to take yourself too seriously, and to recognize and enjoy the quirkiness of life.

TOP: Louis Comfort Tiffany, bronze fireplace screen, early 1900s. RIGHT: 18K Colombina necklaces.

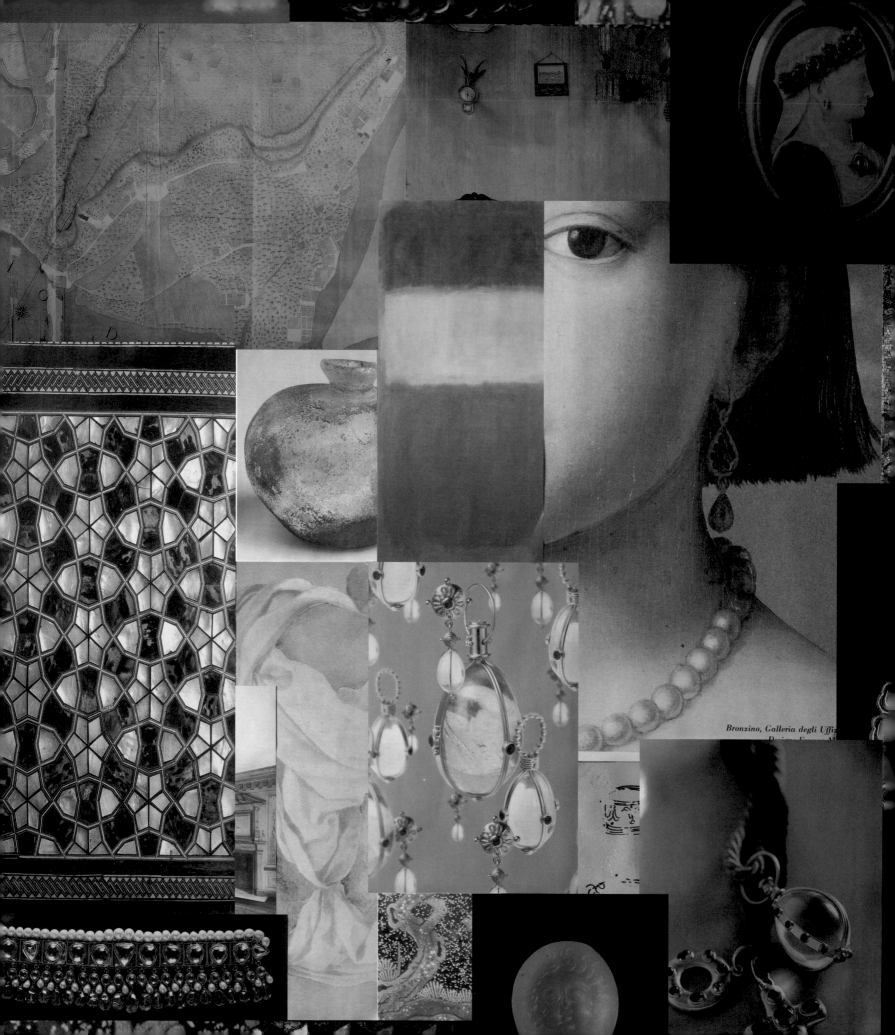

Bronzino, Galleria degli Uffizi

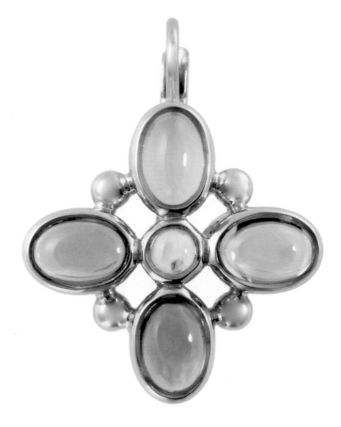

When traveling with my sons, one of our first stops is usually a local paper store where we all choose special sketchbooks to use along the way. My sons often make up their own images but are also definitely influenced by the figures and stories around them, as am I.

I find inspiration in the work of many artists and designers both past and present. One of my favorite designers, Louis Comfort Tiffany, was fascinated by Egypt and the Orient and incorporated exotic motifs from these cultures into his work. I share his passion for blue moonstones, black opals, and sapphires, which comes from my love for sealike colors and reflections. Another artist and fellow Virginian whose

LEFT: Design mood board. TOP: 18K Quadrifoglio earring.

work I find inspiring is Cy Twombly. Having expatriated to Italy in the late 1950s, Twombly's passion for Mediterranean culture, mythology, and the classics permeates his work. An important figure of Abstract Expressionism, Twombly's classical references in his paintings neither detract from nor dilute the modernity of his work. His paintings reveal a connection to the past and are imbued with a timelessness that is completely contemporary. Collecting, finding, and nodding to the historical influences around us help to preserve a visceral link with the past while allowing the designer or artist to retell a wonderful story in a new but surprising way.

Perhaps one of the greatest modern masters is the dancer and choreographer Merce Cunningham. When my husband, a former modern dancer, introduced me to Merce's work, I was so enthused that I wanted to know more. I wanted to personally and physically experience his choreography, so I immediately went to his studios to sign up for his Fundamentals class, which taught the basics of his technique. In the class, I was amazed to study my own reflection in the dance studio mirrors and see the forms that Merce had designed for the body in motion. His language of movement is so distinct that even an amateur such as myself could emulate the basics of his alphabet. In his compositions, I saw a classical foundation yet was mesmerized by his completely original and distinctive style. Moreover, I was inspired by the quality of execution and expression that he obviously demands from his dancers.

TOP LEFT: Merce Cunningham. TOP RIGHT: Merce Cunningham Dance Company. RIGHT (ALL IMAGES): Merce Cunningham Dance Company.

Cunningham is an exquisite craftsman of human movement. Merce's work is modern and, to this day, evolving and experimental, yet there is a strong through-line that makes his choreography always recognizable: a clean line; bold color; nuanced rhythms. One can always expect the unexpected. I like to think that the classicism in Merce's art form is similar to my own. Fresh, modern ideas rooted in tried and tested form that endures.

In jewelry design, as in the other arts, there is a subconscious tradition of placing cultural information into the art, the jewel. Jewelry can be considered wearable art or perhaps more correctly, wearable artifact. It is a direct and personal reflection of human history and habit.

I have made my own exploration of historical visual styles through jewelry design. I embrace the idea of individuality and personal style and, as a result, have never wanted to dress to fit into a prescribed formula of style. Through the jewelry I create, I encourage my collectors to be inspired to find their own personal gems and combinations of pieces reflective of their very own persona. I want my pieces to be collected, treasured, and handed down. The inspiration behind each piece should grow as it is layered with the story of the wearer.

Inspiration, together with the source of craftsmanship and the choice of exquisite materials, goes beyond the element of design. Imbuing a jewel with a connection to cultural history is a dying art, one that has lost its importance in modern times. To make these connections is what drives me as a designer. I need to be inspired to design and subsequently inspired by the work and the process, or there is no reason to do it.

TOP: Florentine details. RIGHT: In the studio.

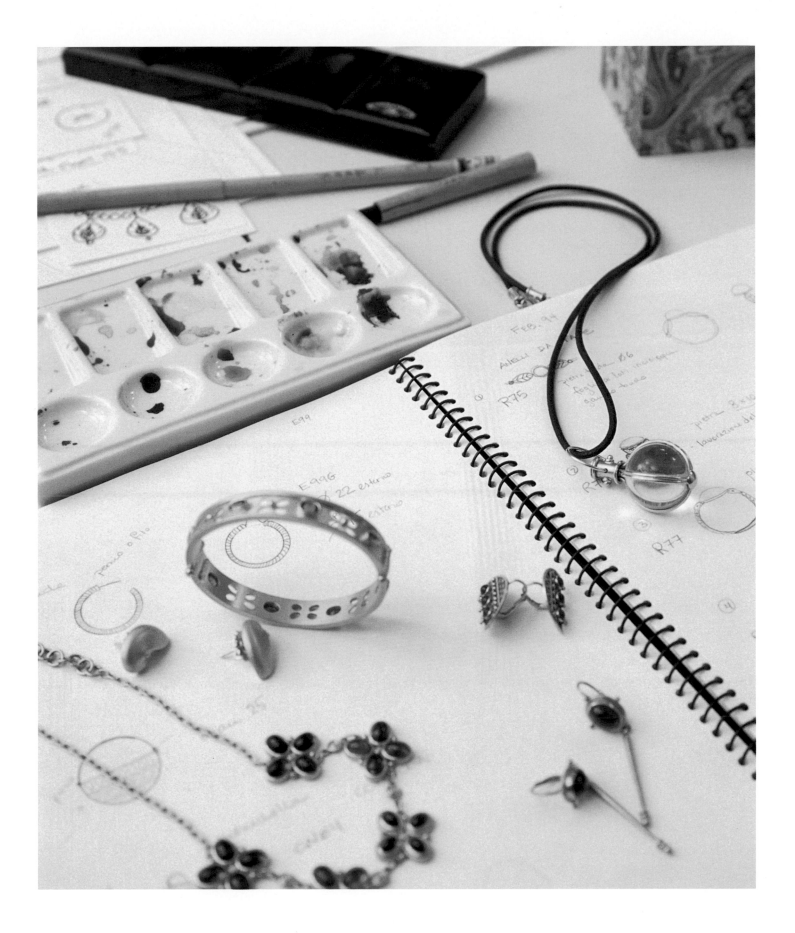

MY LIFE AQUATIC

I HAVE BEEN INFLUENCED not only by my studies in art and literature but by my adventures in nature. I am an avid nature girl and need to regularly distance myself from civilization and any sign or sound of man! To clear my mind, I love to hike to high altitudes and dive to the depths of the sea.

At a young age, largely because of my father's love of the sea, I became a keen snorkler and explorer of tropical waters. In my late teens, all I really wanted to be was a marine biologist. I thought I could be a head plankton researcher somewhere! No doubt my fascination began on the many family holidays in Ocho Rios, Jamaica, on Harbour Island in the Bahamas, and on the Yucatán Peninsula in Mexico. In the Yucatán we spent mornings climbing among Mayan ruins and afternoons snorkeling on the coral reef. In those early days, I would see other families with children already old enough to scuba

dive. I was so envious of their freedom to dive deep down, without the limiting constraint of one single breath of air.

Back in Virginia, as soon as I was old enough to take a scuba course, I signed up. To qualify for diving certification, I had to take an open-water dive exam in a cold, murky mountain lake near home. It was not fun, but it was a good experience, and after that I was able to dive on all our tropical trips. I gained many hours of underwater experience, diving at a variety of locales from shipwrecks to beautiful underwater coral gardens. My mother, who is an amateur photographer, bought an old Nikonos camera for me from a friend, and from there I proceeded to document my undersea findings.

As is my nature, I always focused in on the smallest details—patterns of coral, tiny plankton, and other miniature creatures that inhabit the reefs. The designs these creatures

OVERLEAF PAGES: 18K Bubble bracelet in royal blue moonstone. TOP: Architectural wave motif, Piazza della Signoria, Florence. RIGHT: Early marine exploration, Cozumel, Mexico.

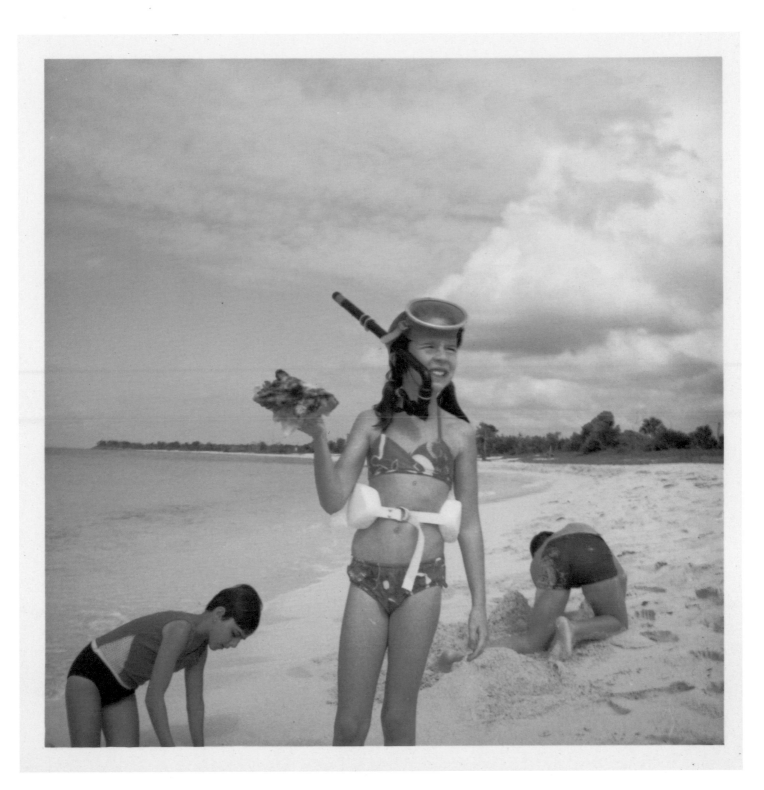

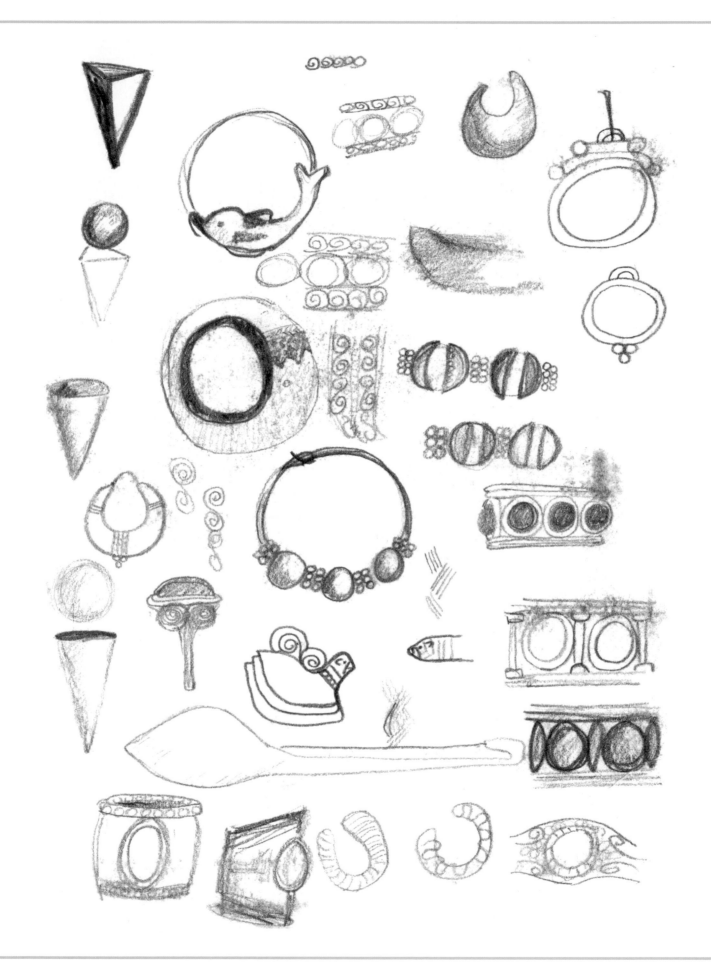

make are endlessly intricate and beautiful and captured my love for detail and color. My work's predominant palette has been strongly influenced by the colors of the sea. In stones, I tend to seek out the best of aquamarines, blue sapphires, blue-green tourmaline, and seafoam green beryl. Blue and rainbow moonstones remind me of the luminescent and changeable quality of the sea's light. I also love pearls and have worked with an array of cultured, freshwater, and South Sea pearls. Pearls represent for me a characteristic that I love— that of being "perfectly imperfect." Each pearl, no matter how

"perfect" it may be, shows Nature's hand in its individuality. Each pearl can differ slightly in its color, shape, and luster. Most pearls on the market are cultivated or farmed, so I don't feel I am depleting nature. I tend to stay away from coral, since even in the years I've been diving I've seen remarkable and saddening changes in the condition of coral reefs around the world.

While I was studying in Switzerland, as a teenager, my parents and grandparents moved from Virginia to the coast of South Carolina. They went to live in an area called the Low Country, a series of coastal barrier islands just under or

OVERLEAF PAGES (LEFT TO RIGHT): 18K Classic ring in royal blue moonstone; a page from my sketchbook. TOP: My collection of conch-shell spirals. RIGHT: 18K Bubble rings.

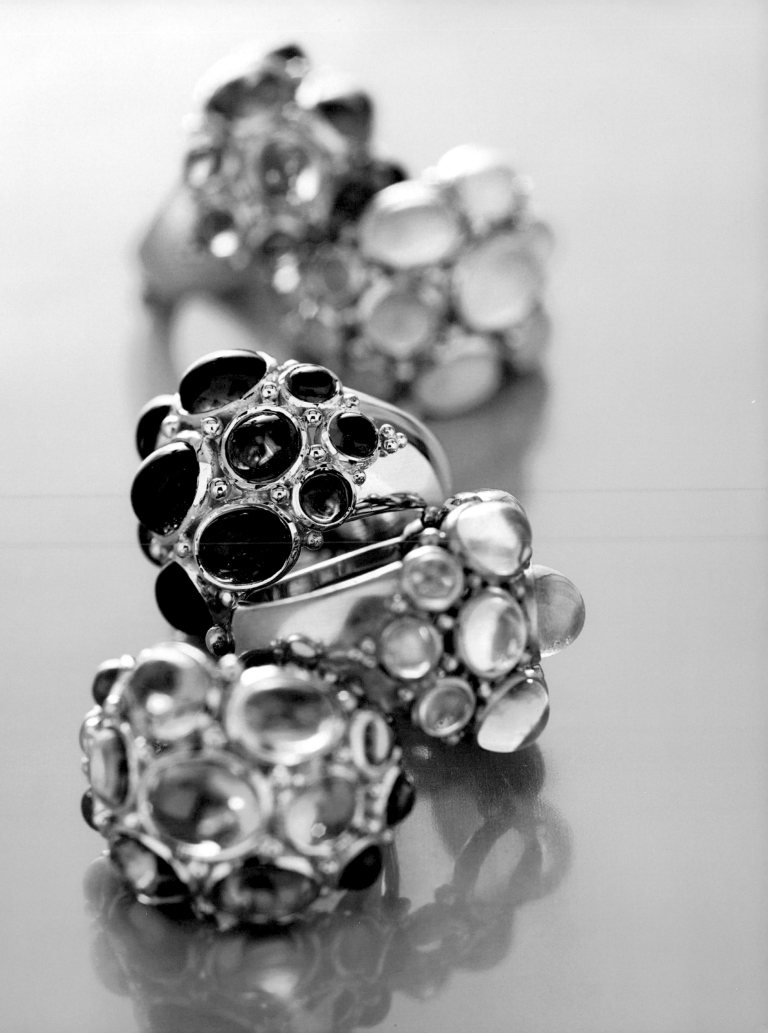

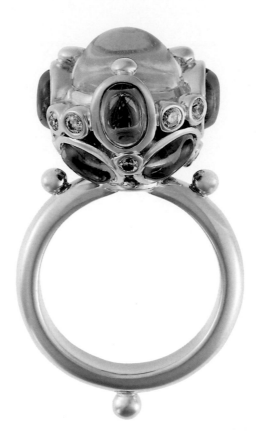

barely above sea level known for their wild, natural beauty and teeming marine life. By chance, Jean-Michel Cousteau, son of Jacques, had chosen Hilton Head Island as his headquarters for an educational research program called Project Ocean Search. Granny and my mother managed to track down Jean-Michel and convince him that, although age-wise I did not qualify to take part in his project, I would be an enthusiastic and able candidate. The next thing I knew I was off with the Cousteau expedition for a good part of the summer to Antigua, and then the next summer to Roatán in Honduras.

Project Ocean Search with Jean-Michel and his team of marine biologists, archaeologists, and environmentalists further encouraged my marine biology yearnings. I spent those summers doing research that was subsequently donated to the local governments. Our work entailed diving at different times of the day and night, taking population counts of the local marine creatures, plotting out reefs, and photographing what we observed. We also conducted archaeological explorations on land. I continued to be involved in macro photography, taking up-close pictures of small sea creatures and plankton;

TOP: 18K Eleonora ring in royal blue moonstone, tanzanite, and diamond. RIGHT: 18K Dolphin pendant in blue sapphire and diamond.

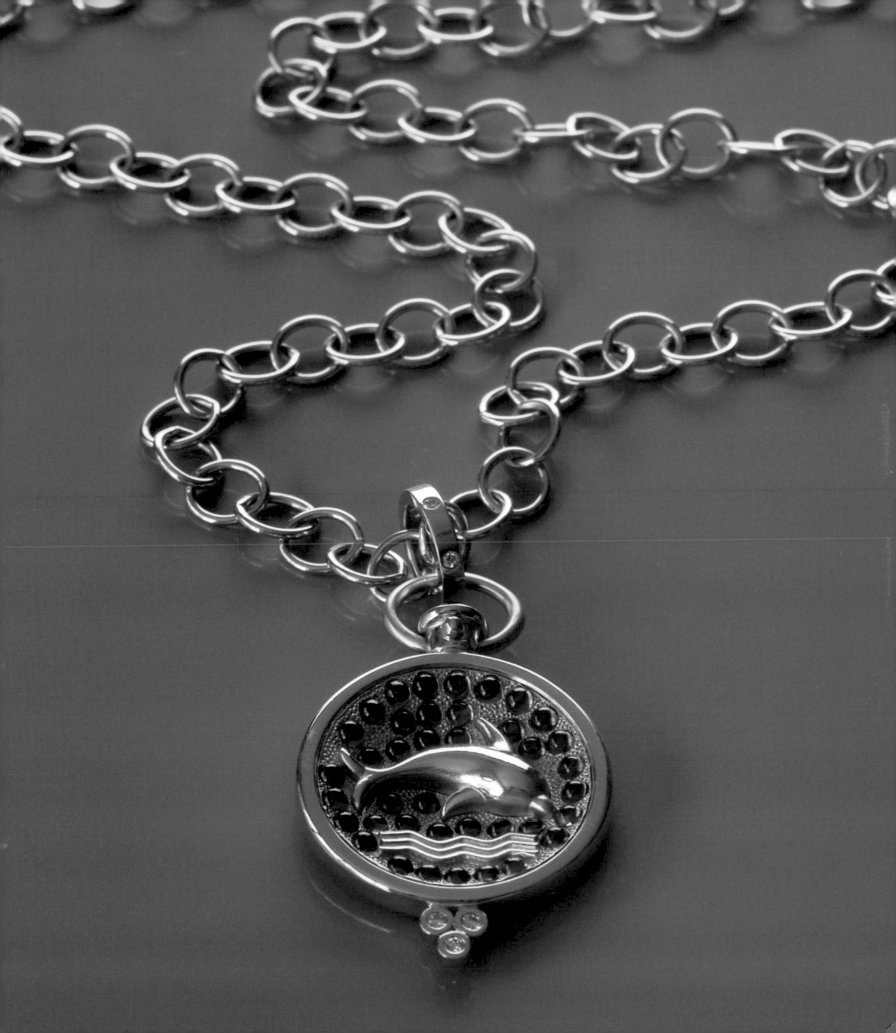

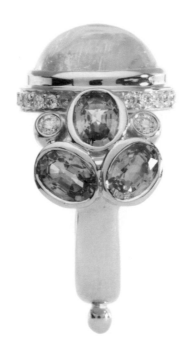

at that level of intimacy everything appears to be gemlike. I believe all of these experiences continued to hone my abilities to observe detail closely and patiently.

These travels were pure adventure for me. Being one of the youngest, I was typically housed in a cabin with Jean-Michel's family. We were each allotted one bucket of water a day for washing, but since we lived in our swimsuits and were in and out of the sea all day, it didn't make much difference. In Roatán, we loved hiking to the windward side of the island, where there were many colorful parrots and monkeys in the trees. One night the small staff that worked at the complex of cabins cooked up iguanas and presented them to us for dinner—to this day I am not sure if this was a joke. None of

us could eat them, not even the local dogs, who would usually devour anything. Jean-Michel was and is today a passionate advocate of the sea and marine life. But what people may not know is that he is an endearing prankster. He loved initiating new young arrivals with an involuntary mud bath in the mangroves, or by pretending to leave you far at sea after returning from a dive. The iguanas may have been his joke.

Night diving in Honduras was new to me. Jumping into the inky blackness of the ocean is both terrifying and exhilarating. The phosphorescent plankton sticks to you, and if you turn off your flashlight, the phosphorescence illuminates you and those around you in twinkling silhouettes. You can pick up sleeping fish with your hands until they come to and wriggle free.

OPPOSITE PAGE (LEFT): Underwater photos I took while diving in Antigua and Roatán; (RIGHT): cupola of the Pazzi Chapel, Santa Croce, Florence. TOP: 18K Este ring in royal blue moonstone, blue sapphire, and diamond. FOLLOWING PAGES (LEFT TO RIGHT): Mark Rothko, *No. 61*, 1953; 18K Classic necklaces in aquamarine and green tourmaline.

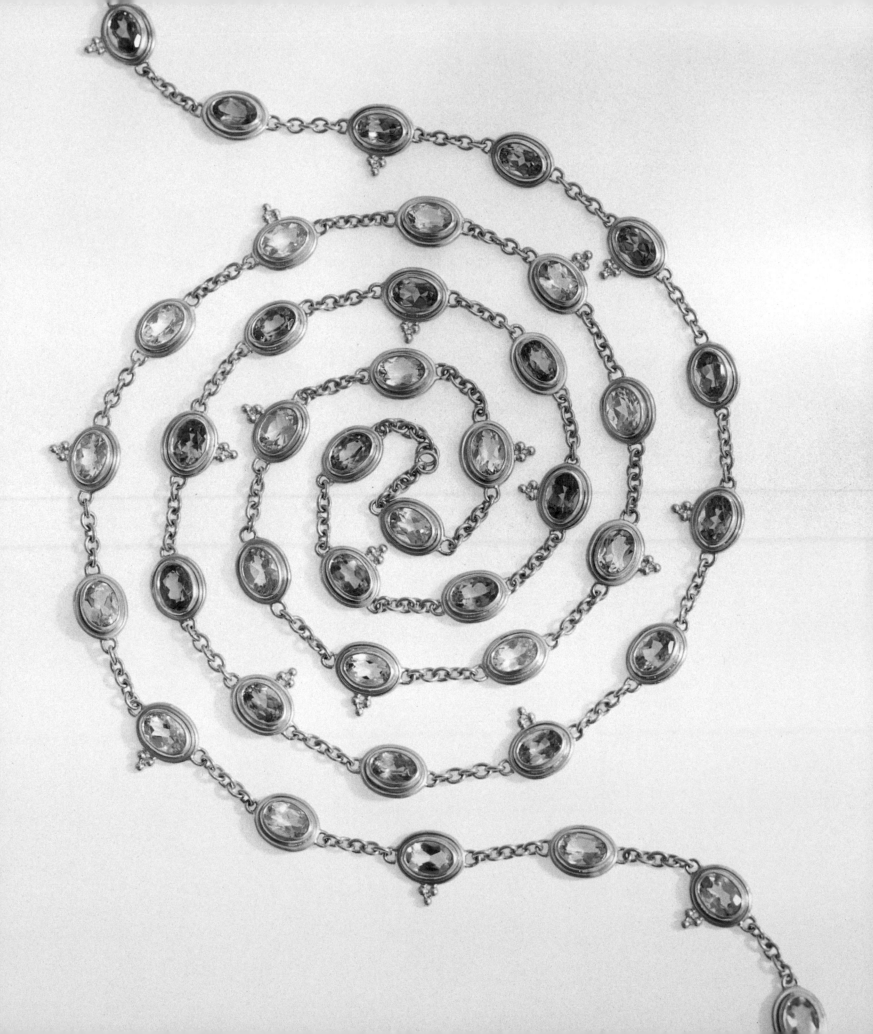

Tiny plankton in shapes of spirals and geometric equations float by as if they're from some other world. It *is* another world, and one that I feel lucky to have had close encounters with.

When it came time to follow a marine biology or fine arts path, I was torn. I loved science but also loved literature, arts, and language. I chose liberal arts believing it would provide a broader world to delve into and, ultimately, draw from. I sometimes wonder what it would be like to be so specialized in the marine world. But I still revisit it by diving whenever possible and introducing my children to it, just as my father did for me.

Post-Cousteau, the next major undersea adventure I was to experience came while studying in Florence. I was sought out by friends of friends, who knew that I was a diver, to

work as an underwater model in the Maldives in the Indian Ocean for a month. The head of my graduate program wasn't thrilled by the idea of my taking a month off, but could hardly blame me for going on this expedition. This time I was hardly roughing it. Living on an eighty-foot sailboat captained by a French couple, we caught and ate lobster almost every night. I was engaged to do two dives a day. It was one of the most magical trips I have ever experienced.

We made most of our dives with the aim of photographing colorful coral and sponge gardens with their abundant jewel-like inhabitants. The only dive that I was less than happy with involved sharks. We picked up a Norwegian divemaster from one of the atolls, and he guided our boat to a place in the reef where he had been regularly feeding sharks. About

TOP: Albertus Seba, Cabinet of Natural Curiosities, 1734–1765. RIGHT: Aerial photo that I took of the sea and reefs around Roatán, Honduras. FOLLOWING PAGES: Mermaid collection.

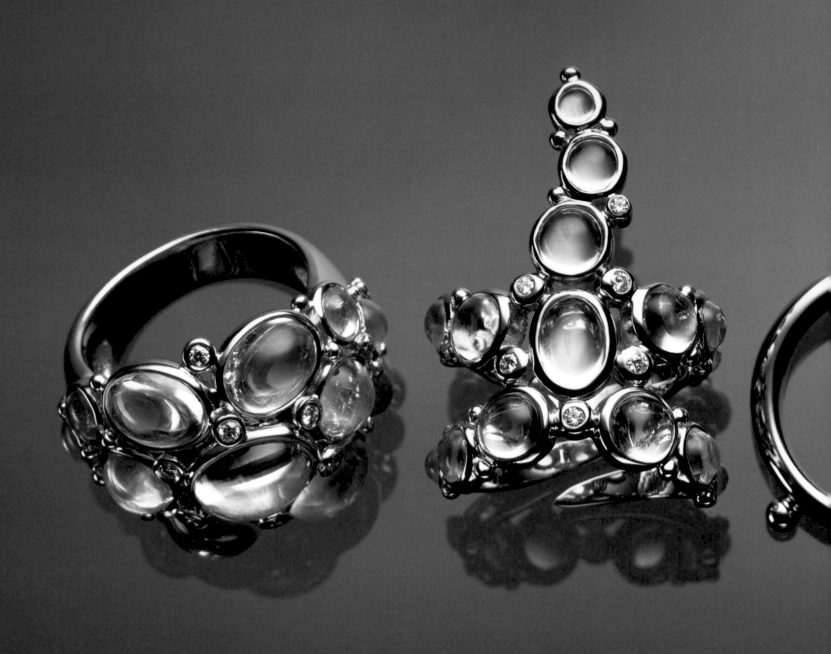

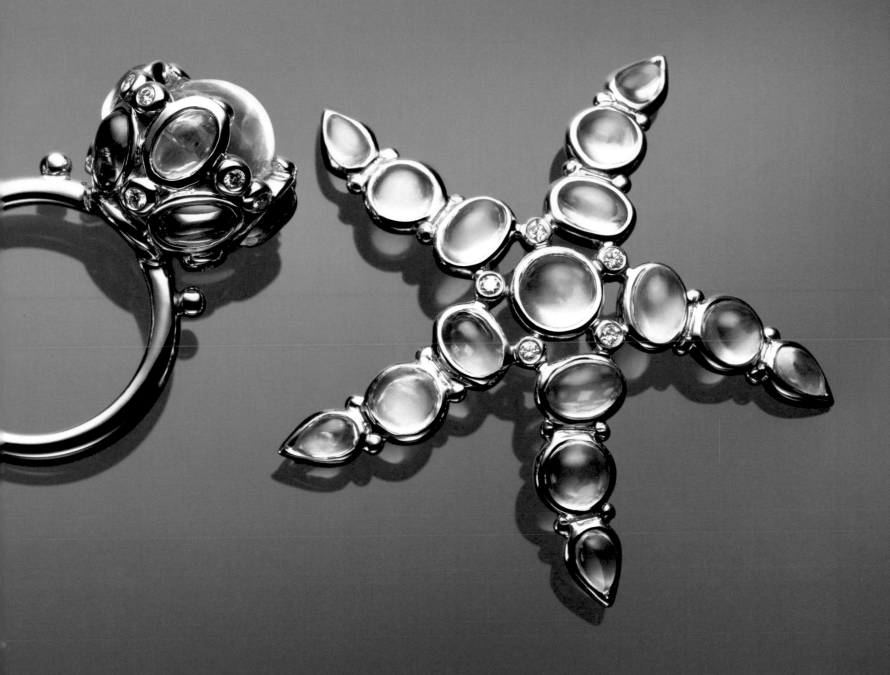

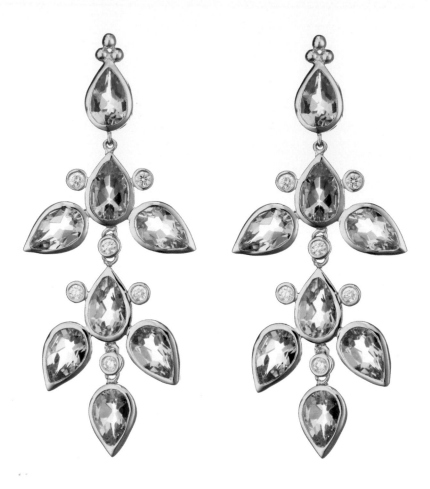

seven of us jumped off the boat, and like Pavlov's bell, the sound of the boat's motor signaled to the local shark population that a snack was on the way. As we descended to about fifty feet, dark torpedo shapes started circling closer and closer. It was extremely eerie.

Once we were down, we positioned ourselves against the backdrop of a steep coral wall. I counted at least forty sharks ranging from small three-footers to some at least eight or nine feet in length. The Norwegian was feeding them fish parts from a plastic bag that he had brought down. The Italian team began to take photographs and motioned to me and the other "model" to move out between them and the sharks. At this point, we shirked our underwater modeling responsibilities and stayed glued to the wall of coral, in spite of a few scratches. It was scary enough with the smaller sharks getting very excited and skittering by us. I suppose my underwater modeling career ended there!

The Maldives is made up of some 1,000 atolls, only a few of which are inhabited or developed. Every evening we would anchor off a different atoll and swim in to explore. Many of the atolls consisted only of an idyllic white sand beach and a few palm trees. Occasionally we would stop at

TOP: 18K Mare earrings in mint tourmaline and diamond. RIGHT: Richard Diebenkorn, *Ocean Park No. 107*, 1978.

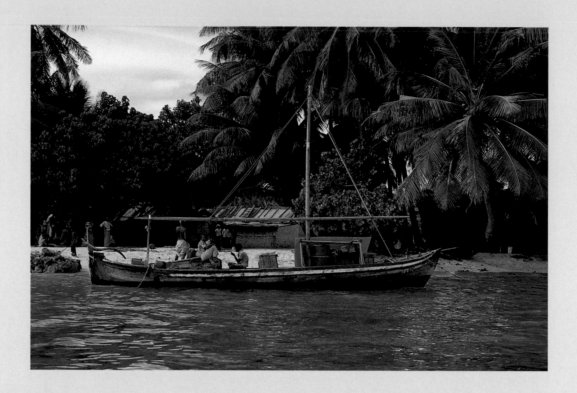

a fisherman's village. Children would come out to see us, and we would trade them Polaroid snapshots of themselves in exchange for shiny cowrie shells.

One evening our captain arranged for a dinner to be hosted for us by some local fishermen. At night if there is not a full moon, the atolls are very dark. On this night there was only a thin crescent. We were led from the shore to the middle of the atoll and seated at a table outside under the stars, illuminated barely by a few low-wattage bulbs on a string. Surrounded by the entire village, which was there to watch, we were served an unidentifiable yet delicious selection of fresh fish curries and rice.

Diving in the Maldives was the best that I have ever experienced. It was like diving in an enormous blue swimming pool just full of life: schools of hammerhead sharks would glide by alongside enormous mantas and a breathtaking array of gem-colored fish, coral, and sponges—a moving collage of color and shape. While on the boat we would see sailfish leaping out of the water, and we would traverse schools of flying fish that would glide like silver streaks through the air beside the boat. I felt what it must have been like to be an early explorer documenting in detail all of these exotic wonders. I am a collector of experiences and images and stories as much as I am a collector of objects from my travels. All of these "collections" are filed away in my mind and provide rich fuel for the imagination.

Stories and adventures of marine treasure still fill my professional life. One source for me is a purveyor of very fine pearls. He is a Frenchman who makes his home in Hawaii and travels to exotic destinations such as Burma to find the most unusual South Sea pearls. At this point in my career,

TOP: Maldives. RIGHT: 18K Melo Melo necklace in rare melo pearl and diamond.

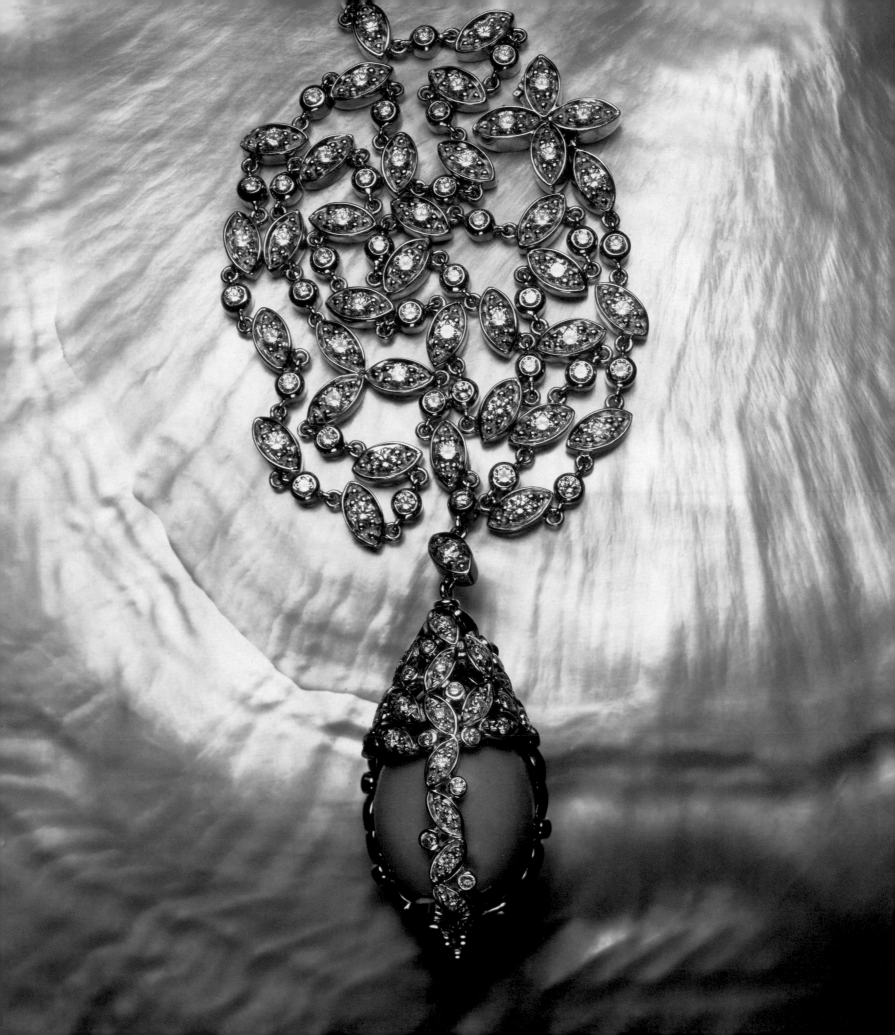

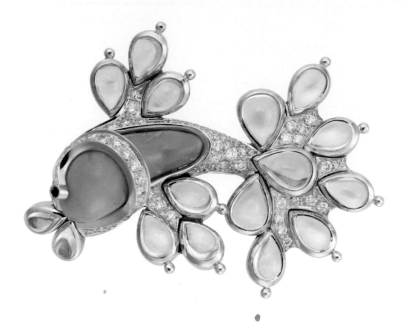

there are a few very specialized dealers worldwide who know my work, know my quality and demands, and have a sense of what I might love. This dealer introduced me to a particular treasure: the melo pearl. He brought me two: one a perfect oval egg, the other a baroque shape, both of an unusual peachy orange color.

As I like to imagine, the Frenchman machetes his way through the jungles of Burma to find incredibly rare natural objects. In the case of the melo pearls, a fisherman in Burma apparently invited him to his hut with the intent of showing him something extraordinary. Indeed it was. The Frenchman had to remain emotionless so as not to betray his knowledge of what the pearls actually were, for if he did, the price would have gone sky high. The Burmese fisherman may not have known what the value of these pearls was in the Western marketplace, but he certainly knew that they were unique objects, and would be worth something to the Frenchman

who periodically passed through his remote village. I never asked what price he paid the fisherman for them.

The melo pearl is extremely rare. Like the conch pearl, it contains no nacre—the layering substance that distinguishes what we think of as a pearl from an oyster. The melo pearl comes from what sounds like an enchanted storybook creature: the melo sea snail. These snails are found in Asian waters such as the South China Sea and the Bay of Bengal. A pearl forms in the melo in much the same way as with oyster pearls: it forms in response to a foreign substance that invades the snail's shell. Melos are generally very round or oval in shape. Colors range from pale tan to dark brown, with orange the most desirable.

The interest in melo pearls is in just how uncommon they are. One in a hundred sea snails produces a pearl, and one in a thousand of those is actually of gem quality. Melo pearls, like conch pearls, cannot be cultivated, adding to their rarity.

TOP: 18K Fanciful Fish pendant with rare melo pearl, royal blue moonstone, and diamond. RIGHT: My abbreviated foray into underwater modeling in the Maldives.

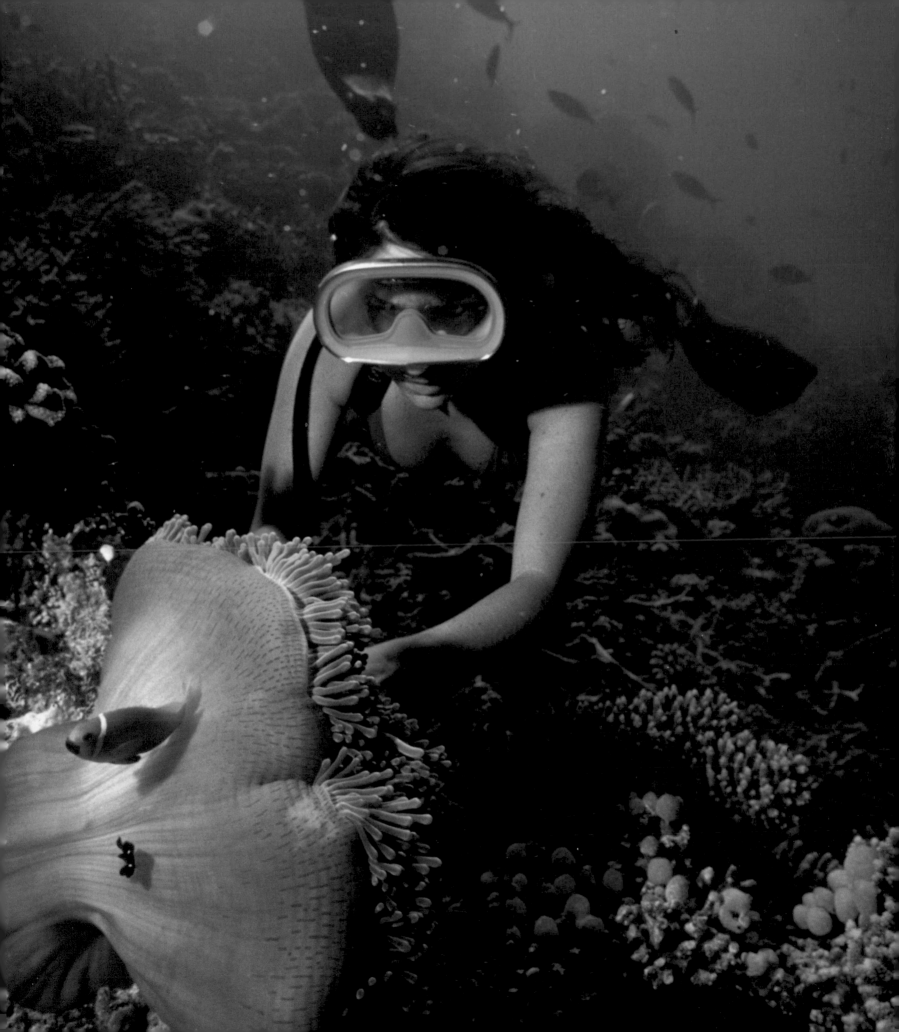

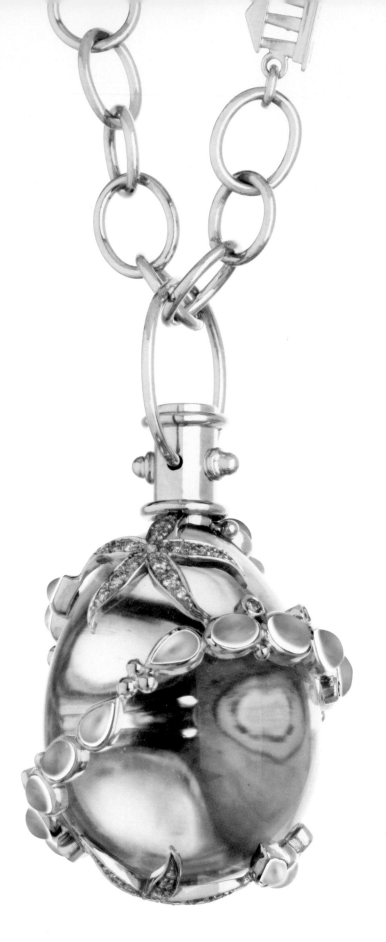

As happens in the jewelry world, the Frenchman gave me the melo pearls to work with on a handshake. He had confidence they would be handled well. The commerce is important to him, but so is the beauty of the find itself, and he cares about the unusual objects he finds. Otherwise, why choose to make your living this way? It is not easy.

The experience with the rare pearl reiterates the fact that you cannot "order up" what you need in the world of pearls and unusual gemstones . . . the way you can with diamonds and gold. The great dealers within each realm of particular gemstones become experts through experience and a lifetime of passion and involvement with the materials and the places they find them.

For me the value of a one-of-a-kind piece such as the melo pearl is enhanced by knowing its story. The path of a treasure such as this is intriguing from start to finish, from the find to the jewel to the collector.

LEFT AND RIGHT: 18K Mermaid amulet in royal blue moonstone, blue sapphire, and diamond.

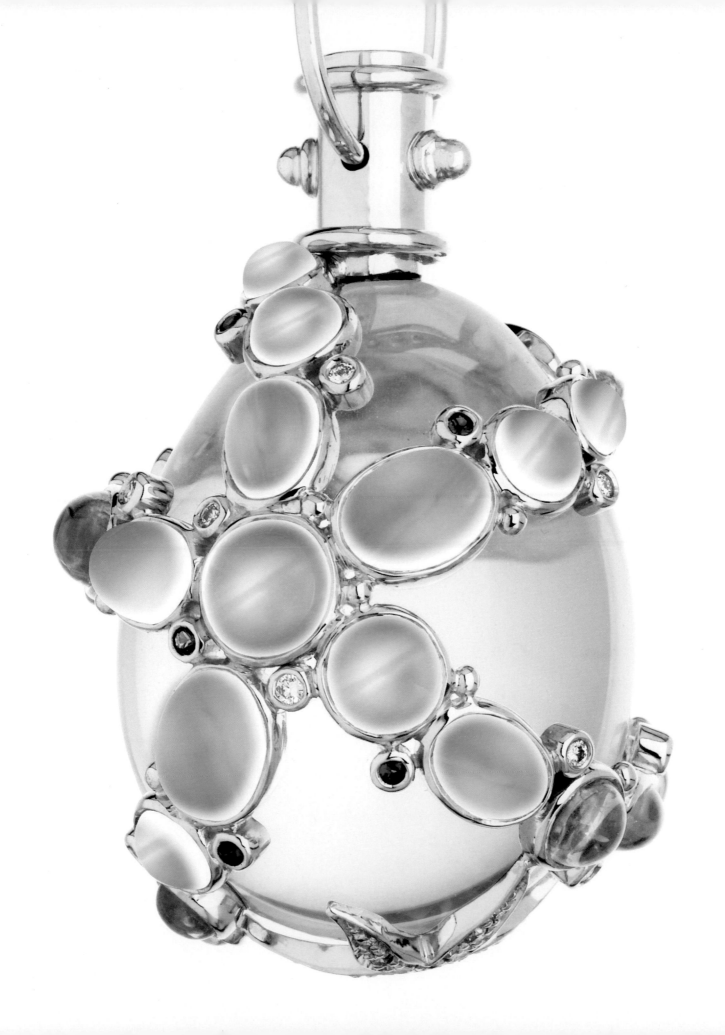

TRUE JEWEL

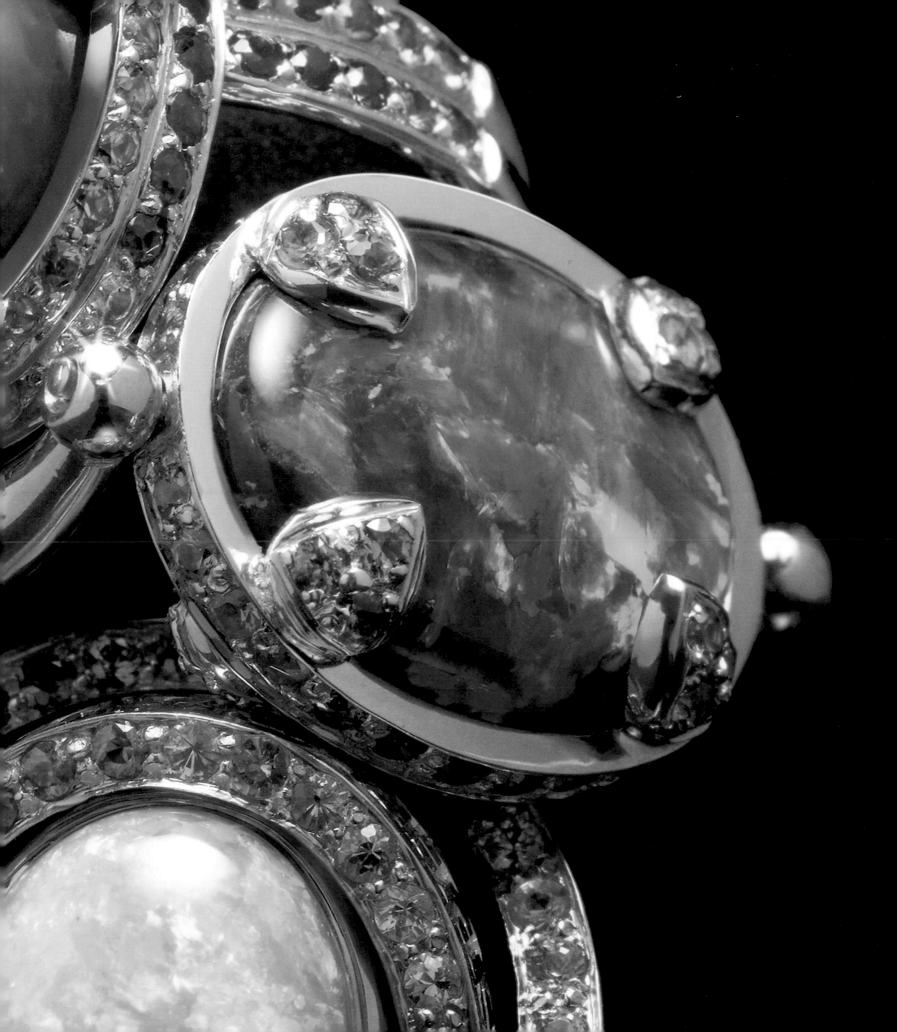

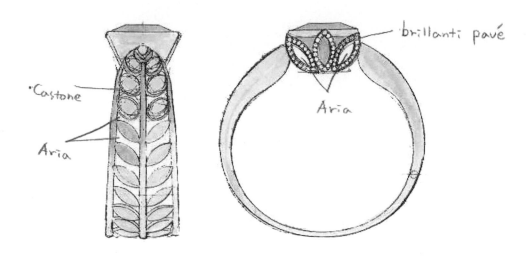

FROM THE EARLIEST OF TIMES, people of every culture, no matter their age, gender, or social status, have adorned their bodies with jewelry. In one of my favorite books on jewelry, *Les Bijoux Anciens et Modernes* (1887), the nineteenth-century French jeweler and self-taught anthropologist Eugène Fontenay wrote, "Show me the jewels of a culture, and I will tell you which culture they are from," which is to say that within a society, its jewelry is revealing of its manners and values.

I love to contemplate the jewelry that is currently worn in different parts of the world: the intricately patterned bead and metalwork of Africa and its strong symbolism, reflective of the rites of specific tribes such as the Masai; the elaborate gold and colorful gemstone jewelry of India that is presented in abundance to young brides; the traditional gift of Fabergé eggs in Russia, where grandmothers wear their lifetime accumulation of bejeweled eggs on a single "charm" necklace; the American hip-hop culture with its large gold chains and diamonds. Each manifestation of jewelry is representative of ideals within those cultures, whether they are a rite of passage, a trophy, or the accumulation of memories.

A great jewel must consist of impeccable craftsmanship, fine materials, and well-executed design. A true jewel has these assets yet goes beyond its materials; it must stand the

OVERLEAF PAGES: 18K Galaxy rings in Lightning Ridge Australian black opal with sapphire. TOP: Study for Vine bracelet. RIGHT: 18K Vine bracelet in seafoam green beryl, aquamarine, and diamond.

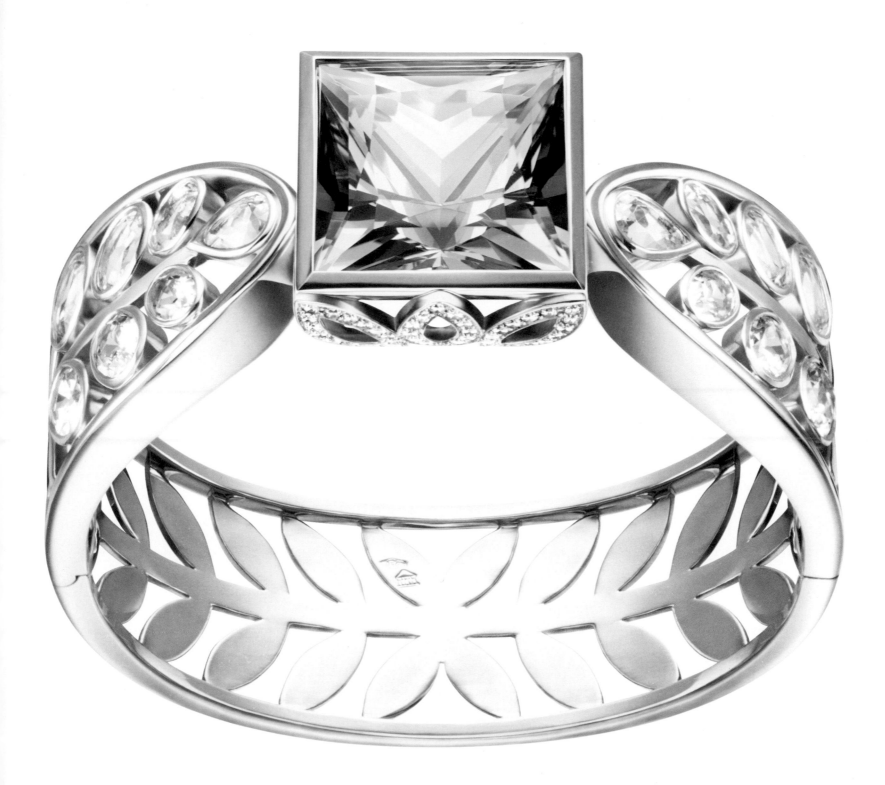

* FIDES * SPERA *

P*T

P*T

T*P

S*H

SARI MAHAN

mis 8 ab.

bordo tipo R5

alt. 6mm

Incisione rombo

T * P

Incisi

interno:

FIDES * SPES *

P*T

AMOR

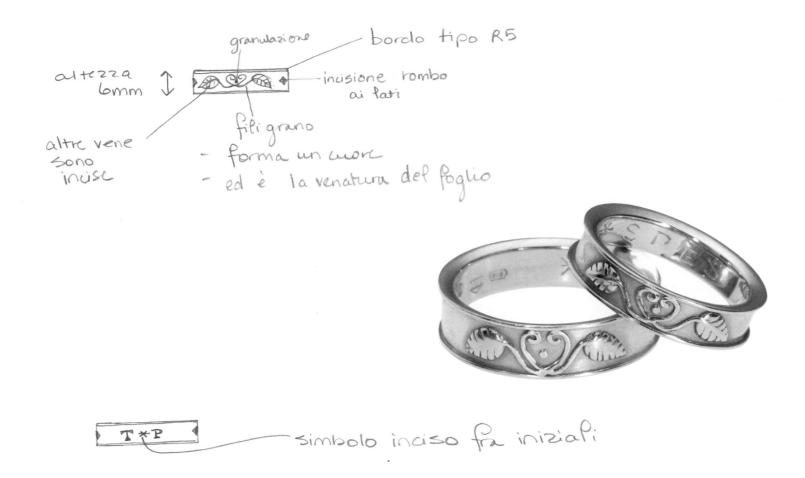

granulazione

bordo tipo R5

altezza 6mm ↕

incisione rombo ai lati

altre vene sono incise

fili grano
- forma un cuore
- ed è la venatura del foglio

T✳P

simbolo inciso fra iniziali

test of time. It tells a story and has the potential to become a miniature history lesson in itself. The fact that a jewel can be valuable beyond its intrinsic materials is what fascinates me. Even after twenty years of designing, the stories and origins of jewelry still inspire me.

When I was in my twenties, before my career in jewelry began, I never considered myself a "jewelry person." I had long collected "tribal" jewelry on my travels, displaying my treasures at home and wearing them as exotic additions to my Western wardrobe. I had never found precious jewelry that appealed to me, not even on the Ponte Vecchio. My impulse to create jewelry came from wanting a jewel that felt personal, not trendy or commercial. It was not about fashion, but about my own personal style. I wanted to create something that was closer to my heart and soul, something reflective of my own values and interests. I think people who buy from me feel the same way. They are collectors, not just trend-watchers.

In the mainstream of Western culture, we've lost sight of the significance of jewelry, how we acquire it, and how it is worn. Most people in this century and the last look to

LEFT AND TOP: My wedding bands: sketches and finished rings.

engagement rings as their one "true jewel." In general, though, the romance and meaning surrounding a jewel is all but gone, even with engagement rings. Too many look to an engagement ring as something outside of themselves. They choose a stone and setting that they think is "correct," socially acceptable, and possibly impressive to their peers. These acquisitions often lack personal meaning and become mere objects void of sentiment. A true jewel should give something special to the owner beyond its material value: a depth of meaning that is added to and passed on.

When I make engagement rings I try to make them as personal as possible by working directly with the person who is to be engaged. My designs for engagement rings tend to be feminine yet distinctive and strong. As in my other pieces, I like to create details that can be viewed at different angles so

that the ring is interesting to behold. The setting and the stone should be balanced, one just as *engaging* as the other. I work with diamonds, of course, because most of my American clients are accustomed to them in engagement rings. There has been a tremendous amount of very effective marketing of diamonds, which helps account for their broad popularity.

But what I really like to do is seek out unusual colored stones. While exploring the history of gold and experimenting with details such as granulation, I found myself yearning to add color. In antiquity, color in the form of stones and pearls was just as desirable as gold. Often it did not matter whether it was a piece of colored glass or an actual gemstone. The effect of color was important in itself. When I first started experimenting with stones, I initially looked to cabochons, smooth-cut stones, in keeping with my interest in ancient jewels.

TOP: Drawings for Coco setting. RIGHT: Platinum engagement rings. FOLLOWING PAGES (LEFT TO RIGHT): 18K Coco ring with emerald and diamond; platinum Coco ring with tanzanite and diamond.

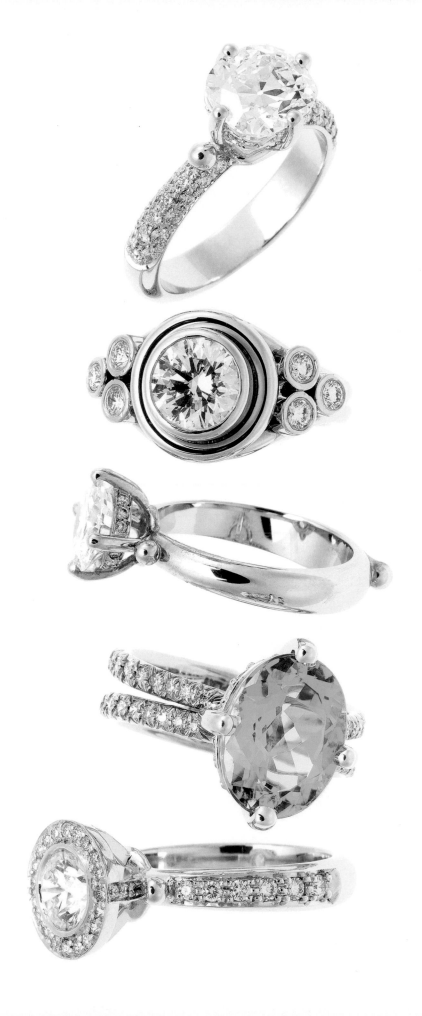

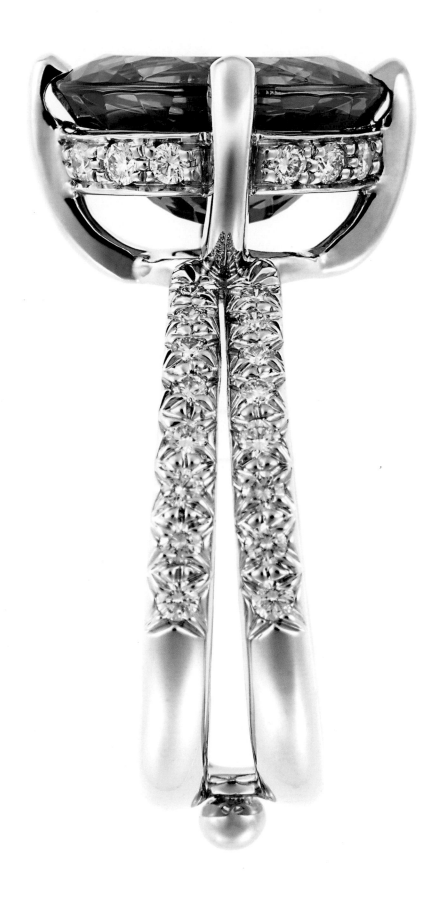

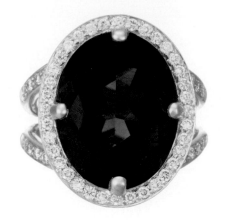
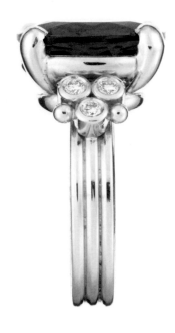
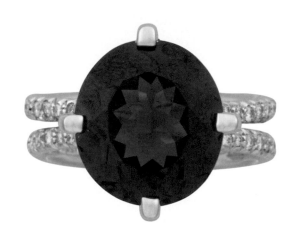
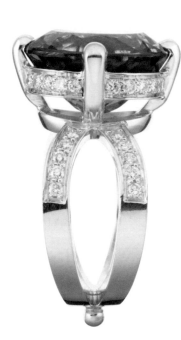
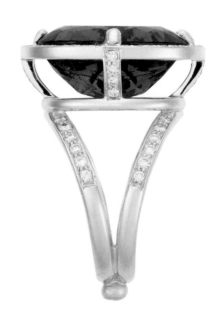

Centuries ago, jewelers did not have the tools to facet gems, so they merely smoothed them to the best of their ability to create cabochons. In all of my early 22-karat gold jewelry, I included only cabochon gems. I still work with gem-quality cabochons, but as my jewelry tastes and knowledge evolved, I have moved to include fine faceted gemstones.

Colored gemstones can be so singular that they seem to be the perfect choice for something as unique as an engagement ring. Typically the colored stones I choose for engagement rings are natural certified stones, meaning they have not been treated in any way to change or enhance their color. These include blue and pink sapphires, aquamarines, rare pink topaz, unusual tourmalines, garnets, and spinels.

What most people don't know about colored stones, including colored diamonds, is that most have been altered in some way. The heating of colored stones is an age-old process that deepens and evens out color. It is an industry-accepted method in all of the big houses. There are also newer processes—such as radiation, used typically to create blue topaz—that change the nature of the stone, rendering it practically synthetic. I always seek out certified natural gems as often as possible when buying color and stay away from overly treated synthetic-type stones.

Historically and still today, particularly in Europe, colored gemstones are used in engagement rings, but Americans consider colored engagement rings unusual. There is less

LEFT: 18K Classic, Coco, and Halo rings in mandarin garnet and pink tourmaline. TOP: 18K Classic earring in mandarin garnet.

knowledge about colored stones. Many people still refer to colored gems other than emeralds, sapphires, and rubies as "semiprecious," but there is really no such thing; the term is archaic. Geologically, diamonds are the purest minerals, and I find that when finely cut and properly set, they are quite beautiful. Diamonds can be ordered easily according to very specific standards. Beautiful natural-colored gemstones are much more rare. What captivates me is the pursuit, discovery, and surprise of great colored gemstones. Unique colored gems require a hunt.

A unique setting further enhances a gemstone. For the wearer to find a small detail that previously went unnoticed adds timelessness and intrigue to a jewel. The carvings in a medieval ring hint at secret messages and meaning. When I am designing I often include small but deliberate "secrets" to make a favorite historical reference or just to add a bit of whimsy: a granule on the shank of a ring references medieval archers' rings. Other design details may not make specific historic references but reveal themselves only at certain angles or upon close inspection. Sometimes only the owner of the jewel is privy to these details. I like to believe that these details unfold themselves and evoke a special bond in the wearer.

I met a woman a couple of years ago who was wearing one of my classic rings with a large oval aquamarine cabochon. She told me she had never been particularly interested in jewelry and had never purchased anything for herself. However, she was out shopping with a friend when she spotted "her ring"

RIGHT: 18K Limited Edition rings. FOLLOWING PAGES: 18K Classic rings.

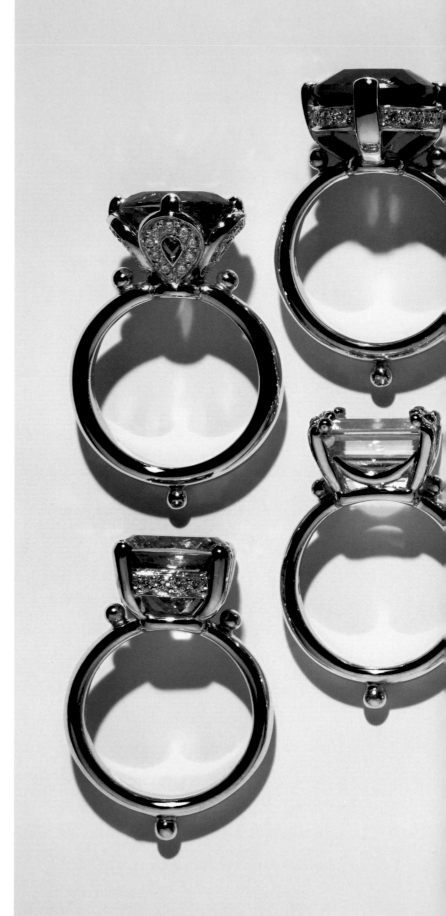

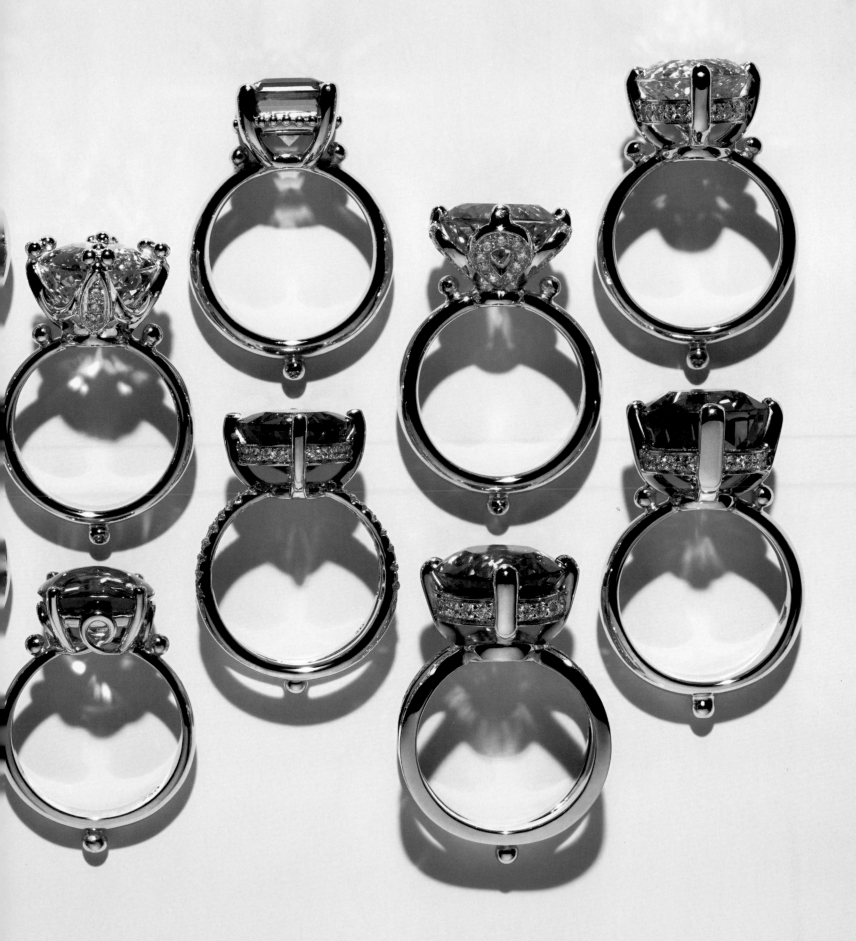

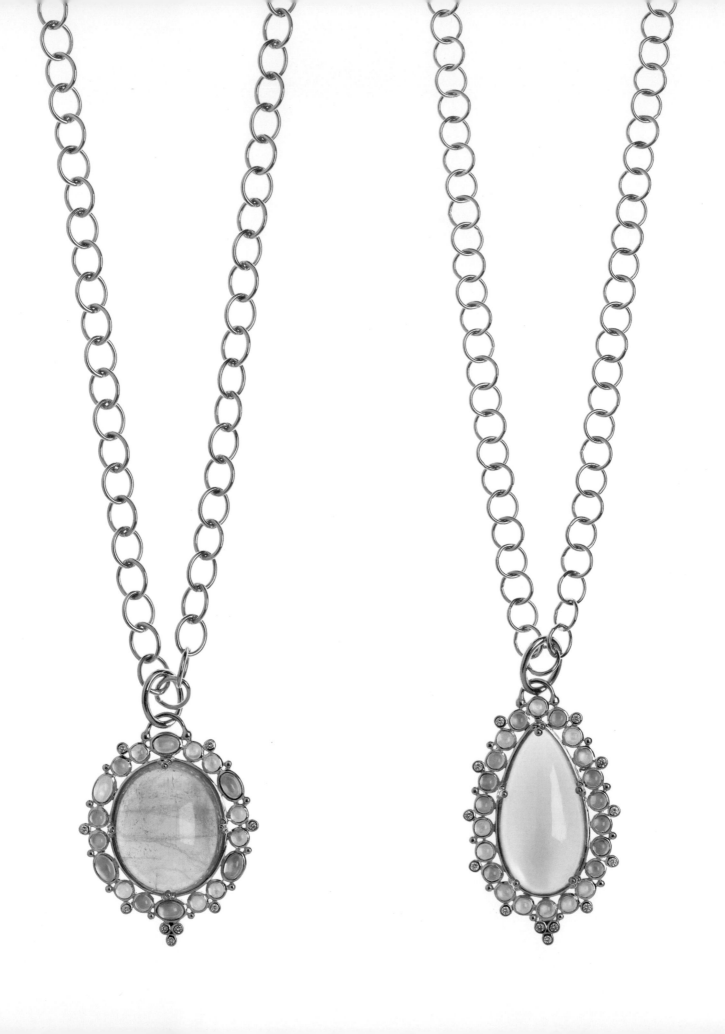

(which happened to be one of "my" rings), tried it on, and something happened. She passionately described how this ring seemed to be "meant for her." In fact, she's not taken it off since. She described how she admires it and discovers different angles and details as she wears it. It has become her signature, part of her persona. I don't know that this happens every day, but it is a great feeling as a designer to make something that gives someone so much pleasure. At the same time, a piece has its own success that goes beyond me. The jewelry takes on a life of its own: the color of the metal, the color and cut of the stone, how it wears. It has chemistry with its wearer. One could say that I am merely its medium.

Great gemstones often travel the world, changing hands between dealers and cutters. I have a client who wanted a pink sapphire for one of my settings. I contacted a dealer who specializes in fine sapphires to let him know that I needed a pink stone. He brought me an exquisite pink six-carat oval sapphire; it might have been the best in New York City or in the country at the time. Its certificate determined that it was completely natural, devoid of any form of enhancement, and the color description read "vivid pink." To even use the word "vivid" on a gemological certificate is exceptionally rare.

Most sapphires are heat-treated to intensify and even out the color. The majority contain natural color gaps or banding; the heating process spreads the color, filling the gaps. This unusual large pink stone had not been heated, an aspect, along with its size, that made it even more rare.

LEFT AND RIGHT: One-of-a-kind Isabella pendants in aquamarine, mango green moonstone with royal blue moonstone, and diamond.

The color was so fine, and the stone so free of internal inclusions, that it was difficult to confirm its provenance. In colored gemstones, an inclusion is an appearance of a feathery pattern or sometimes grainlike lines or spots. Certain mines turn out gems that have inclusions with recognizable patterns that make it possible to identify a stone's origin. With no clues other than the color, experts judged that this particular sapphire was likely to be from Burma or Vietnam. The dealer surmised Vietnam, which would have only added to its rarity since Vietnam's mines were open only a short time.

In one of my favorite reference books, Benjamin Zucker's *Gems and Jewels—A Connoisseur's Guide*, it is stiffly noted that "to the neophyte, an inclusion might be considered a flaw!" I actually love the way some inclusions add character to a stone. Often consumers insist on such clear stones that the specifications verge on being those of a synthetic. Inclusions let you know that the stone is natural.

I did not know until much later, after the *vivid* pink sapphire had been set and sold, that previously it had been sitting at Cartier in New York and had been pulled back by the dealer for me. There is a dual world—a subculture—around jewels. Great stones are often not owned by whom they seem to be owned.

I can remake a setting but I cannot guarantee that I can duplicate the exact color of a special stone. I always tell clients that if they are taken by a particular color in a stone they should think seriously about acquiring it. It is very uncommon that certain colors come around again. All natural-colored gemstones are one of a kind. Each color can vary ever so slightly in shade. There is an infinite range of color in the gem world, something to match every particular taste. Synthetic and artificially colored stones are uniform, which takes the life, individuality, and certainly the preciousness out of the stone. Colored gemstones are as individual as people, and they seem

TOP: Sketch for Magna ring in pink sapphire. RIGHT: 18K Magna ring in yellow sapphire and diamond. FOLLOWING PAGES: 18K Vine bracelet in seafoam green beryl, aquamarine, and diamond.

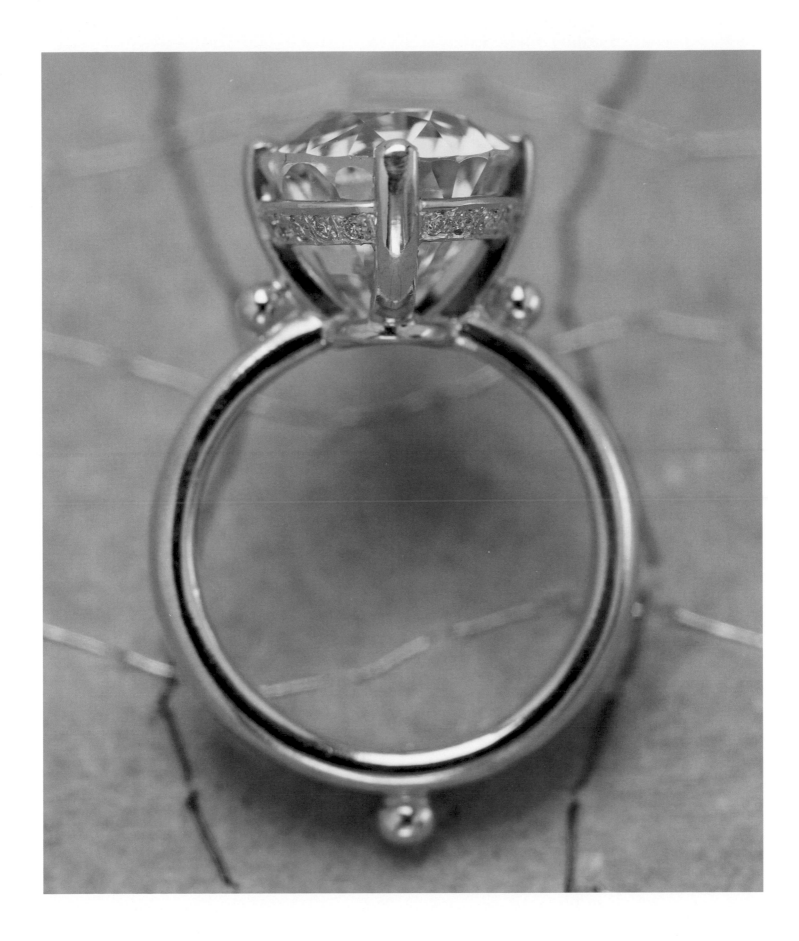

to stir specific emotional and personal responses. The variations of colored stones give you a chance to own and wear something unique that takes its form from the depths of time. I am continually amazed at what the earth is capable of producing!

There are certain stones that I have an ongoing fascination with, and I often design entire collections around them. I love particular shades of tourmaline and beryl. My favorite colors of tourmaline vary from light mint greens to blue-greens to pale pinks and hot bubblegum pinks. Beryl is the mineral family that includes emeralds and aquamarines but also the elusive *seafoam green* beryl. Most green beryl is heated to bring out more blue and qualify as aquamarine. A true seafoam-green beryl in its natural state looks like the color of a tropical sea against white sand. When I find these colors, I buy them. They are never on the market for long, and if you let them go, you may not get another chance for a long time, if ever. Another family of stones that I adore is moonstone. It comes in a variety of colors from milky white to peach to green to blue and rainbow, the latter two being the most precious. I refer to the blue moonstone that I use as royal blue moonstone. I acquire only the cleanest material and then depend on highly skilled cutters to reveal its beauty in high domes with the blue flash revealed just so in the center. The larger pieces are true collectibles; hundreds of carats of the rough are required to cut one perfect large stone. Royal blue moonstone has an enchanting opalescence and must be seen against the flesh to expose its individuality.

Colored gemstones are exotic by nature in that they come from many far-flung locales, from South America to Africa to Asia to Australia. As a result, the gem dealers are a rather nomadic group. They travel in search of the rough material, they travel to their cutters, and they travel to show their wares to designers and collectors like me. The nature of the gem business appeals to my own nomadic nature. I often travel for stones, but the gemstones also travel to me and bring their stories with them.

RIGHT: 18K Butterfly necklace in rose-cut sapphire and diamond.

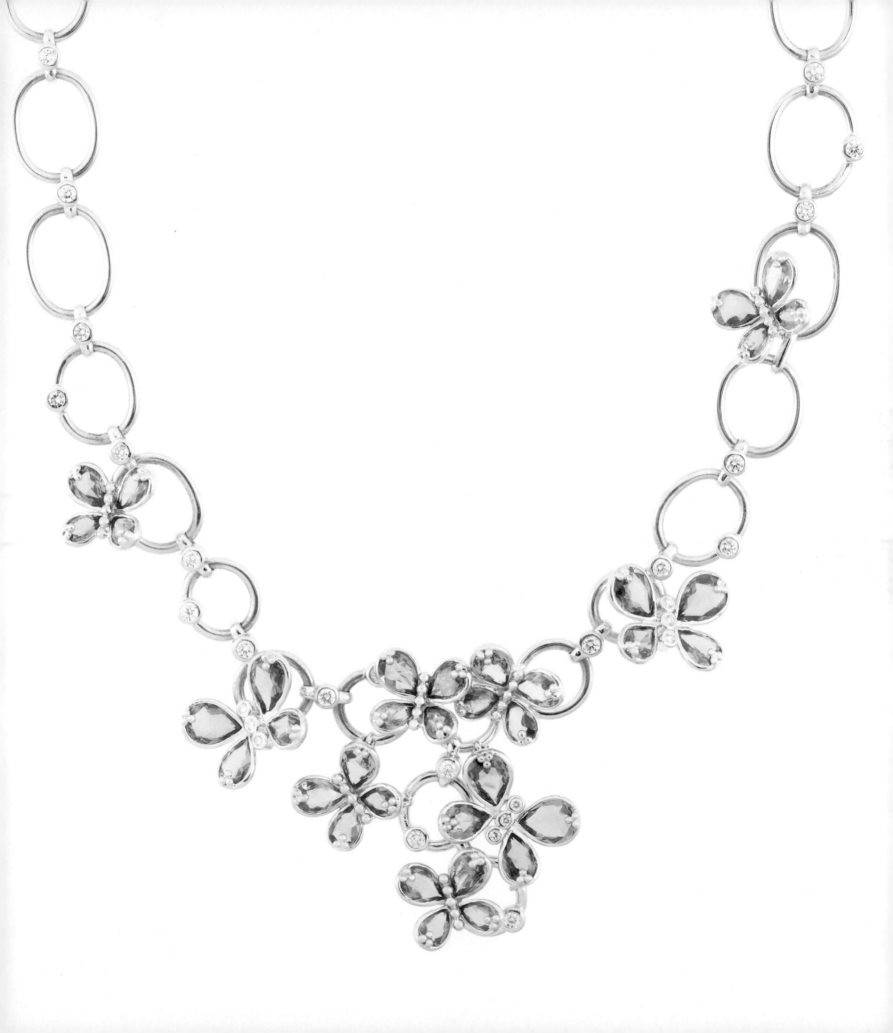

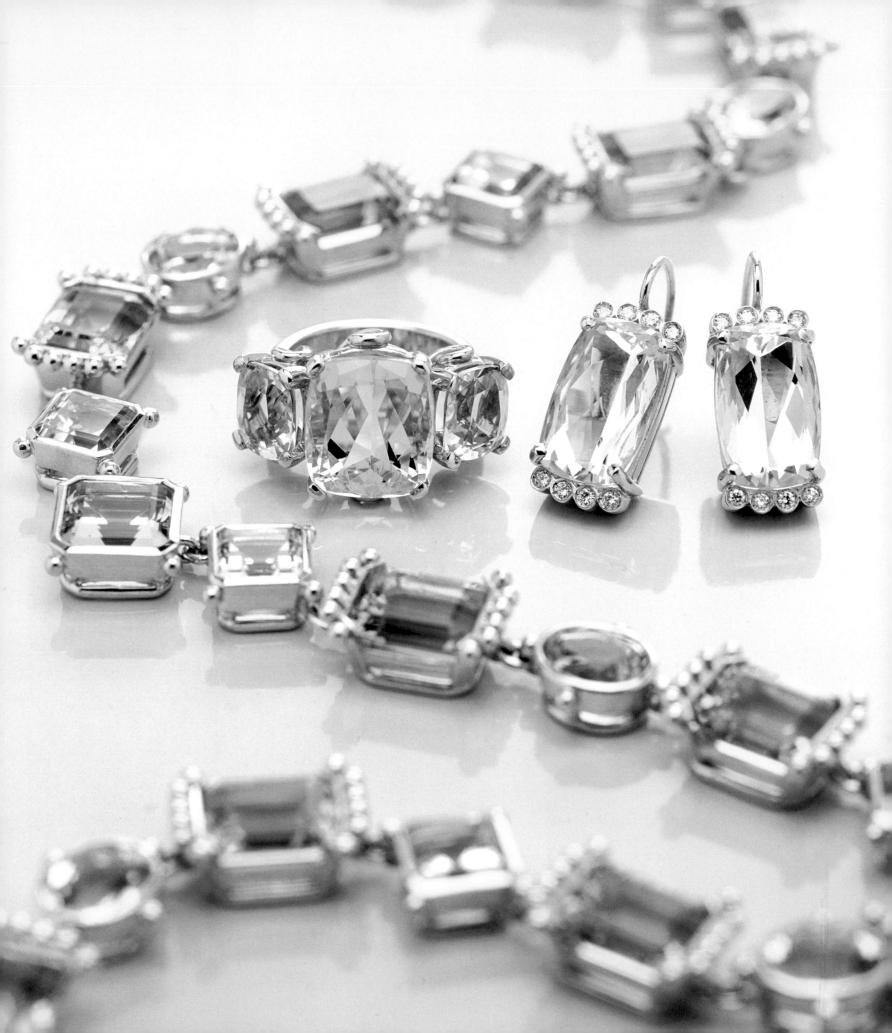

In the world of opal, Australian black opals are the most precious and in a class by themselves. For years I did not work with opals because of their forbidden aura. It is a pervasive myth that you should not wear an opal unless you are born in the month of October. In addition, most of the black opals I had seen were set in such an unbecoming way that the stone was not that attractive to me. What I needed was an in-depth introduction to opal, and that came through one of the more eccentric gem dealers.

I received a call from a man with a thick Aussie accent. He was recommended by one of my other dealers and wanted to stop by my studio to show me his goods. We made an appointment. Later that week, in he walked, an Indiana Jones–type character, hat and dust and all, seemingly just arrived from the outback. He emptied the contents of his pockets onto my desk. He was from Lightning Ridge, Australia, where black opals come from.

Fiery flashes of red, yellow, blue, and green jumped out from a dark background, making the black opals look like small replicas of the earth as seen from outer space. This dealer carried an array of stones with him, from small pieces to large connoisseur collectibles. I was fascinated by the life,

LEFT: 18K necklace, earrings, and triple-loop ring in seafoam green beryl and yellow beryl. TOP: 18K Coco ring in rainbow moonstone and diamond.

vibrancy, and uniqueness of each single stone. Now this particular dealer passes through, sometimes twice a year, with his treasures and always stops in to show me his latest finds.

Lightning Ridge black opal epitomizes my love for the individuality of colored gemstones. I set it in what I believe to be a classic, yet modern way that I think will bring back the attention that this unique stone deserves. And I hope to encourage collectors to disregard its inconvenient mythology!

I am often transported to another world when I meet with my gem dealers. Many of them are as individual as the stones they specialize in. As with my goldsmiths, I soon learned that eccentric characters and idiosyncrasies animate the world of gemstones. Since at least the Middle Ages, the business of gold and gems has been based on travel and trade, global relationships, and trust established across continents. Even today a gem dealer will allow you to borrow hundreds of thousands of dollars worth of stones on a handshake, just as they have done for centuries.

The jewelry industry happily retains a bazaarlike quality; business transactions are often based on instinct and gut feeling. I was so surprised by this early on when a gem dealer to whom I had only recently been introduced would give me a selection of stones to take back to my studio to "play" with and, he hoped, be inspired by! My goldsmiths and gem dealers have influenced and inspired me along the way. They have given me generous instruction and inducted me into their world.

A true jewel is not merely an accessory but an object with a personal story—some might say a soul. There is an emotional connection. A piece has to *speak* to you. It takes on other meanings as it is cared for and worn. A true jewel becomes a personal celebration of the wearer.

TOP AND RIGHT: 18K Galaxy rings in Lightning Ridge Australian black opal with sapphire.

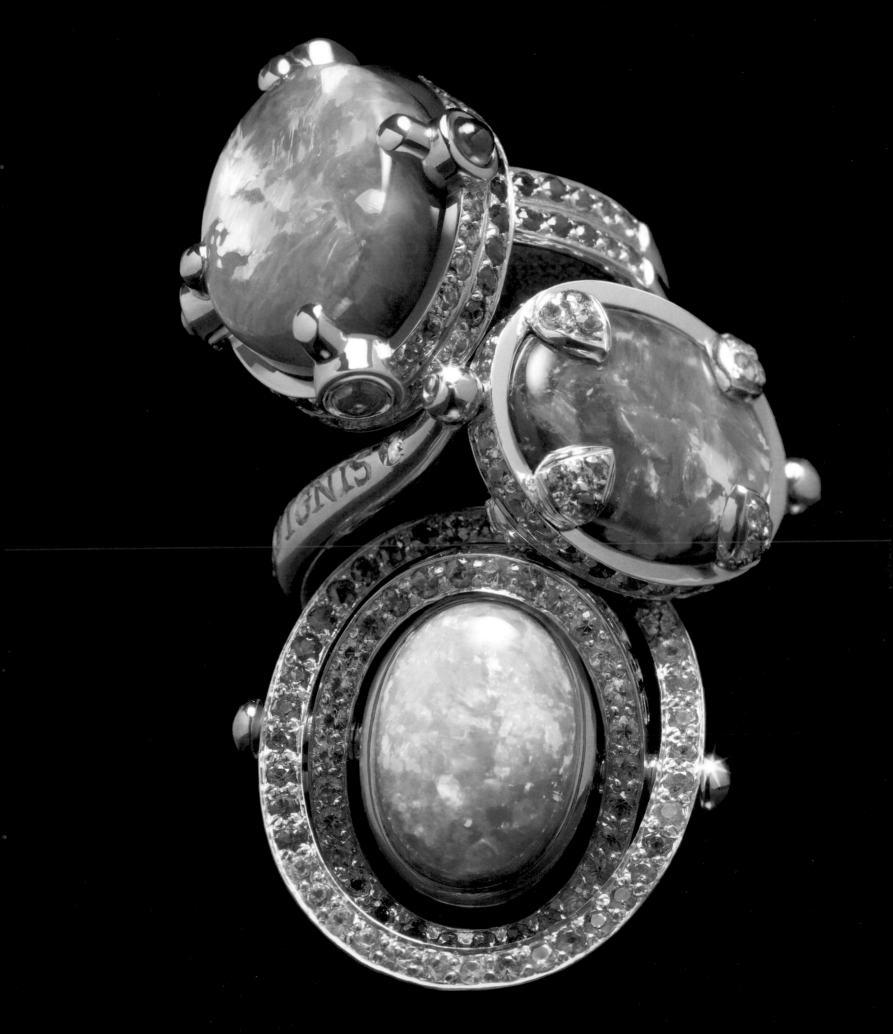

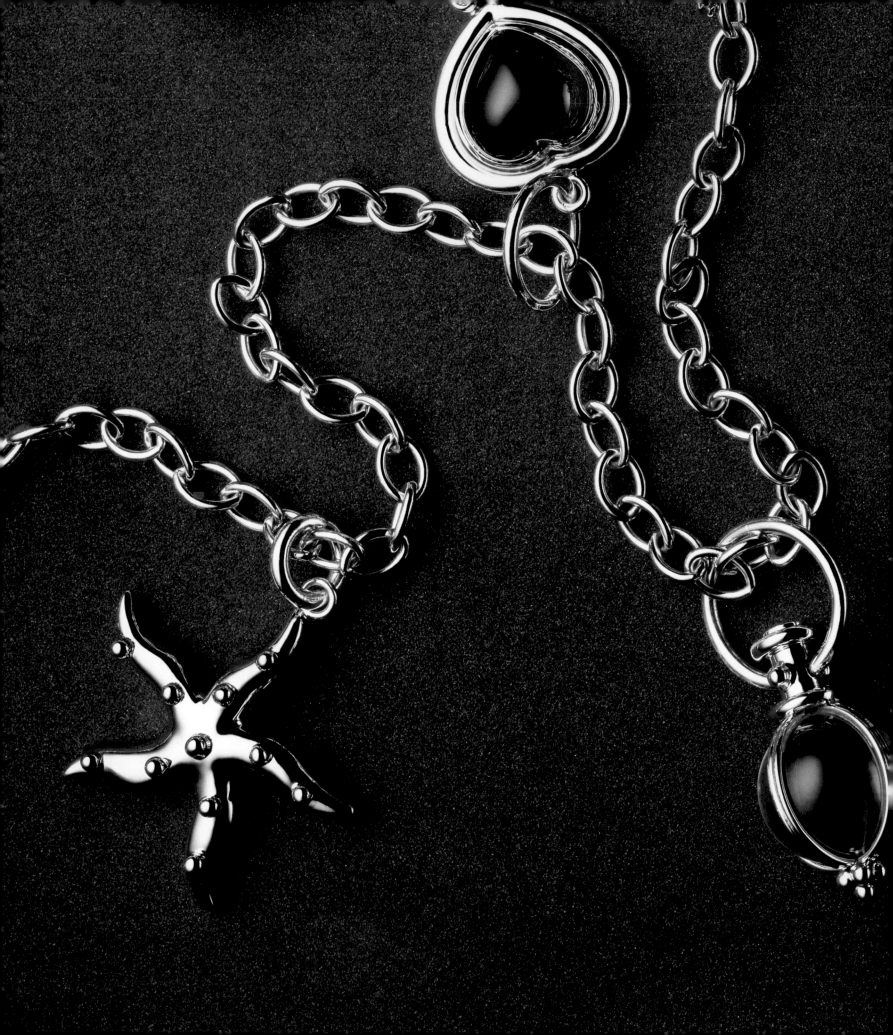

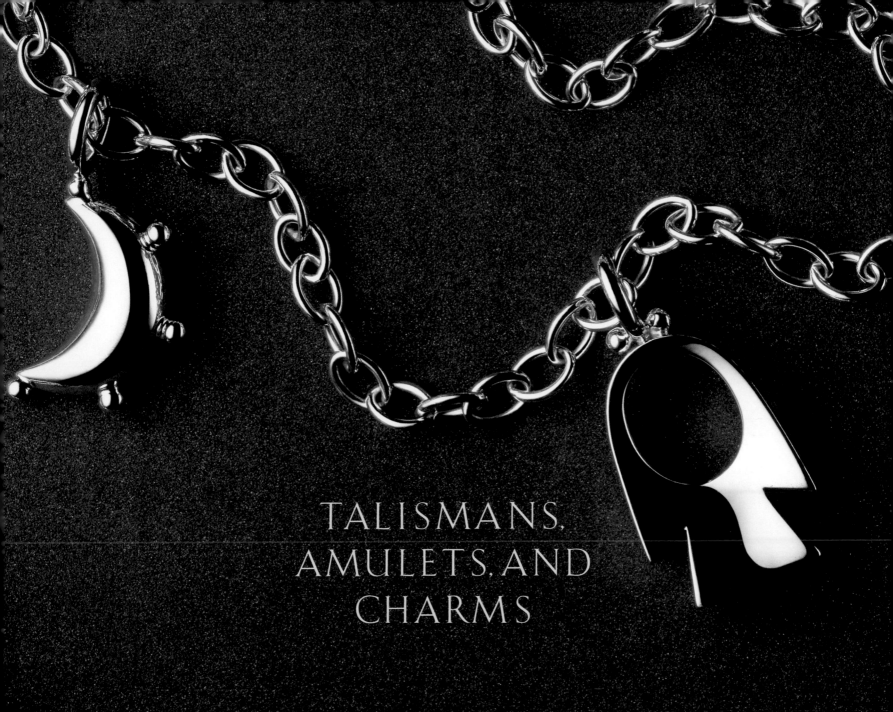

TALISMANS,
AMULETS, AND
CHARMS

TALISMANS, AMULETS, AND CHARMS have been dear to humankind since the caveman. Early man and woman recognized an important function in jewelry. Archaeologists have long found amulets and beaded necklaces right alongside primitive man's earliest tools. Primitive tribes often gave more importance to the wearing of jewelry than to clothing. The first jewelry, in the form of charms, communicated a shared symbolic language to tribe members long before the spoken and written word. Hunters wore special amulets to bring them good fortune in capturing the wild beasts that they hunted for their own survival. Women wore charms for fertility and to bring ease in childbirth.

Early humans turned a variety of materials, no matter how modest, into personal jewels; a charm could be made from a river rock, a piece of clay, a seedpod, or a feather. Not only were these items the bearers of stories that helped solve the mysteries of the universe, but these singular pieces of jewelry helped to delineate and give identity to the individual—a very sophisticated concept!

There are subtle differences between talismans, amulets, and charms. Talismans and amulets both fall under the title of charm in that they are both attributed with power and meaning by their wearer. Historically, a talisman was related to the zodiac and celestial influences and was generally

OVERLEAF PAGES: 18K Cosmos charms. TOP: Fossils and artifacts from my collections. RIGHT: Eugène Fontenay, *Les Bijoux*, sketch of Egyptian necklace with amulets, 1887.

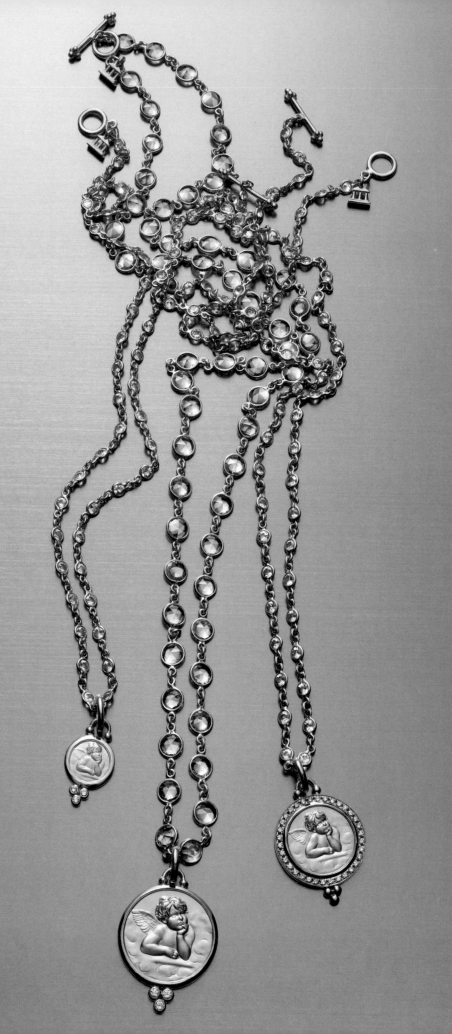

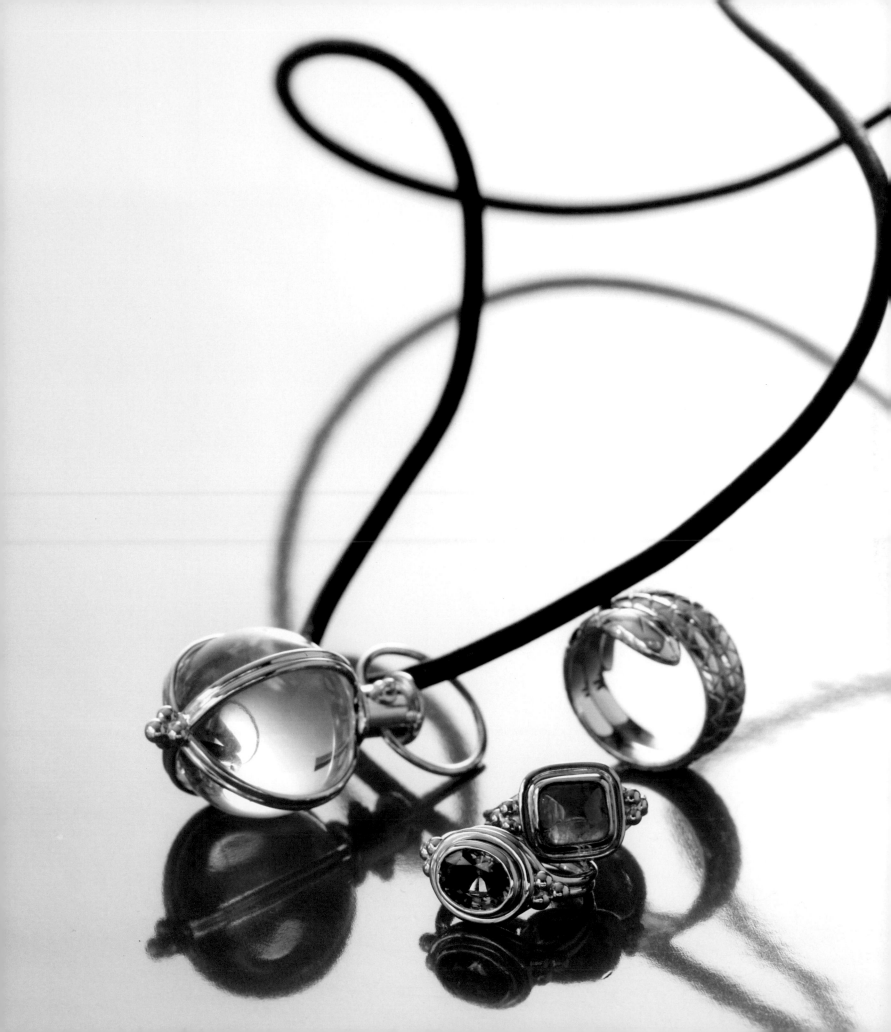

subject to some form of consecration or ceremonial ritual.

An amulet is a personal charm similar to a talisman yet with no specific association. Charms include almost any object—whether worn, carried, or preserved in the home—that is believed to bring some good fortune or act as protection against evil. Lockets also fall into the charm category in that they are receptacles for personal treasures and nostalgic souvenirs: a lock of hair, a baby tooth, a picture, an inscription.

When it comes to my very intertwined personal and professional life, I can say that I am playfully superstitious. I wear and surround myself with many personal amulets and charms. As a jewelry designer, who perhaps should be conscious of marketing her wares, I am probably not always the best at displaying my different creations on my own person, because I do not change my jewelry that often. I just add to it! Most everything I wear holds some specific meaning for me; it is difficult *not* to wear what I wear. Luckily, I am in favor of layering different pieces together, and I have long fingers! I wear the first crystal amulet that I ever made, together with a necklace of rubies that my husband gave me, two angel charms with my sons' names engraved on the back, a pendant with a miniature image of the Hindu god Ganesha (known

OVERLEAF PAGES (LEFT TO RIGHT): 18K Angel charms; my everyday jewelry. TOP: My dresser. RIGHT: A page from my sketchbook.

ANELLI DA FARE

① R75 — pietra tonda Ø6
foglie ai lati incisi sopra
gambo tondo

1° - cN

② R76 — pietra 8×10 (o 10×12)
- lavorazione delicata

③ R77 — pietre 7×9 o 8×10
Sapenti laterali
Sapenti tutto incisi
- si vede dove finiscono
le code

proporzione R36

R82

⑦ tutto oro . Saldato
specie di isco
petali sopra
pallino di gran.
fra uno e l'altro

④ R78

⑤ R79 — tutto oro
inciso sopra
pallina sotto
Mezzo tondo

elisse
cerchio morbido

⑧ filo grosso intorno a gambo tondo
filo girato

⑥ R80

⑨ R83 — II lati
Altezza 5mm

⑩ R81 — filo tondo va diminuire

*PER*SEMPRE

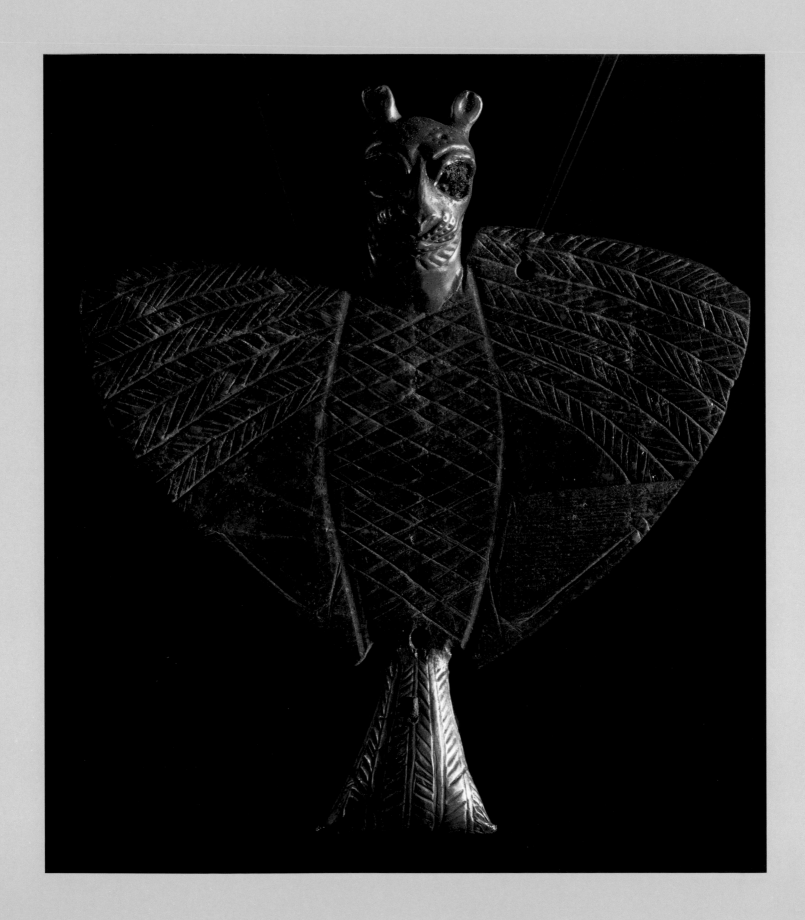

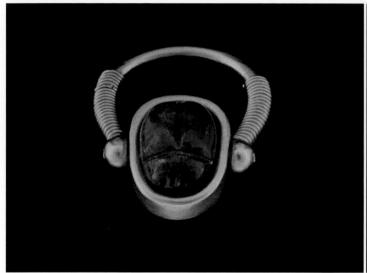

to be the remover of obstacles—very important!), and that's not all. I wear my wedding band stacked with a serpent ring, which represents creativity for me; a cabochon emerald in my first ring setting ever; and a sapphire, also from my husband, set into one of my classic settings. I also often add to the mix a carved blue moonstone moon face or one of my ancient coins set in a swivel ring.

I love ritual and often reread classical myth. When I walk in the woods with my sons, I like to imagine the otherworldly creatures and spirits that, according to the ancient stories, inhabit the rocks and trees and streams. Like many Westerners, I am most familiar with Greek and Roman mythology, but I am also drawn to Egyptian, Hindu, Buddhist, and Native American lore.

Ancient cultures created colorful stories to describe and demystify the natural phenomena around them. Magic in story and myth has guided much of human behavior since

the beginning of time. For the Greeks, thunder and lightning and storms at sea were signals from the gods. Good luck or bad luck was the result of "good" or "bad" human behavior in the eyes of the gods and other spirits that governed every animate and inanimate object. From these beliefs, a code of conduct came into being that helped society apply a general order to life and a resulting sense of security.

The early Egyptians made an array of amulets and wearable talismans that were associated with their religious beliefs. They were thought to protect the wearer and ward off evil spirits. The scarab, one of ancient Egypt's most powerful symbols, celebrates the very unglamorous dung beetle, which lays its eggs in animal droppings and rolls them into a ball to place it where the warmth of the sun will hatch the eggs. To the Egyptians, this was the ultimate symbol of the life force of the sun. The scarab shows up often in Egyptian jewelry: in swivel rings, bracelets, and necklaces.

LEFT: Mesopotamian eagle breastplate in lapis lazuli and gold, from the Treasure of Ur, Syria, 2500 BC. TOP LEFT: 22K "Scarab" swivel ring, circa 1985. TOP RIGHT: 22K Serpent ring, circa 1986.

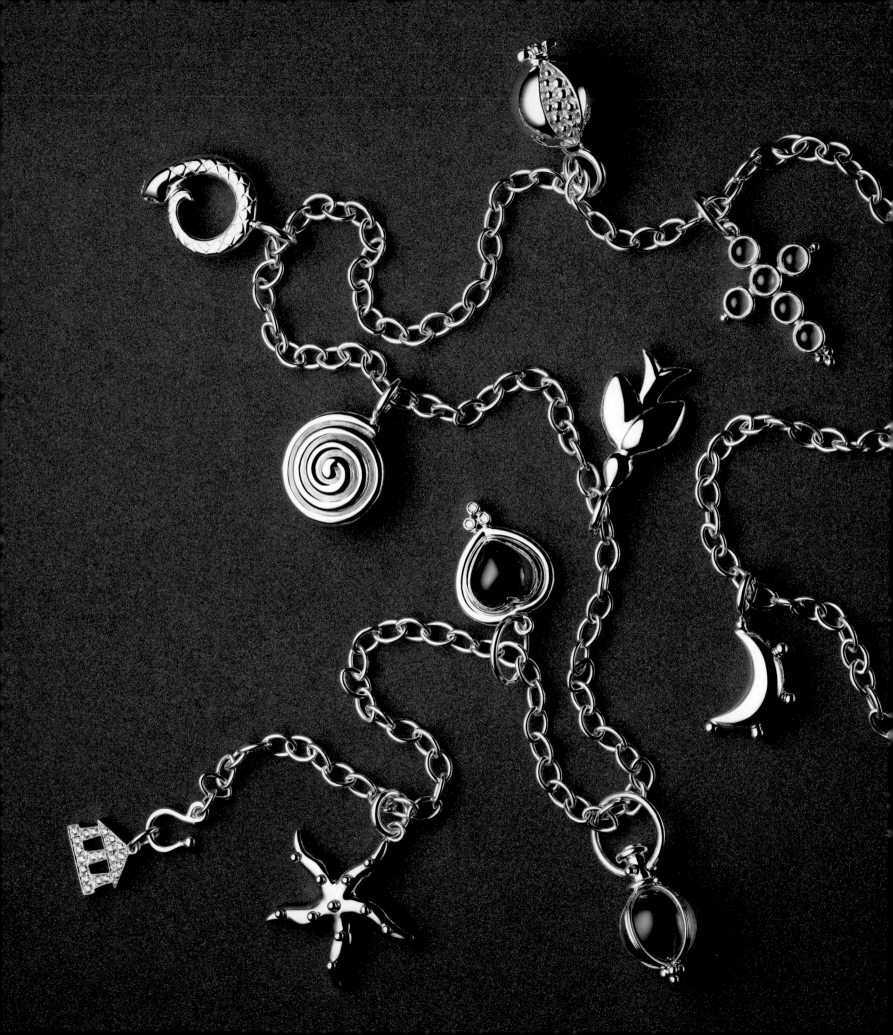

Curiously enough, at the height of the ancient Greek civilization, which extended east of modern-day Turkey and west across to the city-states of Sicily, identical jewelry motifs were popular at the same time at opposite ends of Magna Graecia. Travel was slow, but fashion, trends, and stories were faithfully transported by traders and adventurers. Typically in jewelry today, a piece will be stamped or engraved with an identifying mark, known as a hallmark, that will indicate a specific craftsperson, or brand. Most ancient jewelry is not hallmarked or signed by specific artisans, but it is speculated that during this period when gold craftsmanship had achieved new heights of sophistication, there were "factories" or goldsmith shops across the Mediterranean that shared the same designs for popular items of the day. Like an early version of globalization—a Tiffany of the ancient world, if you will—certain styles were prevalent from place to place. For a young aristocratic Greek woman, a pair of Aphrodite earrings might have been worn to attract the good graces of the goddess and would have been the "must have" accessory across the Mediterranean.

Today, we pride ourselves on being rational and practical creatures ruled by our great scientific and industrial knowledge, yet when it is comes to jewelry, it is remarkable how much superstition and nostalgia still prevail. The following of birthstones and celestial symbols are remnants of past beliefs.

LEFT: 18K Cosmos charms.

Many ancient cultures, from the Romans to the Jews, identified certain stones as associated with the months and astrological signs. It is remarkable and amusing that as sophisticated and modern as we believe ourselves to be, without even being aware of it, we follow pretty closely in the footsteps of our ancient ancestors. We contemporary beings are still wed to our signs and symbols, and the jewelry we choose often reflects our most primal instincts.

I believe that it is human nature to wish to be "connected," whether to family and friends or to a belief system; this may be religious or otherwise. Indeed, jewelry continues to be passed down and exchanged today. Whether family heirlooms or tokens of affection, it satisfies this desire to be "connected." I have met individuals who as part of a group of friends all wear and treasure the same pendant or bracelet as a celebration of their bond when separated by oceans.

TOP: Egg and dart architectural detail. RIGHT: 18K Oliva, Flower, and Cesare bracelets.

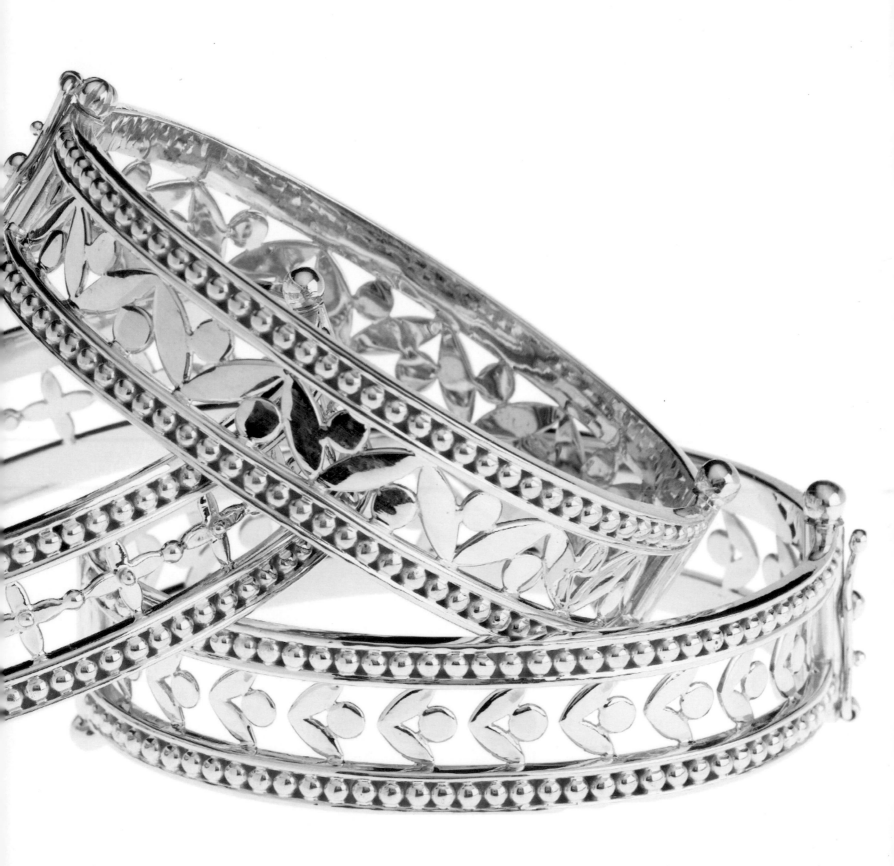

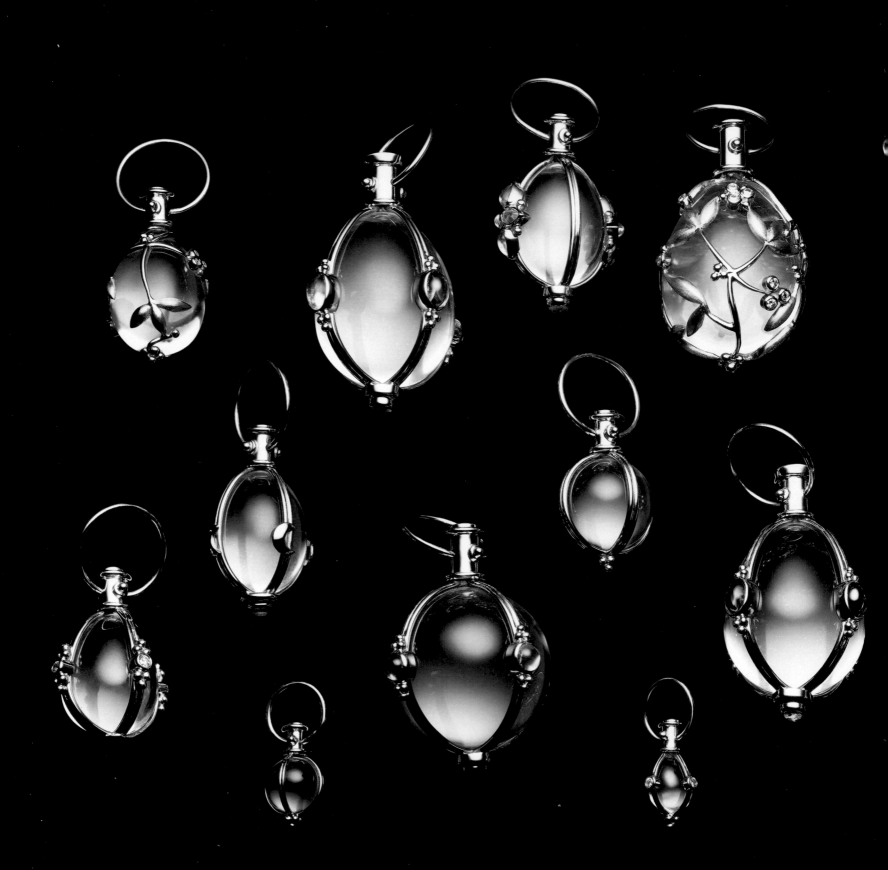

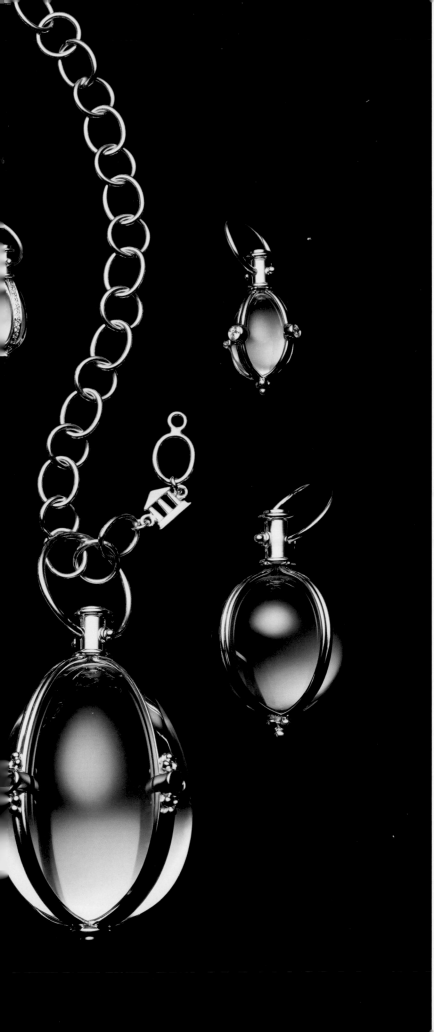

I am driven to design through stories; amulets and charms are natural vehicles. Though we seldom notice or consider their significance, ancient motifs are incorporated into much of the design around us today. For instance, the egg and dart pattern, an age-old symbol of life and death that is prevalent in classical architecture, shows up in architectural detail today. The spiral is another life sign or symbol of eternity that appears in modern renditions, yet it has existed in the art of ancient civilizations for millennia, from China and India to Egypt and Greece. I have a penchant for these ancient patterns and like to incorporate them into my own work. These signs and symbols have evolved over thousands of years and are full of meaning, yet so modern in their pared-down simplicity. I find the combination of ancient symbol and modern form compelling, as I favor a "less is more" approach to design.

My signature jewel is one that I refer to as an amulet. It is made from smooth-cut shapes of natural rock crystal. Rock crystal is a beautiful natural material that gathers and reflects light and color. It might be perfectly clear, or it might contain featherlike inclusions that give it its individual character. In the so-called New Age, crystal is attributed to have certain healing powers, but this is really nothing new. Rock crystal has been revered and treasured for thousands of years. The ancient Egyptians were among the first to gaze into crystal to foretell the future.

LEFT: 18K Signature Rock Crystal Amulets.

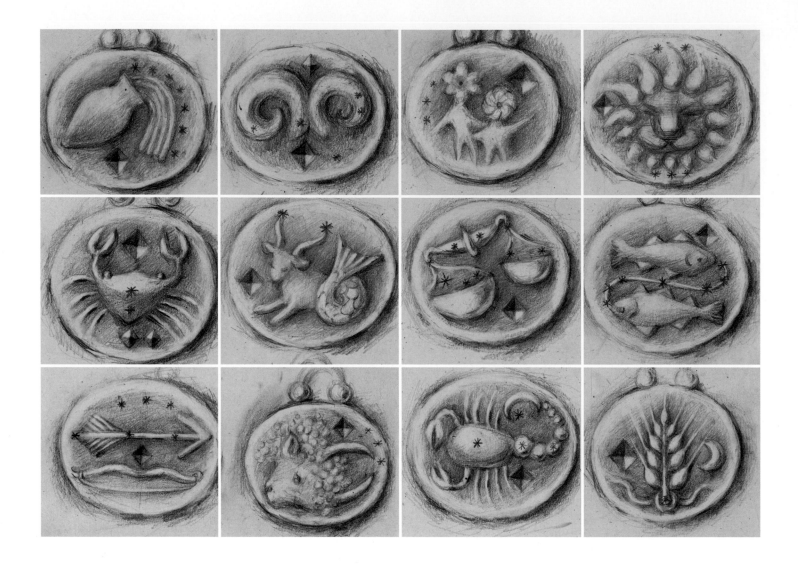

Crystal is considered a symbol of purity and clarity and is reputed to sharpen mental processes, not to mention make the wearer invisible at will! While exploring the history of jewelry, I came across medieval amulets made from rock crystal. Some of these I found in Lorenzo Il Magnifico's collections in the Museo Archeologico in Florence. These provided inspiration for my first rock crystal amulet, which I designed about twenty years ago. As I mentioned, I still wear the first one that I ever made. I don't know that it has helped keep me clearheaded, but it has become a very personal piece and part of my identity, and I don't feel complete without it.

A piece of jewelry often becomes a personal amulet when endowed with meaning by its wearer. Amulets and charms show up in different forms. My grandfather was never without his lucky silver dollar in his pocket. He carried the same silver dollar for decades; it was so worn that it had become merely a smooth piece of metal. The power of any lucky charm is directly related to the degree of faith the owner has in it.

TOP: Studies for Zodiac pendants. RIGHT: Relief carvings of Zodiac motifs from the Basilique de la Madeleine, Vezelay, Burgundy.

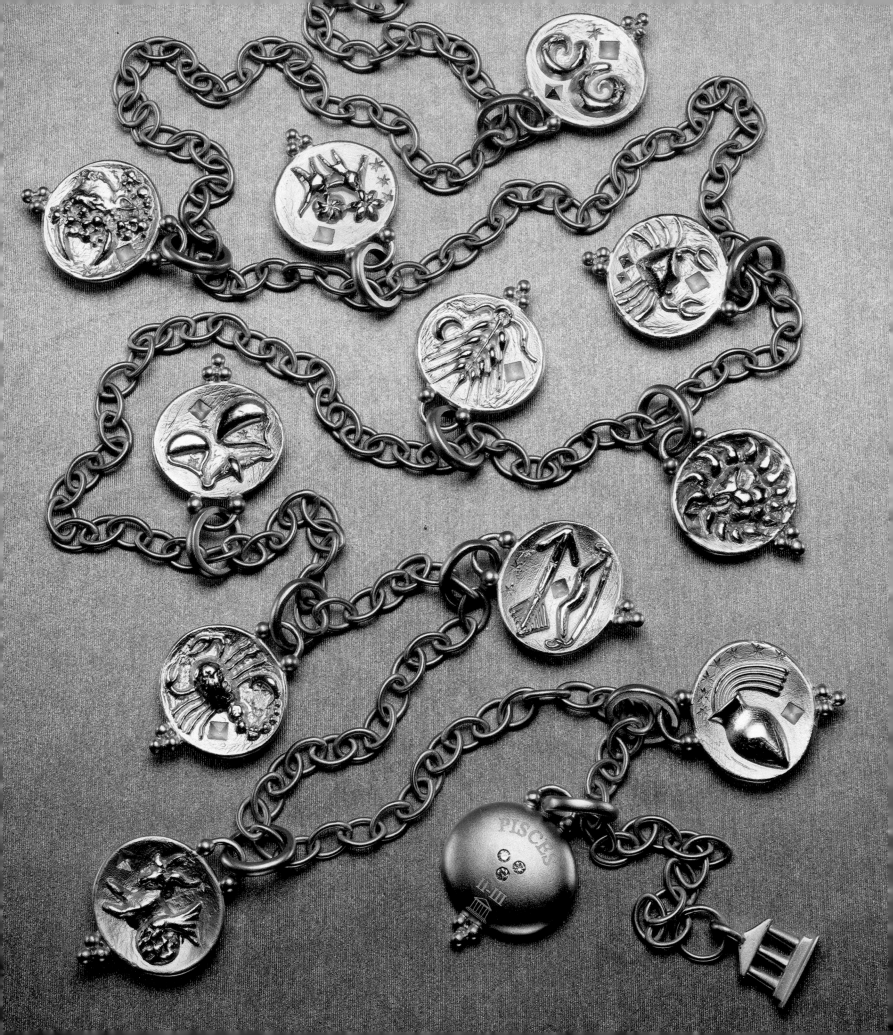

I now add new crystal amulets to my collections every season. They are typically spherical or egg-shaped, and the details are related in design to whatever theme I am working on. Artemis, the goddess of the hunt, was an inspiration for a recent collection. I admire the symbology of Artemis: her combination of strength and femininity, perhaps the first modern woman. The Artemis amulet is covered with golden vines, reminiscent in theme to the Artemis laurel amulets that were popular in ancient Greece. The piece is weighty yet ethereal. In my Mermaid collection, I did not want to merely create seashells as jewels. I wanted to create jewelry for a mermaid. What treasures might a mermaid wear? What would be her favorite charm? My Mermaid's amulet is a crystal egg

embraced by two sea stars made from blue moonstone, blue sapphire, and diamond, all set in 18-karat gold. In another recent collection inspired by the ancient celestial symbols that decorate the Basilique de la Madeleine in the town of Vezelay in Burgundy, I created my own interpretations of zodiac talismans in coinlike pendants.

The rock crystal amulet from this collection incorporates the nine gemstones associated with the nine planets. For me, a talisman, amulet, or charm does not have to have some special power, but it does have to have a story and be meaningful to its wearer. There are many talismans worn today whose meanings have evolved over time. The cross is a symbol that has specific meaning for many. Some believe it is an early

LEFT: 18K Zodiac pendants. TOP: 18K Capricorn swivel ring. FOLLOWING PAGES (LEFT TO RIGHT): 18K Classic charm bracelet; 18K Fiori earrings in royal blue moonstone and diamond.

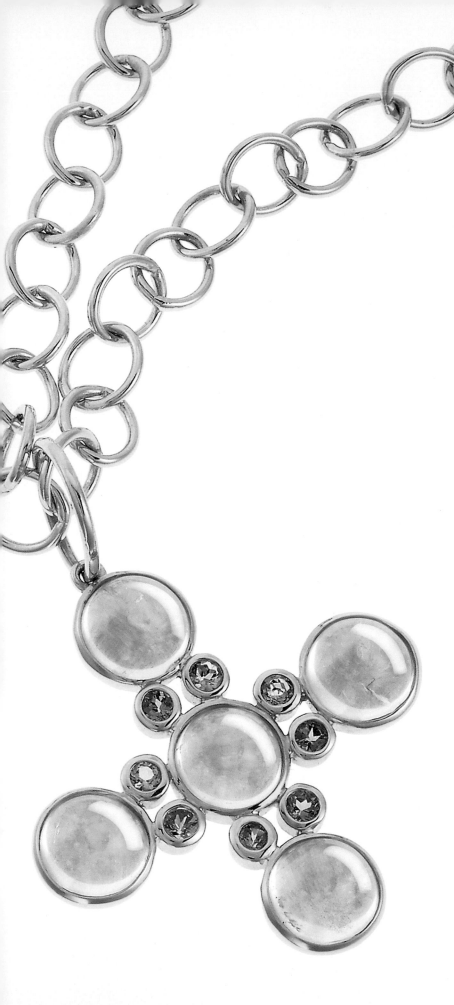

pagan symbol related to the worship of the sun. Early crosses were composed of two equal arms representing heaven and earth and possibly evolved from depictions of the tree of life. Symbols like crosses also made their way from one culture to another through conquest, travel, and trade. Different cultures imported foreign symbols and made them their own according to their beliefs, needs, and desires.

The Star of David is another symbol whose origin predates its current meaning. The six-point star comes from an astrological sign, two overlapping triangles symbolic of the sacred union of the opposing energies of fire and water, or male and female. It was adopted by many ancient cultures, even in Hindu teachings, where this symbol represents the cosmic dance of Shiva and Shakti.

I make my own versions of ancient symbols, including crosses and stars. I find these symbols aesthetically beautiful. My collectors may choose them because they carry specific meaning for them or because they, too, merely love the form.

Many important ancient symbols represent life and death, eternity, or other life affirming aspects. Some symbols that I like to interpret are the crosslike Carthaginian ankh, which

LEFT: 18K Heaven and Earth Cross in royal blue moonstone and sapphire.
RIGHT: 18K Cosmic Crystals in sapphire and diamond from the Celestial collection.
FOLLOWING PAGES: Andreas Cellarius, *Harmonica Macrocosmica*, Ptolemaic hypothesis—geocentric theory of the universe, 1661.

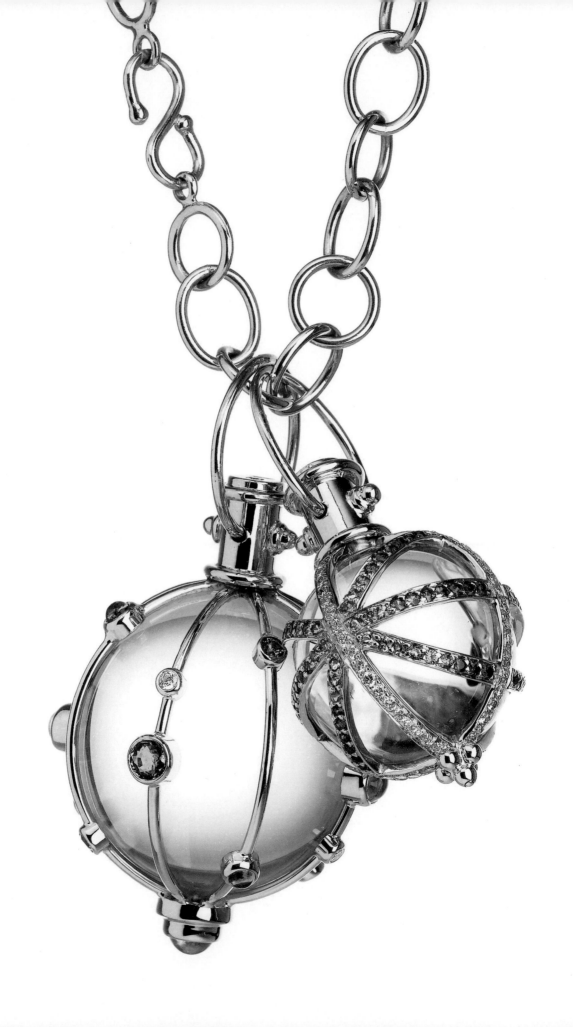

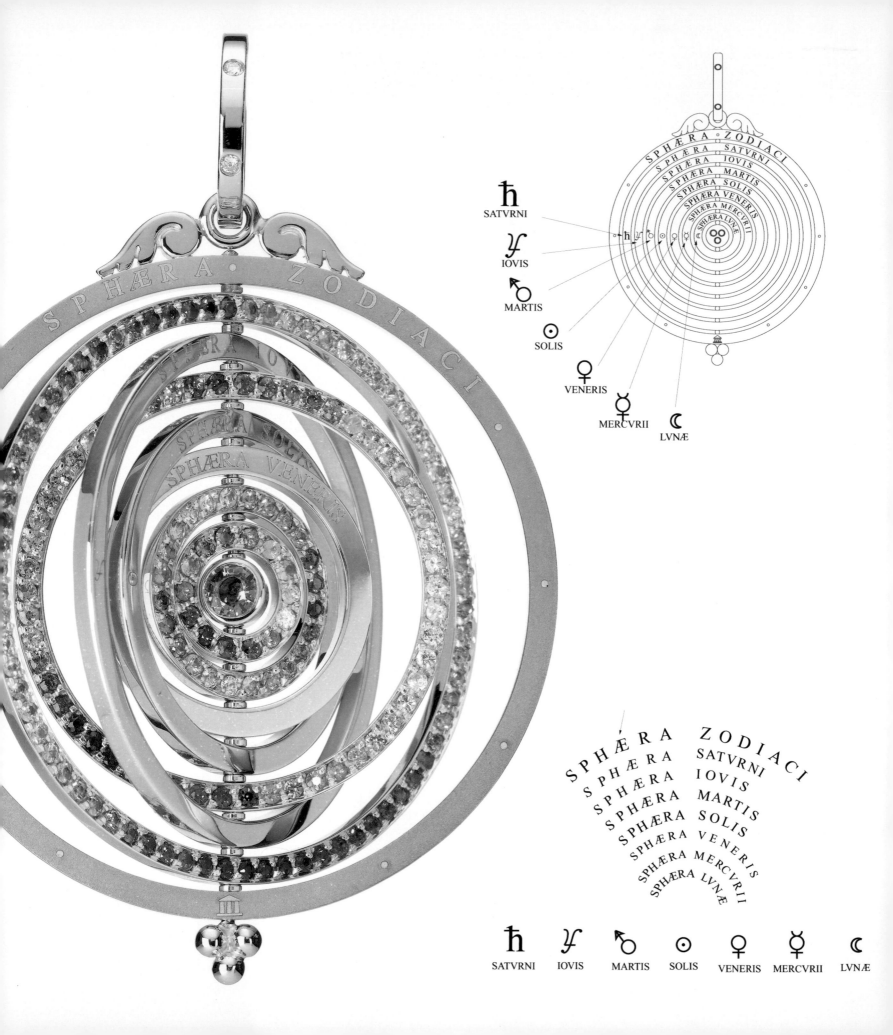

SPHÆRA · ZODIACI

SPHÆRA IOVIS

SPHÆRA SOLIS

SPHÆRA VENERIS

ℏ
SATVRNI

♃
IOVIS

♂
MARTIS

☉
SOLIS

♀
VENERIS

☿
MERCVRII

☾
LVNÆ

SPHÆRA · ZODIACI
SPHÆRA SATVRNI
SPHÆRA IOVIS
SPHÆRA MARTIS
SPHÆRA SOLIS
SPHÆRA VENERIS
SPHÆRA MERCVRII
SPHÆRA LVNÆ

SPHÆRA ZODIACI
SPHÆRA SATVRNI
SPHÆRA IOVIS
SPHÆRA MARTIS
SPHÆRA SOLIS
SPHÆRA VENERIS
SPHÆRA MERCVRII
SPHÆRA LVNÆ

ℏ ♃ ♂ ☉ ♀ ☿ ☾
SATVRNI IOVIS MARTIS SOLIS VENERIS MERCVRII LVNÆ

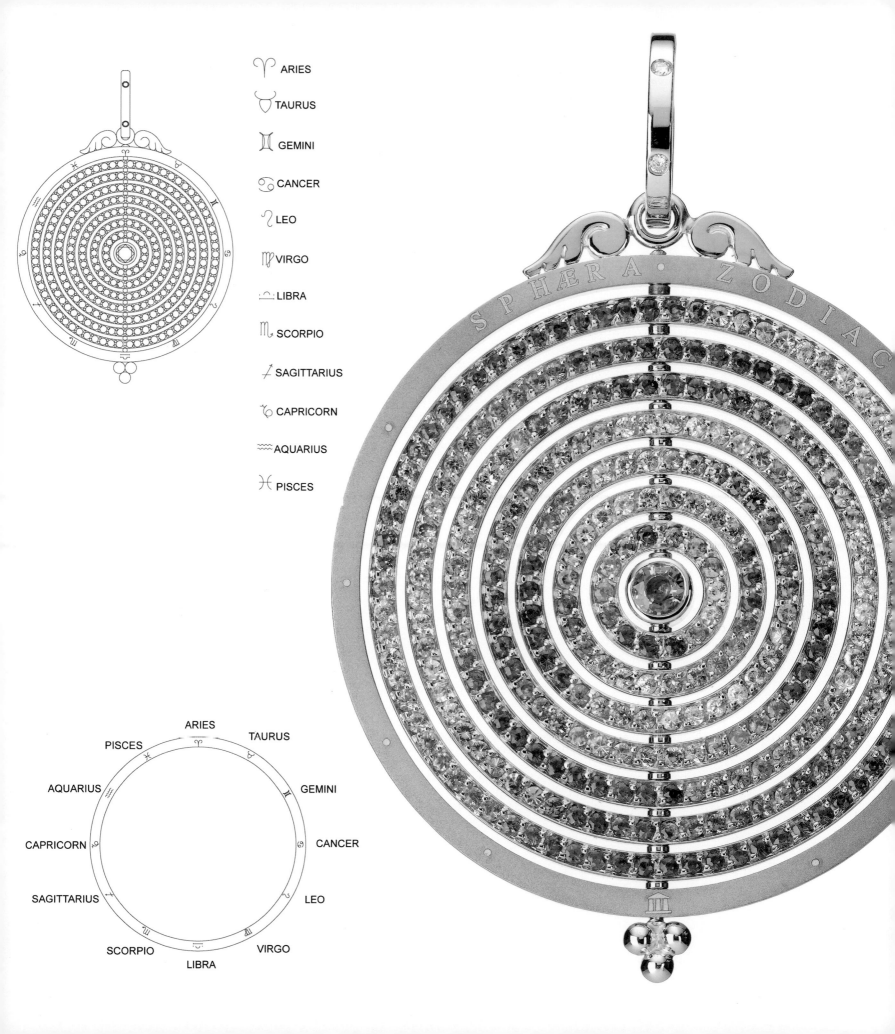

♈ ARIES

♉ TAURUS

♊ GEMINI

♋ CANCER

♌ LEO

♍ VIRGO

♎ LIBRA

♏ SCORPIO

♐ SAGITTARIUS

♑ CAPRICORN

♒ AQUARIUS

♓ PISCES

ARIES

TAURUS

PISCES

GEMINI

AQUARIUS

CANCER

CAPRICORN

LEO

SAGITTARIUS

VIRGO

SCORPIO

LIBRA

SPHÆRA · ZODIAC

is the symbol of Tanit, the Carthaginian goddess that I discovered through the lore of ancient coins; the Ourobouros, the mythological serpent of the classical world (depicted in a never-ending circular motif of the serpent biting its tail); the butterfly, a symbol of the psyche and of transformation; the dove, a sign of peace that was historically a Coptic amulet, an early Christian representation of the Holy Ghost, and of love; and the pomegranate, one of my favorite forms, which has been an important symbol in many cultures and also an important symbol of life and fertility and abundance in the classical world. In the Jewish tradition, the pomegranate is a symbol of righteousness; a pomegranate is believed to have 613 seeds, which correspond to the 613 commandments of the Torah. I also use symbols of the sun and the moon, spirals, and wave motifs to represent the movement of the tides. They all have become part of a design vernacular brought about by my love of storytelling.

The fact that amulets still exist today is very revealing of the human condition. Maybe at our core, we are not much different from early man. Believing in good and bad luck and keeping our charms close to our hearts is one of the most enduring vestiges of the past. In trying times, the deeper human value of jewelry really has no relation to economics, but instead provides a connection that links mankind to its larger universe.

OVERLEAF PAGES: 18K Tolomeo pendants in sapphire and diamond. TOP: 18K Butterfly earrings in rose-cut sapphire and diamond. RIGHT: 18K Butterfly Amulet in rock crystal with rose-cut sapphire and diamond.

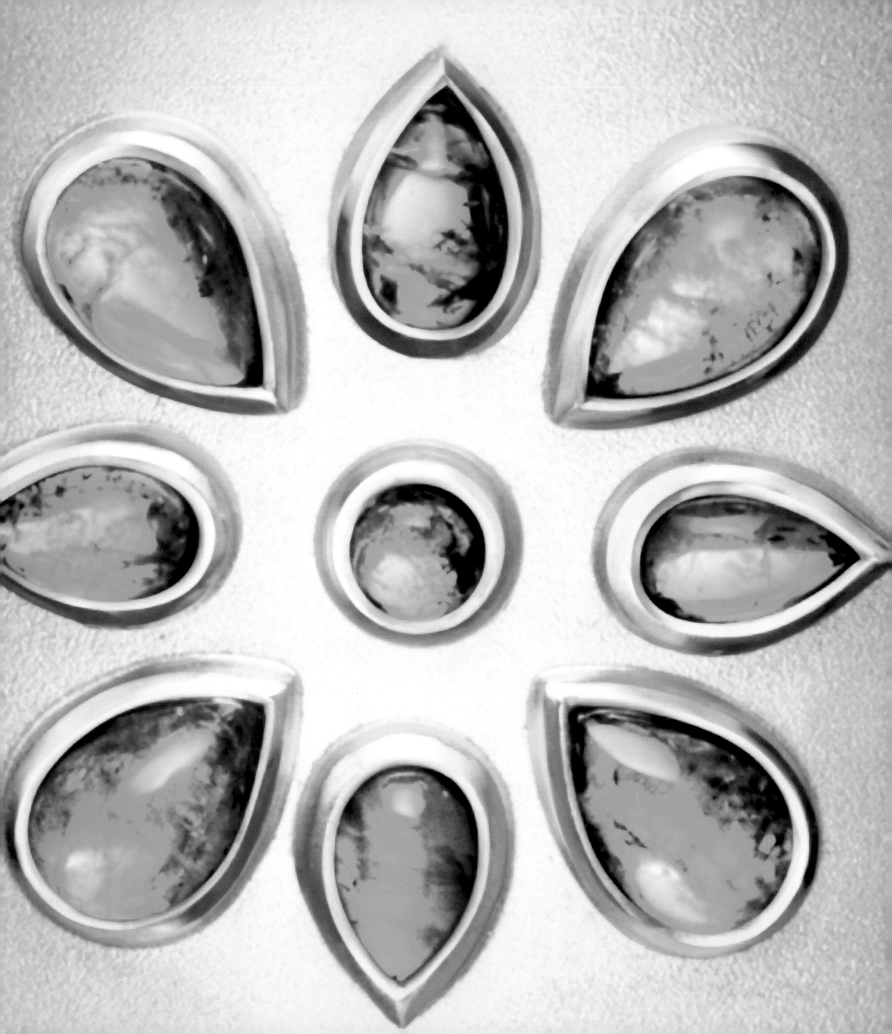

TRAVEL
AND
THE HUNT

TRAVEL HAS ALWAYS BEEN A TREASURE hunt for me. When I travel, I hunt for a variety of treasures, from architectural details to local stories and myths to unusual stones and great craftsmen. Everything I do, see, read, and hear becomes part of the inspiration for creating jewelry. Not only do I bring back objects and forge new work and trade relationships, I bring back images in my head and in my sketchbooks that later translate into design.

True to my upbringing, I am more of a traveler than a tourist. Travel is my most valuable teacher. I like to go off the beaten track, to "go local," in order to get to know where I am. My travel style is somewhat fashioned on that of the nineteenth-century English or European traveler who never went anywhere without a journal or sketchbook. I consider early artists, writers, and naturalists to be kindred spirits as I explore, going beyond the prescribed sites and monuments,

OVERLEAF PAGES: 18K Mandala bracelet in emerald. TOP: Traveling by Ambassador over the Himalayas from Ladakh to Kashmir, 1995. RIGHT: Shopping in Florence for display materials. FOLLOWING PAGES (CLOCKWISE FROM TOP LEFT): *Il Duomo, Florence*, ink on paper, Alexander at age five; exploring Florence with Archer; Alexander, Archer, and friend Gasper sketching on the steps of the Bargello, Florence; *Palazzo Vecchio, Florence*, ink on paper, Alexander at age five; 18K Classic necklace in aquamarine.

DUOMO

FIRENZE

PALAZZO VECCHIO

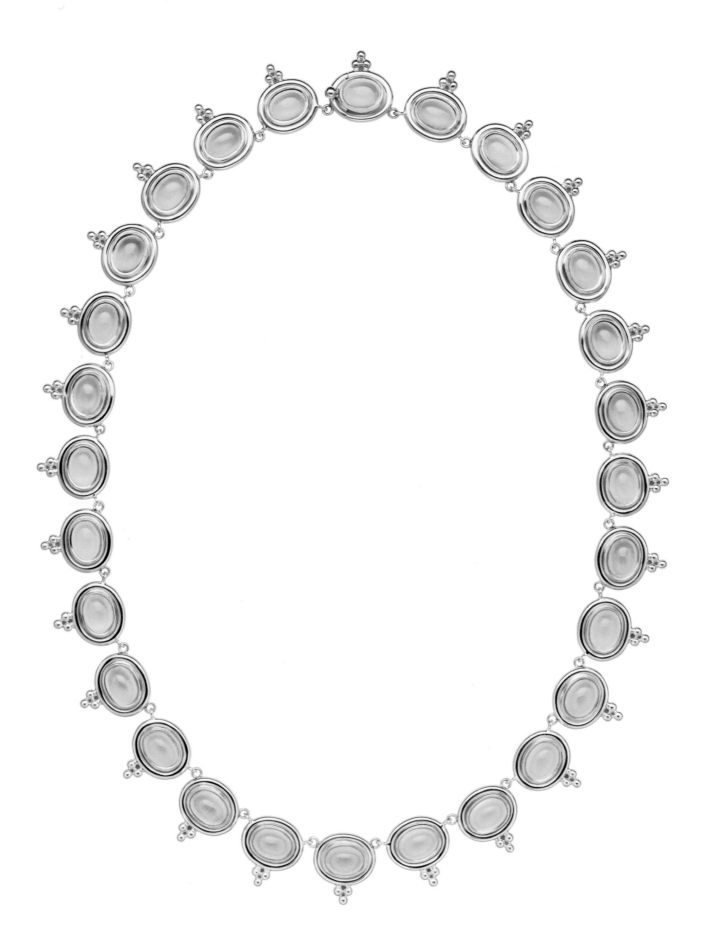

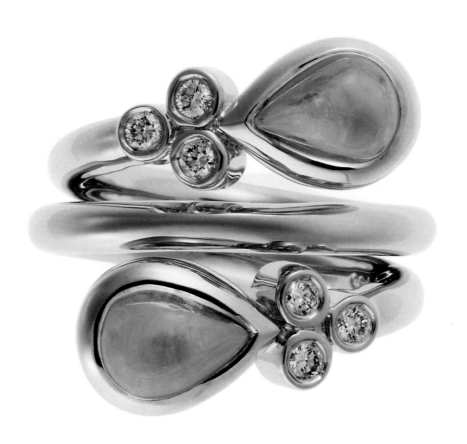

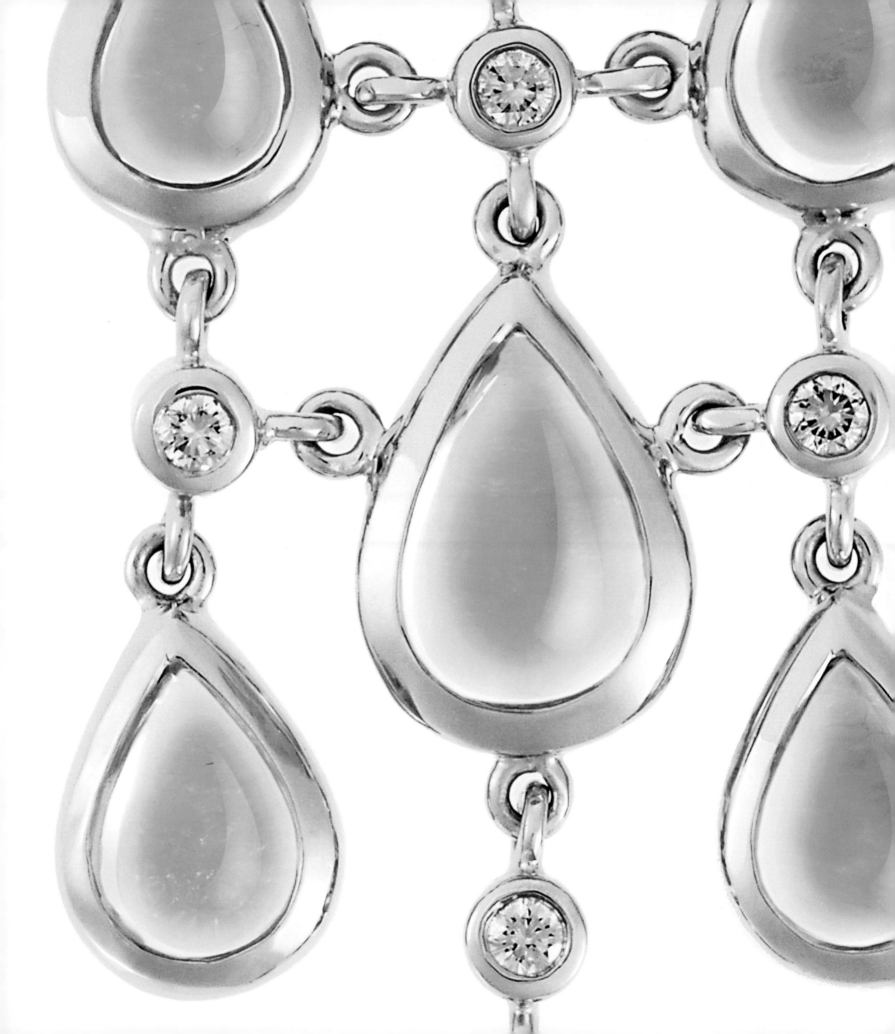

taking my time, reading and sketching, making notes, and listening to the local people of the place. Just as in the United States, cultural differences, shifts in attitude, in dialect, in food, in art, from region to region and from town to town, reflect the character and history of a place and its people. The personality of a culture is like a historical collage of migration, trade, religion, friendships, and rivalries.

It is my nature to collect things and experiences that tell stories from other cultures. My home is filled with the relics of my explorations: Native American pottery sherds found between the tumbleweed after climbing to the top of Black Mesa outside of Santa Fe, remains of an ancient Greek amphora from the hills of Cnidus on the Turkish coast, cone shells from Sri Lanka, Naga beads from northern India, prehistoric sharks' teeth found in the muddy creek beds of Charleston, South Carolina; embroidered Tibetan shoes from Ladakh, ceramic animals made by Egyptian schoolchildren, gilded eighteenth-century angel wings found in the back of

OVERLEAF PAGES (LEFT TO RIGHT): 18K Mummy ring in royal blue moonstone and diamond; detail from 18K Chandelier earring in royal blue moonstone and diamond. TOP LEFT: Fort at Gwalior, India. TOP RIGHT: Fatehpur Sikri, India. OPPOSITE PAGE (TOP TO BOTTOM): Snake charmer, Sri Lanka; Fatehpur Sikri, India.

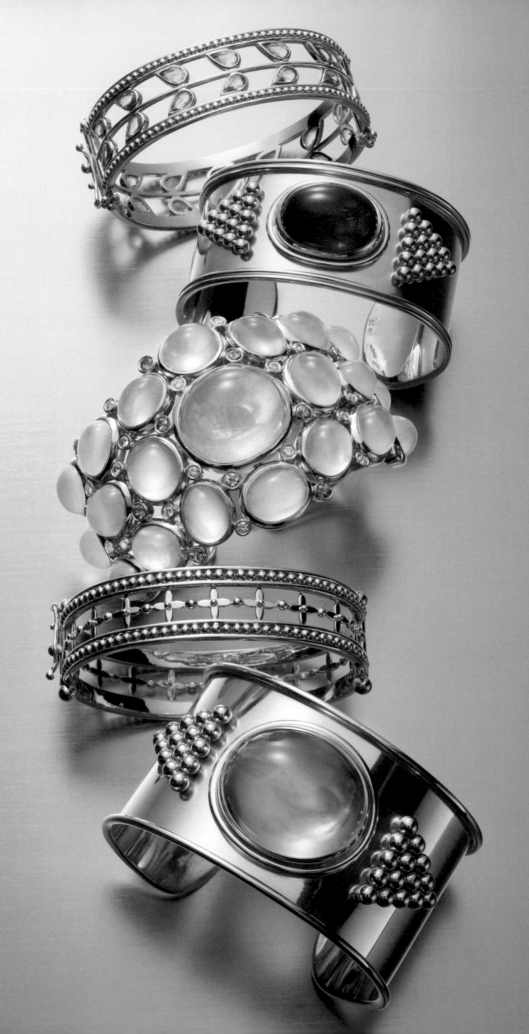

a woodworker's shop in Florence, an antique piece of Fortuny fabric from Venice, a wooden horse head from a doorway in Jaisalmer in India on the border of Pakistan, and of course, my ancient coins, some offered up from the sands near Hasankeyf between the Tigris and Euphrates rivers in eastern Turkey and others from dealers in Turkey and Italy. These are personal treasures that keep my adventures alive in my imagination. They animate my everyday life, inspiring plans for the next quest.

I can always find a reason to travel. It refreshes the mind and satisfies my innate passion for the visual world. All said,

travel has become an indispensable part of my design process. My inspiration can come from the pattern along a window cornice or from the misty green of a Tuscan hillside. It's important not only to study a culture's arts but also to spend time in its markets, cafés, and countryside. My travel tools consist of a good map, sketchbooks for capturing small details and travel writings, and novels and histories from the land where I find myself. For example, when in Greece and Turkey, I read Herodotus and the Greek myths; when in India, I take along *The Adventures of Ibn Battuta* and a collection of Hindu mythology; in Sri Lanka, I pick up Buddhist teachings

LEFT: 18K bracelets. TOP (ALL IMAGES): Egypt and North Africa.

and read Michael Ondaatje's *Running in the Family*, about growing up there; and when in Florence, I reread Boccaccio's *Decameron*, Vasari's *Lives of the Artists*, and travel logs and letters of late-nineteenth- and early-twentieth-century foreign visitors to Tuscany. In general, I seek out descriptions and observations by travelers from earlier centuries when the pace of travel was slow and contemplative. Ideas and design themes come to me through these colorful writings as I access and visualize the everyday lives and mannerisms of other times.

To consider beads and other gems is to study a history of travel and human migration. Jewels are passive travelers themselves, marking the routes of traders and conquerors. The compact size and portability of precious gems and jewels have forever led them to cross borders and exchange hands in distant lands. I find myself a part of that age-old tradition!

Besides stringing beads together for my friends in elementary school, my earliest venture into jewelry commerce

was during travels in India. I found a market in Delhi where a dealer was selling antique Naga beads. Nagaland is situated in the northeastern corner of India, next to Burma. Former headhunters, the Naga people loved to adorn themselves with elaborate pectorals, necklaces, and belts in bright orange and saffron and turquoise. The fascination is that threaded among the Nagas' indigenous beads is an occasional Venetian glass bead. At some point, this native tribe must have been exposed to traders from the West who exchanged wares such as Venetian beads for local treasure. In my imagination, the beads came east with Marco Polo on his way to China!

The same phenomenon stands out in the most northern reaches of India, in Ladakh, known as Little Tibet, in the foothills of the Himalayas. Here you see women passing in the streets wearing huge pieces of Persian turquoise and Mediterranean coral. The wonder of finding these materials in such a far-flung and isolated locale is mind-boggling.

TOP LEFT: Taxiing through Nepal. TOP RIGHT: Outside of Kathmandu, Nepal. OPPOSITE PAGE: Antique Naga beads collected in India. FOLLOWING PAGES: 18K Mandala bracelet in emerald.

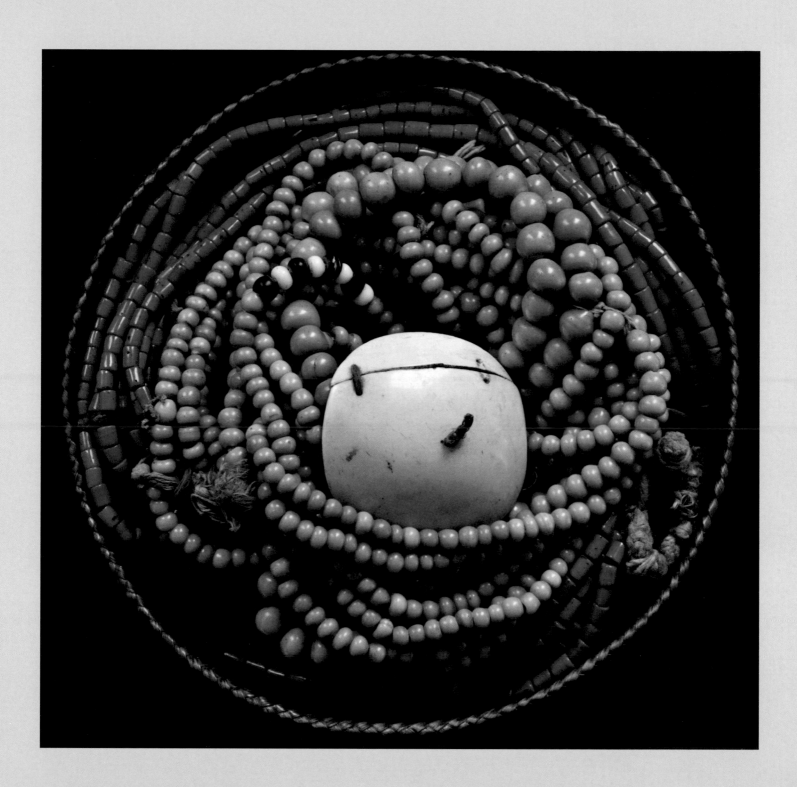

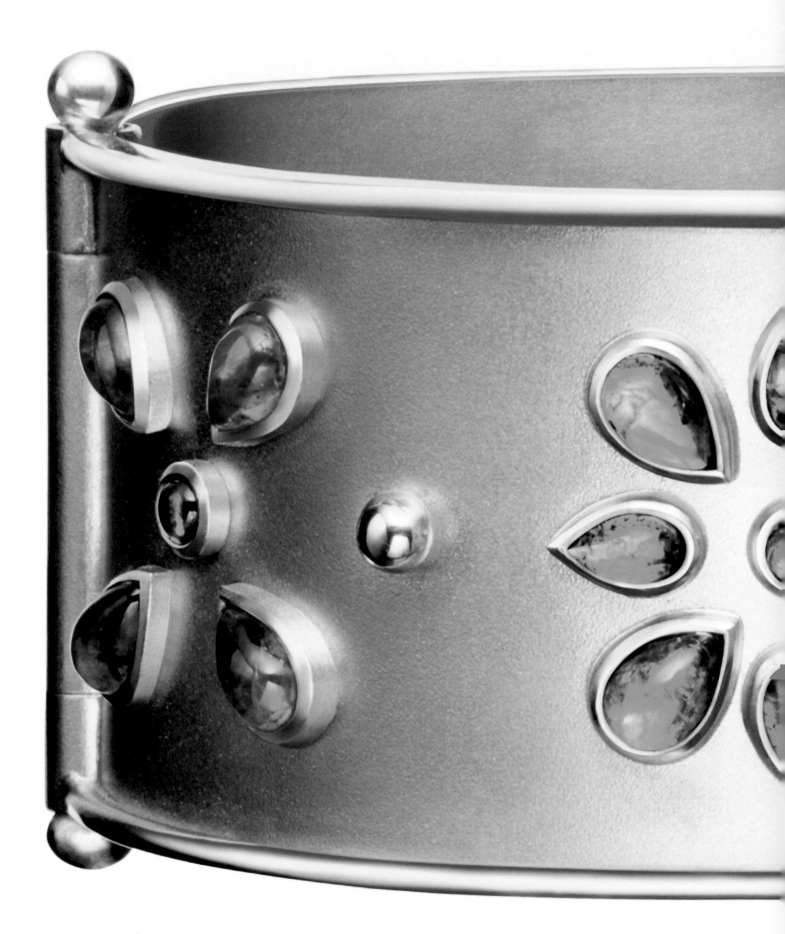

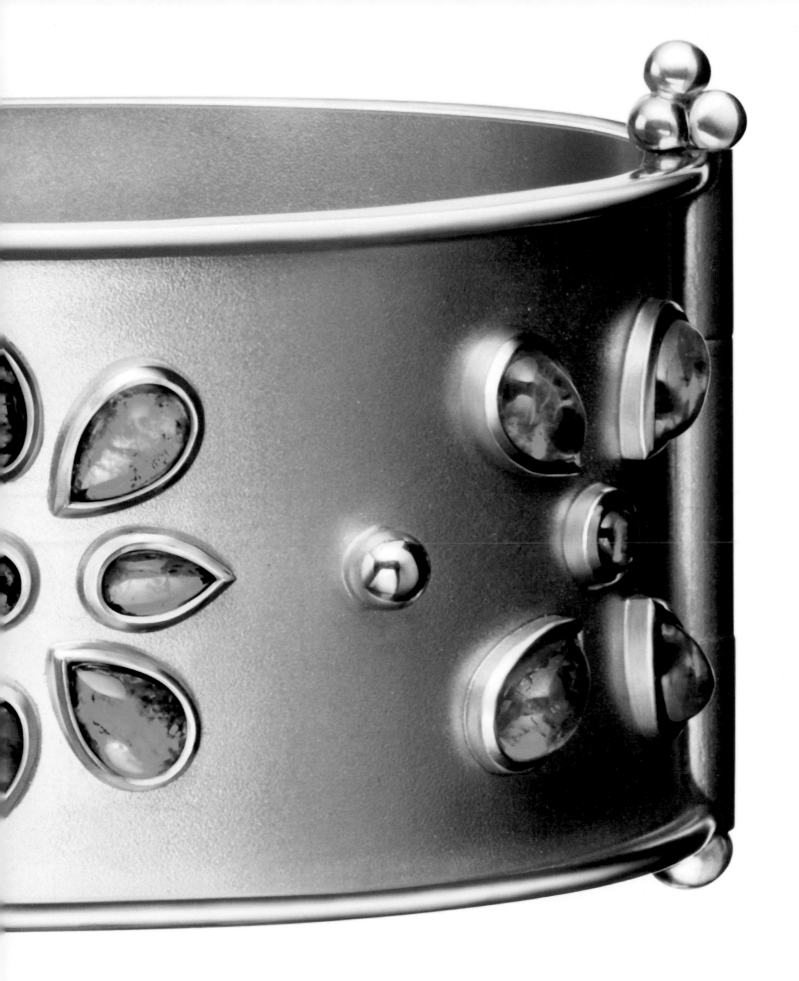

When I venture out into the world to find new materials and ideas, I feel I am a traveler on a path that has been well trodden by centuries of travelers before me.

As I admired the beads and learned the history of the Nagas, I decided that perhaps I could support my wanderlust by becoming a trader myself. I would follow the footsteps of an early traveler and trader such as Jean-Baptiste Tavernier. Tavernier was a seventeenth-century traveler and merchant who recounts his adventures in his *Travels in India*. He traveled the Indian subcontinent in search of gems and gold and was taken with the exoticism of his trip.

I returned to Italy with my loot and sold a few pieces and kept the rest for my own personal collection. I soon found that researching, designing, and coming up with my own ideas for jewelry was my strength. I enjoy commerce, but am more suited to dream and create than to negotiate!

In Italy, my life of designing jewelry began to unfold, and I put travel to use in a supportive role in the process. My travels through the Mediterranean laid the groundwork for my early designs. I still travel regularly to Italy for inspiration and to spend time with my artisans there. In Florence, I visit and revisit my favorite places and works: Donatello's *Annunciation* in Santa Croce and his bronze *David* in the Bargello; Brunelleschi's chapel for the Pazzi family; the frescoes of Benozzo Gozzoli in the Palazzo Medici-Riccardi; Jacopo Pontormo's *Deposition* in the Cappella Capponi in Santa Felicita. I go for walks in the nearby countryside where I lived in Settignano, over the hills to Fiesole past towered villas, Etruscan tombs, and a Roman theater. I have my own way of looking at all these sites. I enjoy and respect the composition as a whole, but my eyes go to the detail. I seek out the pattern and the play of color, examine the textiles and the headdresses,

OPPOSITE PAGE: Florentine details. TOP LEFT: Outside my first flat in Via della Vigna Vecchia, Florence. TOP RIGHT: Loggia of Santa Croce, Florence.

the ornamentation of a bridle or the border of a veil. I look for the story and the allegory. I look at the decoration and ornament around the pieces, and observe the balance and the scale.

As I walk the streets, my eyes follow the lines of the buildings, seeking out the details in the doors and windows, door knockers, and horse ties. . . . Even the metal torch holders on the walls have a story. Although simple instruments are made of humble material, if you look closely, every one is in the shape of a dragon or serpent with small hammered patterns, each slightly different from the next. This is the type of care for detail that I love: the unexpected, almost hidden, story and humor. I try to include this type of detail when I design.

In the Tuscan countryside, where the landscape has hardly changed for centuries, I imagine the great artists of the Renaissance, such as Leonardo, looking at these same hills.

When I look at his paintings such as his *Annunciation* in the Uffizi, the landscape that he creates is so familiar. I walk past the villa that the fourteenth-century Florentine writer Boccaccio supposedly used as the backdrop for his stories in the *Decameron*. I can picture the storytellers that he portrays in his book. They were five well-to-do young couples who took refuge from a plague-stricken Florence behind the garden walls of a beautiful hillside villa, where they distracted themselves with stories of love from the most bawdy to the most pure and true. I like to imagine how they were dressed and what jewels they may have worn, not to mention the trappings of the colorful characters of their tales.

As I wander the back streets of Florence past Dante's house I ponder further the details of his fourteenth-century world. On which corner, as a small boy, did he first see his

TOP: Walking through the hills of Settignano. RIGHT: 18K Tree of Life pendant. FOLLOWING PAGES: 18K Classic Mosaic necklace.

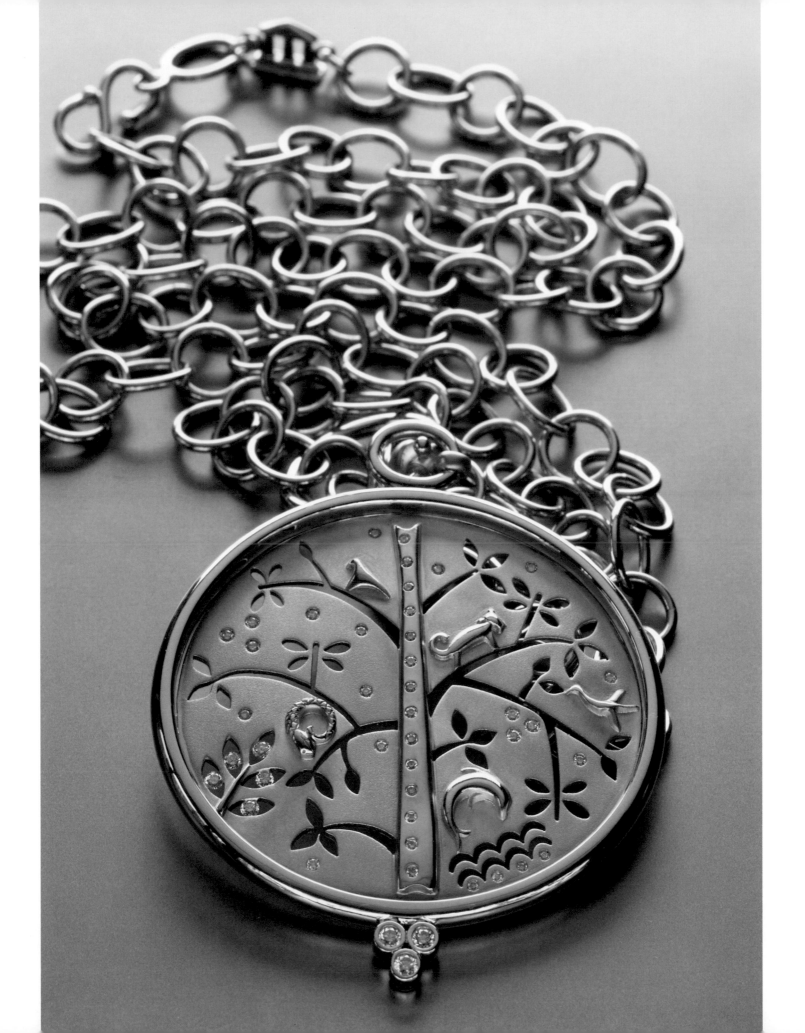

beloved Beatrice, the inspiration for his treatise on language and poetry *La Vita Nuova*, and his guide to Paradise in the *Divine Comedy*? And back along winding hillside roads, I pass by the villa that supposedly belonged to Beatrice's family and wonder if Dante ever made his way into these hills with the hope of catching a glance of the young woman. The literature makes the landscape come alive. What was Beatrice's style? Was she friendly with the young men and women in the Medici court? What jewels did she treasure and wear?

Curiously enough, traveling in the Indian subcontinent is similar to traveling in Italy in that there are distinct cultural differences region to region and the tradition of craftsmen and artisans lives on as it has for centuries in both places. A few years ago, I went to Sri Lanka for the first time in search of sapphires, blue moonstones, cat's eyes, and stonecutters. I expected to find a place similar to India, but although Sri Lanka does share some characteristics with southern India, it is substantially different. The majority of Sri Lankans are Buddhists, and the history and tradition of Buddhism colors the everyday workings of the country. Whenever possible, my husband and I travel together with our sons and as a family; we have made the journey several times to this former Kingdom of Ceylon, referred to as "India's teardrop."

On our first visit we met with the trade commission for

LEFT: North African markets. TOP: Unusual tourmalines.

jewelry and gems in the capital, Colombo, and were directed to Kandy to meet with a selection of gem dealers. Conveniently, when traveling in Sri Lanka and India, it is very economical to have your own car and driver, so the four of us piled into a van and headed out of Colombo for the four-hour drive to Kandy. Along the way, we stopped at roadside stands to buy baby bananas and king coconuts, into which you poke a hole to drink the sweet liquid.

The locals told us that we must stop to visit the Pinnawala Elephant Orphanage. Elephants are traditionally very important in Sri Lanka. They are still used for work in the fields; most every Buddhist temple keeps a resident elephant, and wealthy families like to accumulate elephants as a sign of wealth. Since modern equipment has replaced many working elephants and it is costly to keep and care for an elephant,

their well-being is threatened. The Orphanage was established to adopt and protect elephants that are no longer needed, are too old to work, or have been injured. In fact, there is a three-legged elephant there that lost a foot to a mine in Sri Lanka's war zone to the north. I love animals but was never so overcome with affection for elephants until I visited those at Pinnawala. On a grassy ridge, we walked among a large herd of female elephants and their young. Young men known as *mahouts* take care of the elephants and guide them twice a day off the ridge, across the road, and down a hill to a river where they bathe. Just above the river is an open-air café where you can sit and drink Ceylon tea and watch the elephants.

The Pinnawala café has become one of my favorite cafés in the world. It is a perfect place to slow down and reflect upon these majestic beings and life itself. Now, after several

OPPOSITE (TOP TO BOTTOM): Kandy, Sri Lanka; elephant orphanage, Pinnawala, Sri Lanka. TOP: 18K Coco ring in green tourmaline.

visits to the country, we always plan extra hours to sit and watch the elephants play and wrestle in the river. The elephant calves climb on their friends, while young adults loll on their sides, letting the water rush over them, using their trunks like snorkels. Despite their size, their most remarkable quality is their capacity for silence.

Because of its important symbolism, the elephant appears decoratively all over the Indian subcontinent. The elephant image itself has not yet fit into my collections, but I do use the beautiful Sinhalese word for elephant, *aliya*, to name certain pieces. Just as I use classical names such as Artemis or Arcadia or Minoan, it is more about the origin of a feeling in the design rather than a literal reference. The elephant is historically a sacred creature providing life and sustenance and is granted deep gratitude and reverence by cultures such as the Indian and Sri Lankan. After becoming more closely acquainted with the creatures on these trips, I like to honor them and be reminded of them in my work, if only through a word and name.

On our first Sri Lankan adventure, upon arriving in Kandy, we checked in at the Queen's Hotel in the center of town right across from a large and important Buddhist temple,

LEFT: 18K Golden Lion Archer chain. RIGHT: Egyptian details from my travels.

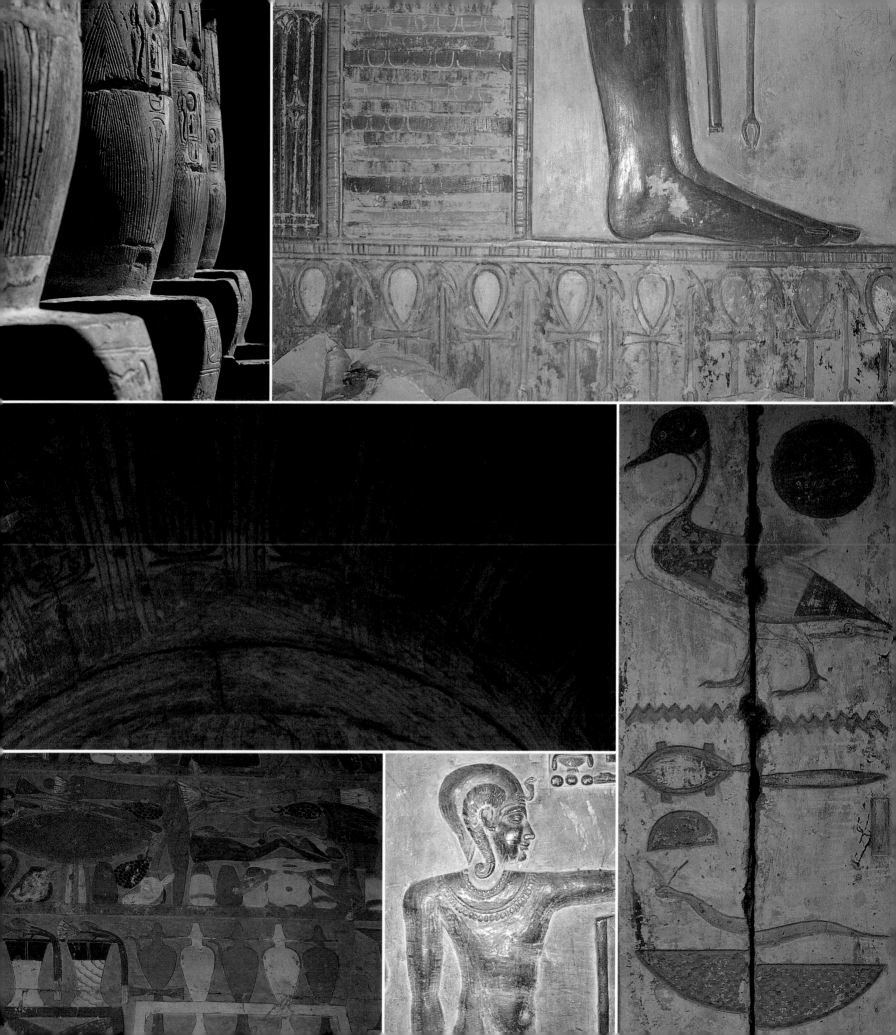

the Temple of the Tooth, which supposedly houses the relic of one of Buddha's teeth. We were soon greeted by one of the dealers whom we had arranged to meet. He led us through the streets back to his workshop, where we were invited in and served tea and biscuits.

There is a colonial feel to business transactions there and in India, where greetings and visits are formal and full of respect. As in many Eastern countries, there is a strong tradition of exchanging gifts. In Sri Lanka, we mostly receive gift versions of elephants: bejeweled, carved wood, and bronze. Business transactions take place while spending a great deal of time drinking tea and talking of family and our respective cultures.

As in my business experiences in Italy, there is a slower pace that can sometimes be frustrating. Ultimately, slowing down our Western ways tends to lead to deeper understandings and successful and satisfying working relationships.

What I gain from travel is direct access to all forms of beauty. The world is filled with richness and treasures, human and animal and, of course, vegetable; animate and inanimate. The joys and challenges of absorbing and redefining such riches is a process without beginning or end. Everything I have ever needed to quench my creative yearnings is available to me through travel, art, and literature. No advanced technology is necessary, just a quiet mind and a sketchbook.

TOP: 18K Tree of Life earrings. RIGHT: 18K bracelets. FOLLOWING PAGES: 18K chains with temple charms.

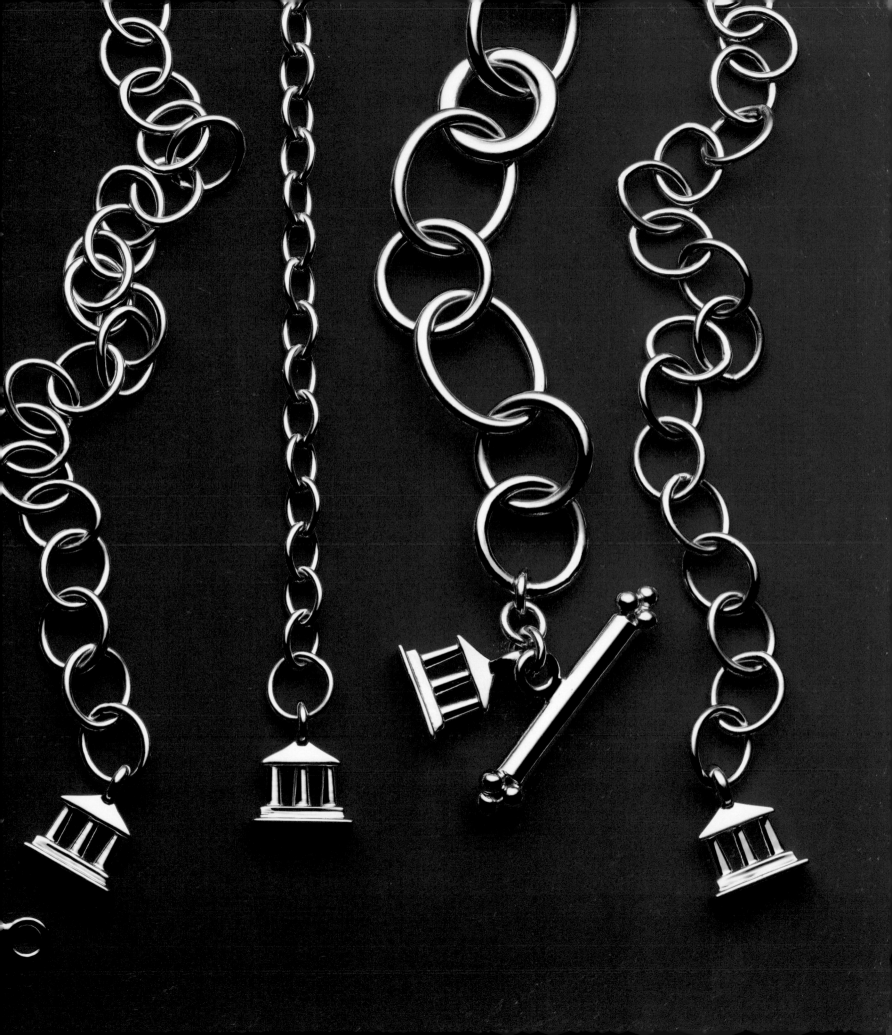

ACKNOWLEDGMENTS

I AM GRATEFUL TO PAUL, my inspired and enthusiastic husband and partner. You understand better than anyone the heart and soul of what I love to do in life and work.

I would like to thank my parents, who laid the foundation and opened the world to me through books and travel.

I am indebted to my talented staff, my goldsmiths, and the force of individuals who cleared the path for me and have given their time, thoughts, and efforts to this project:

Amanda Plant, my photo editor and essential partner on this project. Your spirit, skill, and talent are without boundaries.

Lou Iacovelli, whose imagination has no limit and who encouraged me to share my story.

My agent, Kathleen Spinelli, for making it all happen with such ease.

Gasper Tringale, photographer and friend, for your meticulous eye, and indefatigable capacity to trek the hills of Florence with me.

Mitchell Feinberg, whose photography is fine art. You capture the soul of the jewelry.

Karen Kelly, for helping me give shape to the book.

My editor, Cassie Jones, for her skillful shepherding of this project to its home in the Collins Design imprint.

Notably my talented friends and advisers, Selene Eng, Misun Chung, Susan White, Carol Edgarian, Julie Holyoke, and Mose Ricci, for their generous wisdom, advice, and support.

My great thanks to Marta Schooler, Liz Sullivan, Ilana Anger, Teresa Brady, Agnieszka Stachowicz, Diane Aronson, Roni Axelrod, Johnathan Wilber, and all those at Collins Design and HarperCollins who helped to make this book happen.

And my appreciation goes to Maureen O'Neal and Judith Regan, who believed in this project from the beginning and set the wheels rolling.

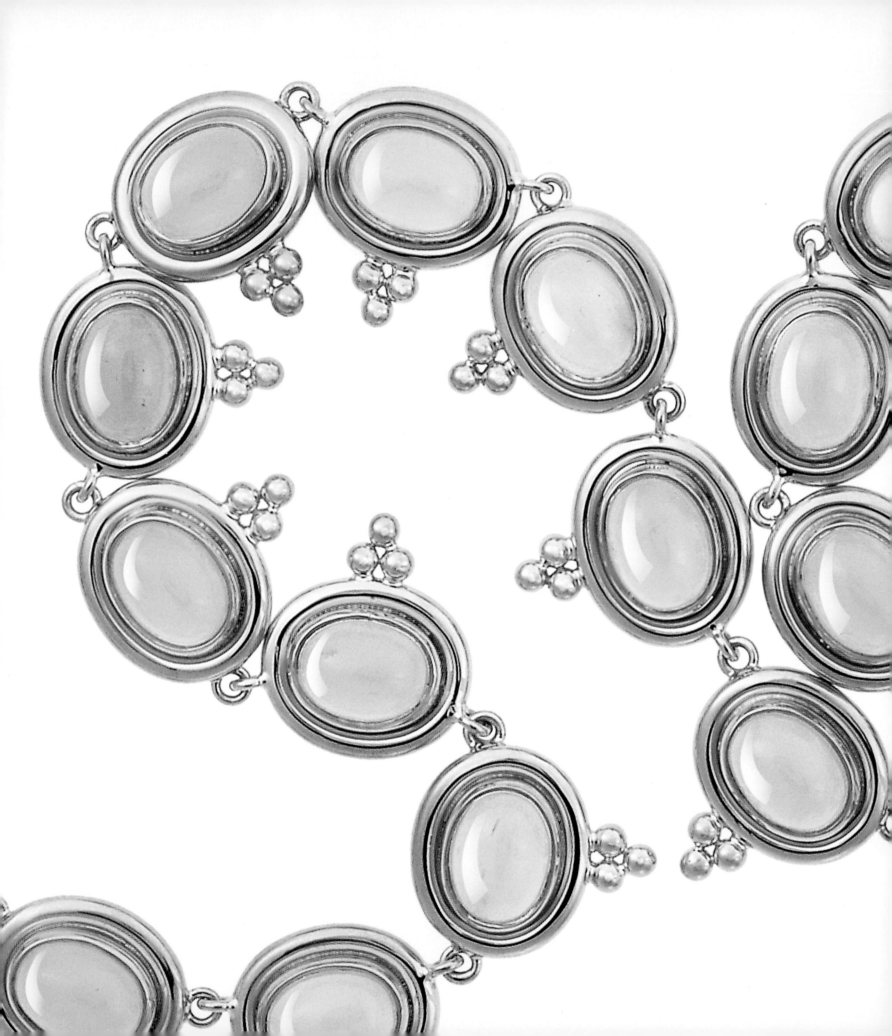

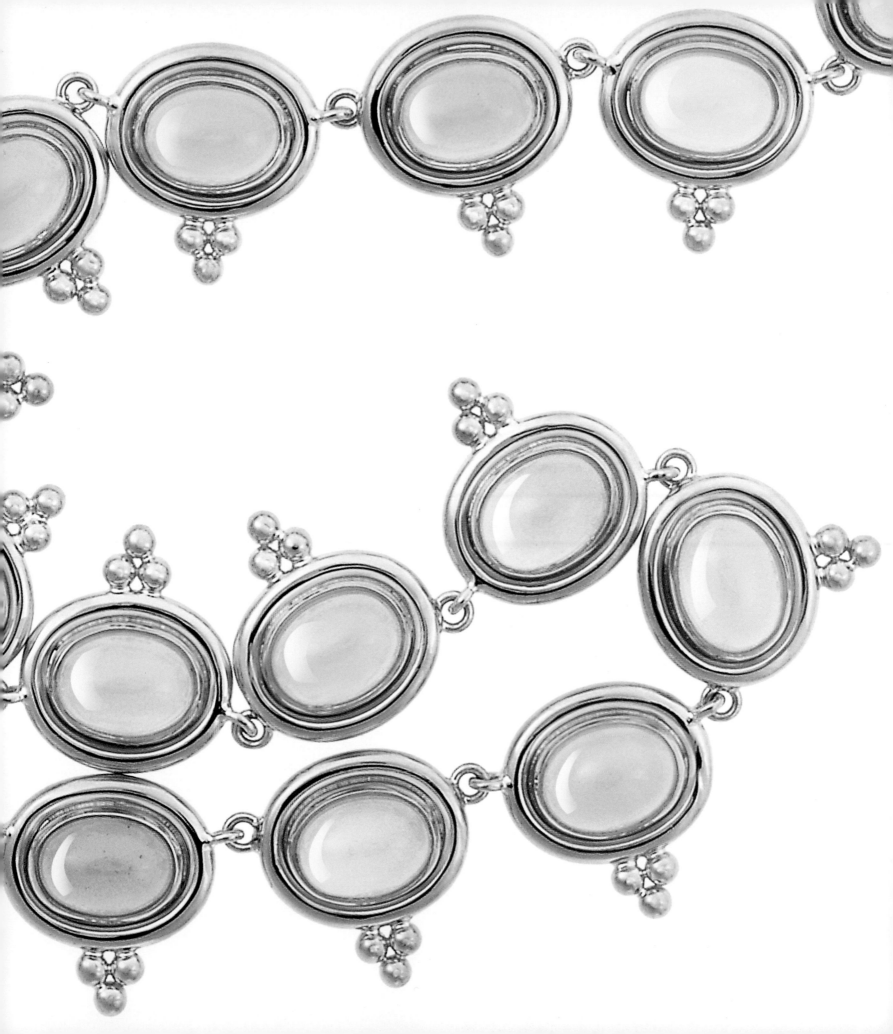

CREDITS

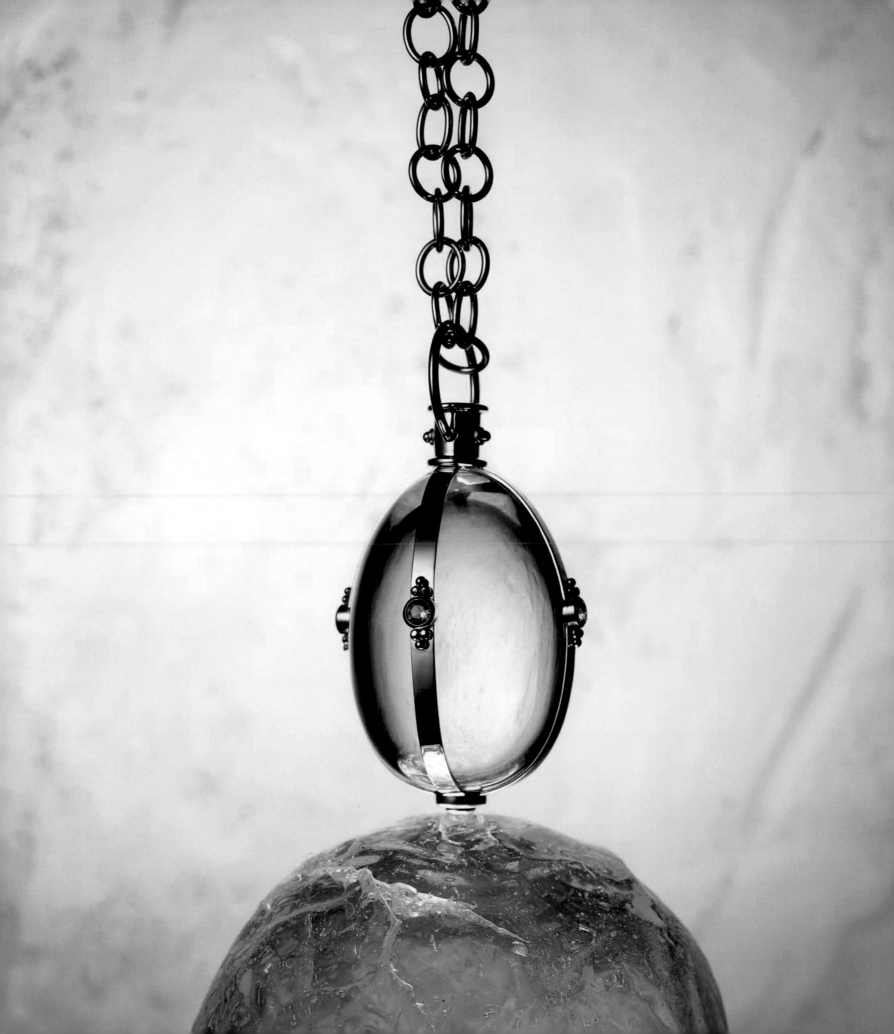

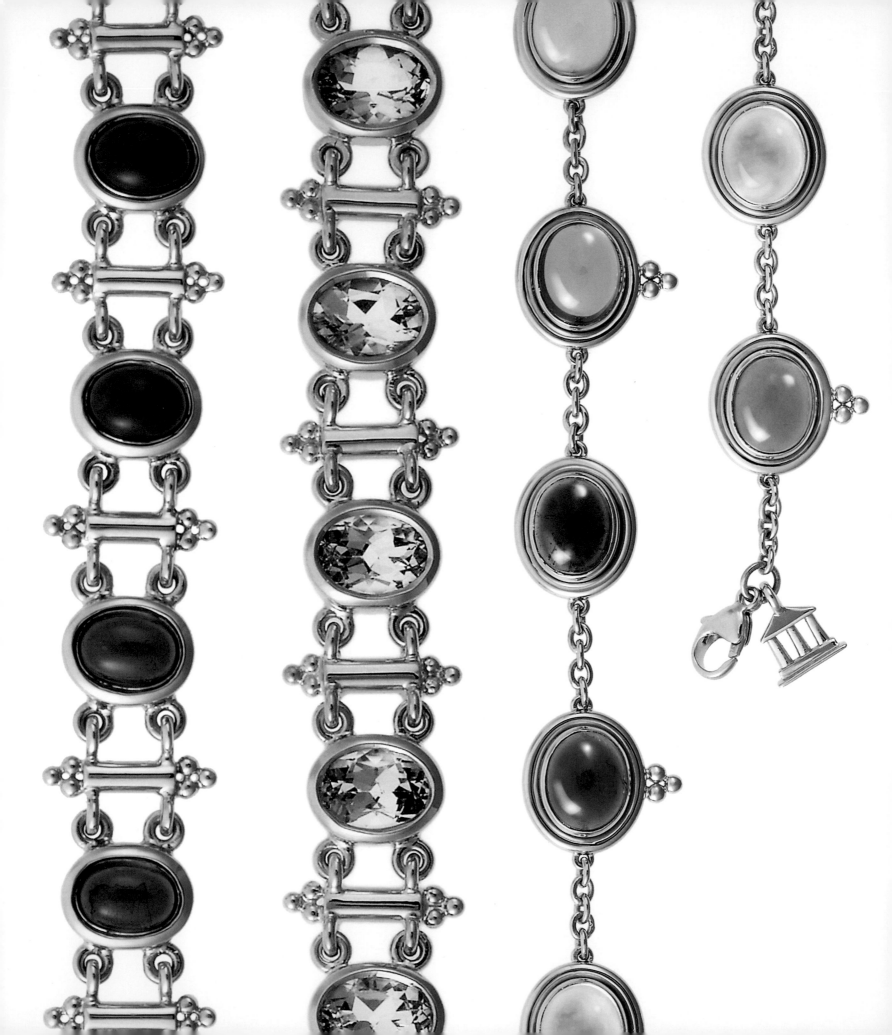

PHOTOGRAPHY

Hiroshi Abe: 1, 17, 22–23, 28–29, 95, 103, 105, 141, 146, 155, 199, 206.

Sylvere Azoulai and 2A Studio: 122–123, 149.

Zoltan Babo and Sarolta Wienold: 19, 32, 102, 152, 193.

Anita Calero, courtesy of *Town & Country*: 50.

Ed Chappell, courtesy of Robert Rauschenberg and Merce Cunningham Dance Company, Set Design by Robert Rauschenberg: 93 (top and bottom right)

Tony Dougherty, courtesy of Merce Cunningham Dance Company: 92 (top right)

Mitchell Feinberg: Cover, 6–7, 11–13, 54–55, 84–85, 112–113, 117, 134–135, 142–143, 150–151, 160–161, 164–165, 168, 200–201, 210–211, 217, 221.

Sarah Howard: 86.

Robert Kirk: 36–37, 66, 159.

Erik Kualsvik, courtesy of Drayton Hall, a National Trust Historic Site, Charleston, South Carolina: 15 (top).

Erich Lessing/ Art Resource, New York and National Museum, Damascus, Syria: 158.

Merce Cunningham Dance Company: 92 (left).

Next Big Thing: 170, 180–181, 194–195.

Shin Ohira: 222.

Eric Piasecki, courtesy of *Elle Decor*: 156.

David Prince: 209.

Doug Rosa: 16, 154, 179, 190.

Leon Steele: 125.

© 2006 Kevin Sturman, courtesy of *Vogue*: 212.

Geert Teuwen: 25, 38, 42–43, 46–47, 69–70, 73, 76, 78–80, 83, 91, 96–97, 100, 104, 107, 114, 118, 120–121, 127, 129–133, 136–139, 145, 147–148, 162–163, 169, 171–173, 176–178, 185–187, 203, 205, 208, 214–215, 218.

Gasper Tringale: Author photograph, 8, 33, 39, 52–53, 62–63, 94, 98, 106 (right), 183, 184 (top right and bottom right), 196–198.

© 2003 Jack Vartoogian/Front Row Photos, courtesy of Merce Cunningham Dance Company: 93 (bottom left).

Leonard von Matt, courtesy of Madeleine Kaiser-von Matt, Gemeinnutzige Stiftung, Switzerland: 71–72, 75.

OVERLEAF PAGES (LEFT TO RIGHT): 18K Classic necklace in aquamarine; 18K Rock Crystal Amulet with ruby, sapphire, and emerald. LEFT: 18K Beatrice and Classic bracelets.

ART AND ARTIFACTS

Agnolo Bronzino, *Portrait of Bia de' Medici,* 1541: 65; *Portrait of Maria de' Medici,* 1530s: 81; *Portrait of Eleonora di Toledo,* 1544–1546: 82 (right) courtesy of Uffizi Gallery, Florence; and *Portrait of Florentine Noblewoman,* 1540, courtesy of the San Diego Museum of Art: 82 (left).

Andreas Cellarius, *Harmonia Macrocosmica,* 1661: 174–175.

Richard Diebenkorn, *Ocean Park No. 108,* 1978, courtesy of the Collection of the Oakland Museum of California: 115.

Disc earring, Magna Graecia, sixth century BC, courtesy of © The Trustees of the British Museum, London: 41.

Etruscan pin from tomb of Littore di Vetulonia, 630 BC, courtesy of Museo Archeologico, Florence: 45.

Etruscan "grape" earrings from San Paolo, fourth century BC, courtesy of Museo di Villa Giulia, Rome: 48.

Etruscan braid ties from Cerveteri, seventh century BC, courtesy of Museo di Villa Giulia, Rome: 60.

Fayum mummy portrait, tempera on wood, Egypt, second century AD, courtesy of Museo Archeologico, Florence: 44.

Fayum mummy portrait of Eirene, tempera and gold leaf on wood, 100–120 AD. Photo by: P. Frankenstein and H. Zwietasch, courtesy of Landesmuseum, Würtemberg: 67.

Fayum mummy portrait of a woman with gold hairpin, tempera on limewood, 140–160 AD, courtesy of © The Trustees of the British Museum, London: 68.

Eugène Fontenay, *Les Bijoux,* 1887: 153.

Mark Rothko, *No. 61,* 1953, courtesy of Museum of Contemporary Art, Los Angeles, courtesy of ©1998 Kate Rothko Prizel & Christopher Rothko/Artists Rights Society (ARS), New York: 108.

Albertus Seba, Cabinet of Natural Curiosities, *Tabula 14* and *Tabula 15,* 1734–1765, courtesy of Koninklijke Bibliotheek: 110.

Louis Comfort Tiffany, Bronze fireplace screen early 1900's, courtesy of University of Michigan School of Art & Design and College of Architecture and Urban Planning: 88.

Cy Twombly, *Natural History (Some Trees of Italy), Part II, Sheet 3,* 1976; lithograph, collotype, and collage; courtesy of Thomas Segal Gallery: 87.

Giuseppe Zocchi, *Vedute di Firenze e. della Toscana,* eighteenth-century engravings, courtesy of Libreria Editrice Fiorentina, Firenze: 31.

EPHEMERA

Author's collection: 14, 15 (bottom left and right), 20–21, 24, 26–27, 30, 35, 40, 49, 57–59, 61, 64, 74, 89, 90, 99, 109, 119, 167, 182, 184 (top and bottom left), 192.

Temple St. Clair: 10, 18, 51, 56, 68–69, 77, 101, 106 (left), 111, 116, 124, 126–127, 128, 140, 157, 162, 166, 176–177,188–189, 192, 202, 204, 207.

ALL REASONABLE EFFORTS HAVE BEEN MADE TO CONTACT THE COPYRIGHT OWNERS OF THE IMAGES IN THIS BOOK. ANY OMISSIONS ARE INADVERTENT.

RIGHT: 18k Cocktail Rings in pink tourmaline, green tourmaline and diamond, aquamarine, and iolite.

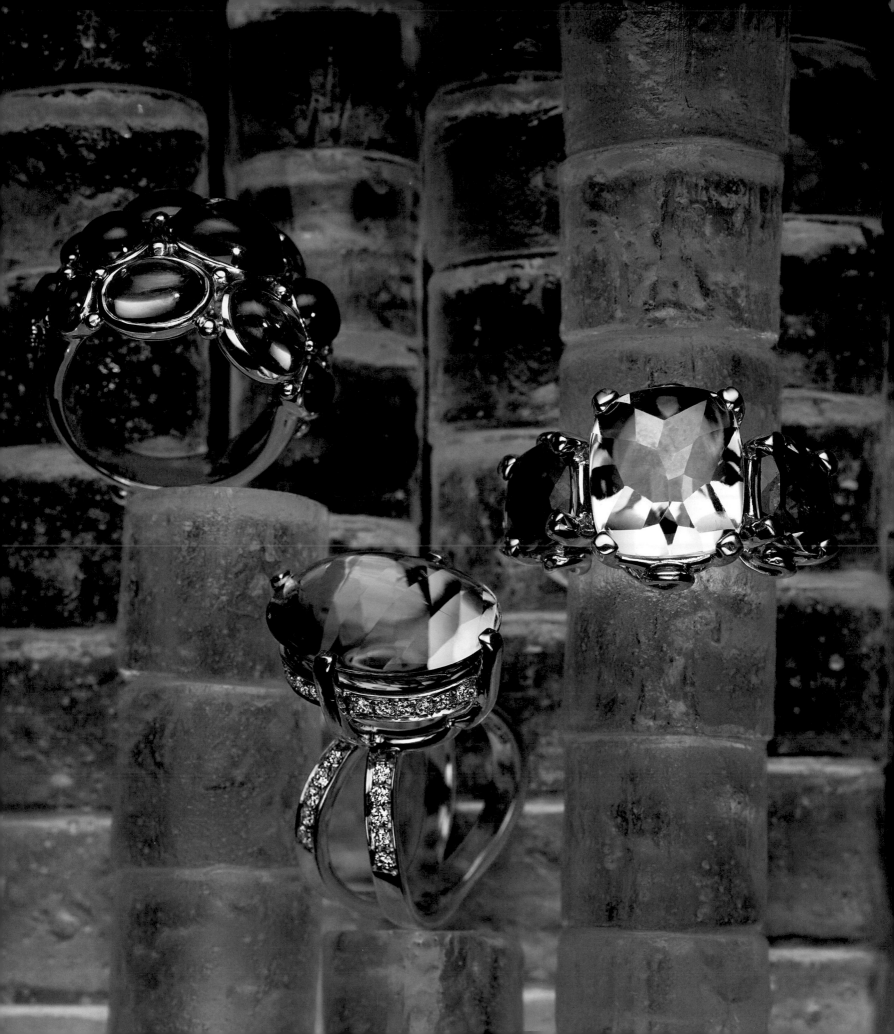

ALCHEMY

COPYRIGHT © 2008 BY TEMPLE ST. CLAIR

All rights reserved. No part of this book may be used or reproduced in any manner whatsoever
without written permission except in the case of brief quotations embodied in critical articles and reviews.
For information, address HarperCollins Publishers, 10 East 53rd Street, New York, NY 10022.

HarperCollins books may be purchased for educational, business, or sales promotional use.
For information, please write: Special Markets Department,
HarperCollins Publishers, 10 East 53rd Street, New York, NY 10022.

FIRST EDITION
Designed by Agnieszka Stachowicz
Printed in China.

Library of Congress Cataloging-in-Publication Data has been applied for.

ISBN-13: 978-0-06-119873-1
08 09 10 11 12 SC 10 9 8 7 6 5 4 3 2 1

18K Crown rings in royal blue moonstone, tanzanite, diamond, and South Sea pearl.

Brunswick County Library
109 W. Moore Street
Southport NC 28461